GANDHI
in the Gallery

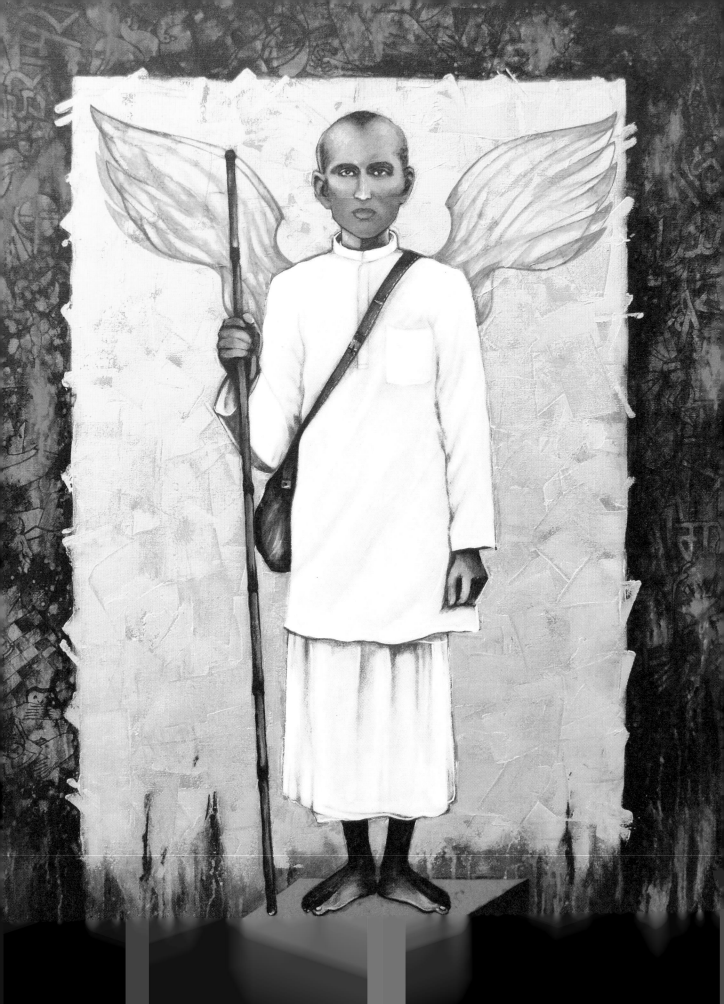

GANDHI
in the Gallery

THE ART OF
DISOBEDIENCE

SUMATHI RAMASWAMY

Lustre Press
Roli Books

FOR AMMA

on the occasion of her eightieth
(albeit a tad later than intended!)

© Sumathi Ramaswamy, 2020
Published by Roli Books
M-75, Greater Kailash-II Market
New Delhi-110 048, India
Ph: ++91-11-40682000
E-mail: info@rolibooks.com
Website: www.rolibooks.com

ISBN: 978-81-944257-8-6

Editor: Chirag Thakkar
Design: Adviata Vats
Cover: Sneha Pamneja
Pre-press: Jyoti Dey

Printed and bound at
Samrat Offset, New Delhi

CONTENTS

ACKNOWLEDGEMENTS: WITH GRATITUDE

I have undertaken this short book on Gandhi and the artists of India fighting with every breath what a colleague (half-jokingly) referred to as 'Gandhi fatigue.' The fatigue has only escalated in recent months on account of the commemoration of the 150th anniversary of the Mahatma's birth that has produced a barrage of shows and exhibitions, government schemes, talks, conferences and publications (including mine!). The stakes for me, however, are both intellectual, and political-ethical. Gandhi is arguably the most analysed Indian of the twentieth century, and my fellow historians and other social scientists have produced an enormous body of important scholarship on the man and his movement from which I have benefitted. But the deep suspicion of the image that is ingrained across the social sciences, and indeed, an unfounded conviction regarding its irrelevance, has meant that the labour of art in producing the phenomenon that we name the Mahatma has been largely ignored. This has meant that the vast published scholarship on him has neglected to address the manner in which Gandhi has circulated in the Indian public sphere as image and as bio-icon, a concept I borrow from postcolonial theorist Bishnupriya Ghosh, who uses it to show how some flesh-and-blood people of our times have become the focus of intense visual saturation, and circulate in the public sphere as highly mediated and mediatized figures. Gandhi is undoubtedly the most palpable of such Indian bio-icons. Yet, art historians, who should have been at the forefront of the study of the man identified by influential art critic Geeta Kapur as the prime representative phenomenon of twentieth-century India, have held back, perhaps because some of the art is deemed banal, others hagiographic, still other too obviously political.

Taking inspiration, however, from these very artworks, I have persisted in writing this book. Hence, my first words of gratitude are to those artists who have taught me to recognize that Gandhi was a master choreographer of his own image, and that social scientists like me who ignore this fact, risk missing a constitutive component of his creative politic and ethics. Through my engagement with their art, I have come to the conclusion that non-violent disobedience (or what Gandhi named as satyagraha) is itself a deeply aesthetic regime, with practices akin to works of art. Indeed, I have over time come to believe that Gandhi himself must be seen as the paradigmatic artist of disobedience. Amongst artists who took time out of their busy schedules to talk to me about their investment in Gandhi and helped me reach these conclusions, I thank Pinak Bani, Aparna Balachandran, Arpana Caur, Shabbir Diwan, G.R. Iranna, Sachin Karne, Ravikumar Kashi, Gopal Swami Khetanchi, Riyas Komu, J. Nandkumar, Surendran Nair, Ashim Purkayastha, A. Ramachandran, Rekha Rodwittiya, Debanjan Roy, and Gulammohammed Sheikh. A special debt is owed to Atul Dodiya, whose many works are discussed in these pages and deserve a book in their own right; Gigi Scaria, who gave me the honour of curating my first exhibit (https://sites.duke.edu/iconicinterruptions/); and Tallur L.N., one of whose luminous sculptures adorns the cover of this book. I am also very grateful to Aparajithan Adimoolam and Parthiv Shah for sharing the works of their fathers, and talking with insight about them with me.

Only a sliver of the vast archive of images of artworks that I have accumulated over the course of this project is presented in this book, and for their help in tracking these down, I am indebted to librarians and archivists in several countries (including at Duke University), but especially to private collectors in India: Anil and Manan Relia who have been a fount of information and gracious hospitality each time I visited Ahmedabad; Vijay Kumar Aggarwal who generously threw open the doors of his Swaraj Art Archive in Noida (and his assistant Prarthana Tagore); Kishore Singh at DAG; Rakesh Sahni at the Gallery Rasa and Reena Lath of Akar Prakar, both in Kolkata; and Rajen Prasad and Ashok Kumari of Sahmat for their infinite patience (not to mention cups of garam chai, snacks, and mithai!) while I worked in the archives of the organization in New Delhi. Without doubt, this work would not have been completed if it were not for the assistance of Projjal Datta at the Aicon Gallery in New York, Tridip Suhrud in Ahmedabad, A. Annamalai at the National Gandhi Museum in New Delhi, and wonderful friends at Mani Bhavan Gandhi Sangrahalaya in Mumbai: Usha Thakkar, Yogesh Kamdar, and Sandhya Mehta.

Jayanta Sengupta at the Victoria Memorial Hall (Kolkata), Sabyasachi Mukherjee and Nilanjana Som at the Chhatrapati Shivaji Maharaj Vastu Sangrahalaya (Mumbai), and Pankaj Bordoloi at the Rashtrapati Bhavan Museum in New Delhi helped me secure rare images from their important collections, for which I am very grateful.

Two anonymous reviewers – both undoubtedly scholars of great erudition and expertise – offered thoughtful and rigorous feedback on an earlier draft of this manuscript, which only further strengthened my arguments and gave me confidence in my conclusions. Over the years, I have learned enormously from scholars of Indian art who have been hospitable and generous in welcoming me into their midst and sharing their wisdom and insights: Naman Ahuja, Susan Bean, Rebecca Brown, Chaya Chandrasekhar, Janice Glowski, Tapati Guha-Thakurta, Kajri Jain, Monica Juneja, Partha Mitter, Shruti Parthasarathy, Romita Ray, Tamara Sears, Kavita Singh, Gayatri Sinha, and Karin Zitzewitz. My deepest appreciation for R. Siva Kumar for the reach of his intellect and spirit, and sharing with me his unsurpassable knowledge of Santiniketan's artists who were so vital in the development of a Gandhian iconography. Siva Kumar also introduced me to his doctoral student Arkaprava Bose, who generously helped me track down vital Bengali sources and helped with translations. I am immensely thankful to him as I am to Anurag Bhattarai, who painstakingly helped me verify sources and images, worked his way patiently through the *Collected Works of Mahatma Gandhi* – ninety-seven large printed volumes – to share nuggets of vital information, and helped in innumerable ways, big and small. This work would indeed not have been possible without his cheerful assistance and long hours. Not least, many thanks to Rohini Thakkar for her timely help with Gandhi's Gujarati writings.

I have had the good fortune of presenting different aspects of this work in various venues: in Kolkata, Mumbai and New Delhi; in Copenhagen, Heidelberg, Leiden, Oxford and Paris; and in the US, at Brown, Columbia, Rutgers and Syracuse, the University of California at Berkeley and in Los Angeles, the University of Pittsburgh, the University of Southern California, Wesleyan and Duke. My heartfelt thanks to my hosts and interlocutors in all these places for their thoughtful engagements and questions that helped me finesse my arguments and ideas.

In 2016, the Alexander von Humboldt Foundation in Germany honoured me with the Anneliese Maier Research Award. This generous five-year grant has not only provided me with funds to carry out research on this complex project across many continents, but has enabled my fruitful collaboration with dear friends (and superb scholars in their own right), Christiane Brosius, Monica Juneja, and especially Barbara Mittler, whose own comparable scholarship on Mao has helped me address new questions to Gandhi and to his artistic devotees and interlocutors. To the Foundation and to Trinity College of Arts and Sciences at Duke, my sincere appreciation for their financial support over the past few years.

My wonderful editor Chirag Thakkar commissioned this work while he was with another press and has stayed with it over the years, not letting me get discouraged when institutional demands and family care kept me away from 'my Gandhi book.' All along he has been a force of wisdom, encouraging me to write a cross-over book that would reflect both my scholarly commitments and be within reach of a general readership. To him – and to the superb design and production team at Roli, especially Adviata Vats – my sincere gratitude.

Not least, none of this would be possible without my family: my siblings, accomplished academics themselves; my wonderful partner in life and work, Rich Freeman, who sustains my intellect and soul; and my mother, to whom I dedicate this work. In the summer of 2018 when I wrote the bulk of these chapters, she spent some weeks with me in Durham, recovering from a serious illness, which did not deter her from plying me with difficult questions over meals and during our daily walks, including the peskiest of them all when she would look at an artwork that I would show her with great excitement, and ask, 'What is there in that?' In trying to answer that question and others, I believe this work has been infinitely strengthened, and for that, and for her lifetime of care, support and affection, I owe her gratitude beyond words, and my love.

Sumathi Ramaswamy
Durham, NC, and New Delhi, India
February 2020

'Gandhi' means 'perfumer,' and so was the man in relation to our malodorous century.

– *Ramachandra Gandhi*

Something is always happening in the arts… which incandesces the embers glowing in the depths of society.

– *Jean-François Lyotard*

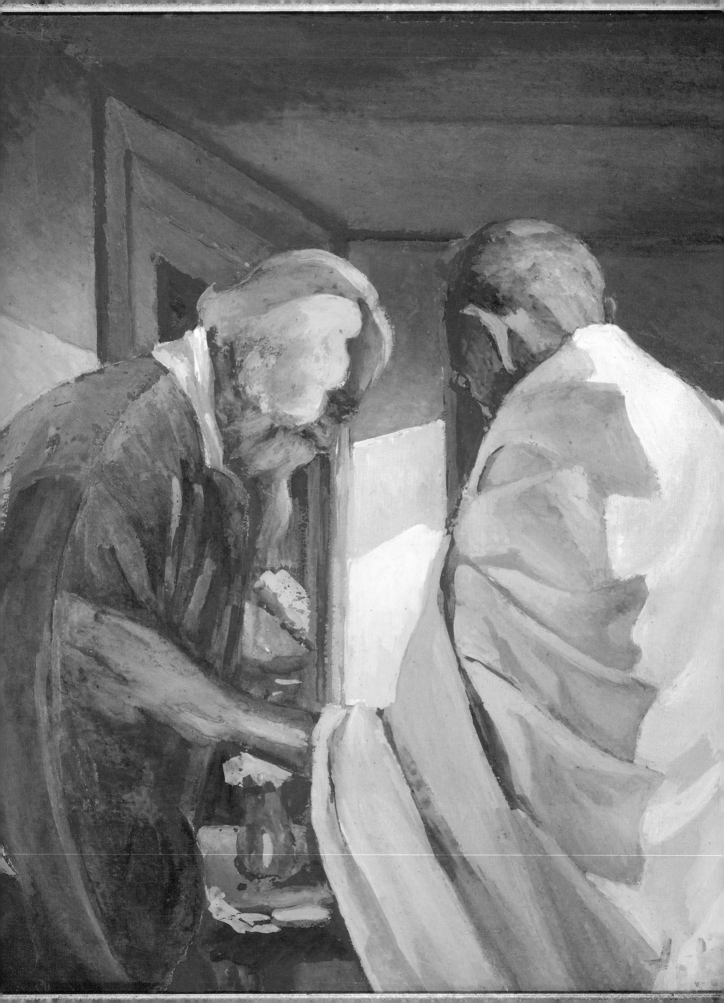

1
THE MAHATMA AS MUSE

'He is with the great artists, though art
was not his medium.'[1]
– *E.M. Forster*

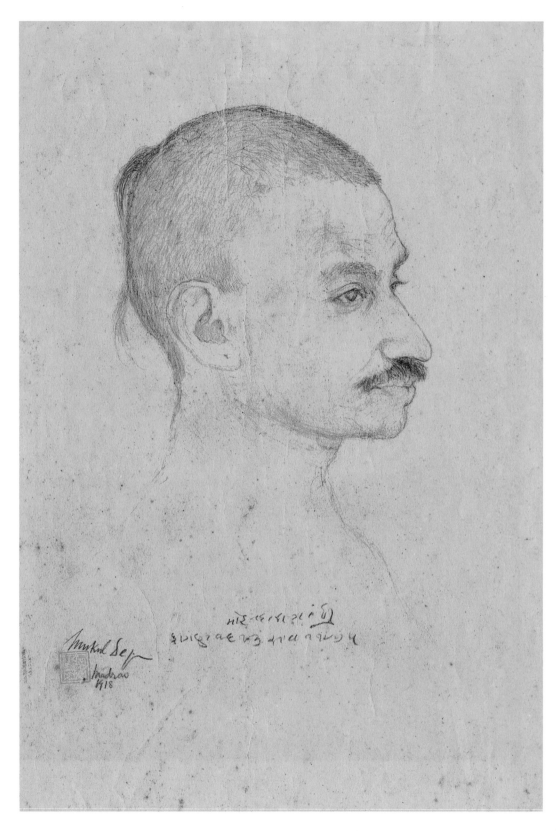

Figure 1.2 - Mukul Dey, *Mohan Das Gandhi*, 1919. Portrait in pencil on paper, 34.5 x 51 cm. With permission of Kala Bhavan, Visva-Bharati University, Santiniketan.

SITINGS/SIGHTINGS

One hundred and fifty years after his unremarkable birth in Porbandar and over seventy years after his momentous death in New Delhi as the nation's father, Mohandas Karamchand Gandhi (1869–1948) is a hallowed but hollow figure in the country of his origin and work, as suggested as well by the cover image of this book. He is seemingly visible everywhere but nowhere really to be seen, his complex ideas reduced to empty platitudes, his radical disobedience tamed and tempered. Yet, one realm of Indian society – although by no means can it be readily homogenized – continues to invest in him, labouring across various media to this day to produce remarkable new interpretations of the man and his movement. Fascinatingly – but to some extent paradoxically, as I hope to show – the visual artist has emerged as Gandhi's conscience-keeper, reminding us of the meaning of the Mahatma in his own time and today. In so doing, these artists also reveal why this most disobedient of 'modern' men has grabbed their attention, resulting in a veritable art of disobedience as homage to one of the twentieth century's most creative prophets of disobedience. That is the story, hitherto largely untold in the vast scholarship on Gandhi, that I narrate in these pages.[2]

But first, to hear from some artists of their encounters with a man who seized their imagination and who they were compelled to capture on paper or canvas, in stone or bronze, even whilst he sought to resist their attempts with a seeming disdain for their very practice.[3]

It was March 1919 in the city of Madras (now called Chennai), although the artist who later recalled the moment got the year wrong and perhaps also some of the specific details, but no matter, for he was seeking to create with broad strokes the look of a new kind of leader who was on the ascendant in national politics after making a name for himself amongst the downtrodden Indians of South Africa. In his own words,

It was Mrs. Sarojini Naidu who took me one morning to the house where Gandhiji was staying at the time. I found him sitting on a *taktaposh* (wooden bed) with only a loincloth tied round his waist, talking to several people who sat round him on the floor. His hair was closely cropped, but he had a *shikha*, the Vaishnava Hindu's tuft of hair at the back of his head. It stuck me [sic] that he was a great saint and a political leader at the same time. Mrs. Naidu then introduced me to Gandhiji and told him of my errand. Gandhiji smiled sweetly at me, as if signifying his consent to my doing his portrait. He went on talking to the people in the room, while I busied myself with my pencil. I finished the portrait within an hour. Gandhiji looked at it and said, "Do I really look like that? Of course I cannot see my face from that angle." Then he passed it round to the persons assembled there. At my request he put down the following words in Gujarati: "Mohan Das Gandhi, Phagun Badi 3, Samvat 1975." After thus putting his name and date on the drawing, he again gave me another of his characteristic smiles.[4]

At the time of this encounter, Mukul Dey (1895–1989), for that was the name of the artist whose words I quote, was not yet the notable print-maker he was destined to become. He had published his first book, *Twelve Portraits*, in 1917 after receiving his early training in Rabindranath Tagore's Santiniketan ashram school, and in Chicago. The portrait he reportedly completed in pencil within an hour after meeting Gandhi shows the latter in profile with close-cropped hair, a dark moustache, and a prominent *shikha* (Figure 1.2).[5] Dey recalls that he was barely

Figure 1.1 (pg 12) - Jamini Roy, Gandhi and Tagore *c.* 1940s. Tempera on card, 38 x 28 cm. With permission of Nirmalya Kumar.

clad 'with only a loincloth around his waist,' a garment that the Mahatma was to formally adopt for public consumption only two years later, as I note in the next chapter. Although not in the best of health in the wake of a surgery in January, Gandhi was also poised to launch his first nationwide campaign (the Rowlatt Satyagraha, as it came to be called) that would secure for him the status of the (moral) leader of the anti-colonial movement against British rule until his death three decades later. So, Dey's portrait captures Gandhi at the very cusp of his critical transformation from a moderately well-known activist into the national – and global – icon he was to become.

A decade after this portrait, and around the time he was appointed the first Indian to head the prestigious government art school in Calcutta in 1928, Dey was seized by 'a sudden impulse' to draw the Mahatma with the new drypoint technique, of which he was deemed the foremost Indian exponent after his training in London. He visited Gandhi at his headquarters in Sabarmati Ashram to see 'how this great saint lived in his hermitage.' Gandhi, in turn, was reportedly surprised that 'such a frail and unimposing person as himself was worthy of being portrayed by an artist coming from such a great distance.' On this occasion, when he reportedly stayed with the Mahatma for a month, Dey produced four different drypoints, some pencil sketches, and also a portrait of Kasturba (Dey is among only a handful of artists who drew and painted Gandhi's wife, without whose support the Mahatma could have arguably accomplished little).

These works, some of which were later published in the year of Gandhi's death, show the Mahatma in the familiar guise of a barely clad spare man.[6] Dey also offers a memorable account of Gandhi's routines from this time: that he lived in quarters almost without any furniture, that he shaved with a Gillette razor, that he had his body, 'almost black, with age,' massaged daily with ghee, that he used a cold mudpack, and that 'he always walked very fast.' Dey was also convinced over the course of his stay 'that the Mahatma had a deep love for the Fine Arts.' In a letter to C.F. Andrews (who facilitated the visit), Gandhi acknowledged Dey's presence but in a mere few words, although this is one of the few occasions on which the Mahatma took

the trouble to remark on any artist (or photographer) seeking to capture his likeness. 'Mr Mukul Dey is here and began operation [sic] immediately he came.'[7] Dey met the Mahatma at various times in subsequent years, and produced more work. On one such occasion, in December 1945 in Santiniketan, he presented Gandhi with his 1928 drypoint portrait of Kasturba (who had died the previous year). Despite the Mahatma's apparent lack of interest in art and images, he reportedly held the work 'tenderly close to his eyes, as if he was talking to her for a while.' He was clearly moved in this instance by a work of art.

The next artist's sighting takes me to Cuttack in the closing days of 1927 where Gandhi arrived in a rather depressed state of mind in the course of touring flood-ravaged Orissa (now Odisha). By then, his transformation from embodied substance to bio-icon was well under way.[8] His portrait had been unveiled in the Shree Ram Free Library in Poona on 17 November 1918.[9] A photograph by N.V. Virkar had been published on the front page of the *Bombay Chronicle* on 1 July 1921 to accompany an article titled 'India's Miracle Worker.'[10] Abanindranath Tagore (1871–1951) had featured him in a beautiful 'wash' painting with his uncle Rabindranath, a work that I discuss later (Figure 2.12). The London-trained Lalit Mohan Sen (1898–1954), who later produced other engravings featuring the Mahatma, had created a woodcut print titled *Mahatma Gandhi*, on a commission from the London newspaper *Daily Telegraph* around 1922 (Figure 1.3). In contrast to his fully-clothed look in Sen's print, fellow Gujarati Ravishankar Raval (1892–1977) had painted him bare-bodied and clad just in his *dhoti*, facing a British judge during his famous court trial in Ahmedabad in 1922. He had even been put on display in a London gallery when a portrait by Bene Israeli-turned-Muslim painter Samuel Fyzee-Rahamin (1880–1964) received a rather unflattering appraisal: ' "Mahatma Gandhi"... is a masterpiece of characterization. Gandhi belongs to the merchant caste, and centuries of clever bargaining lurk in his gaze and hover around his shrewd lips, whilst the high forehead proclaims the ideals, and the thin naked body, the ascetic.'[11] Not least, numerous mass-printed lithographs, snapshots, bazaar portraits, and

Figure 1.3 - Lalit Mohan Sen, *Mahatma Gandhi, c.* 1922. Woodcut print on paper, 15.5 x 13.3 cm. © Prabartak Sen/ Victoria & Albert Museum, London.

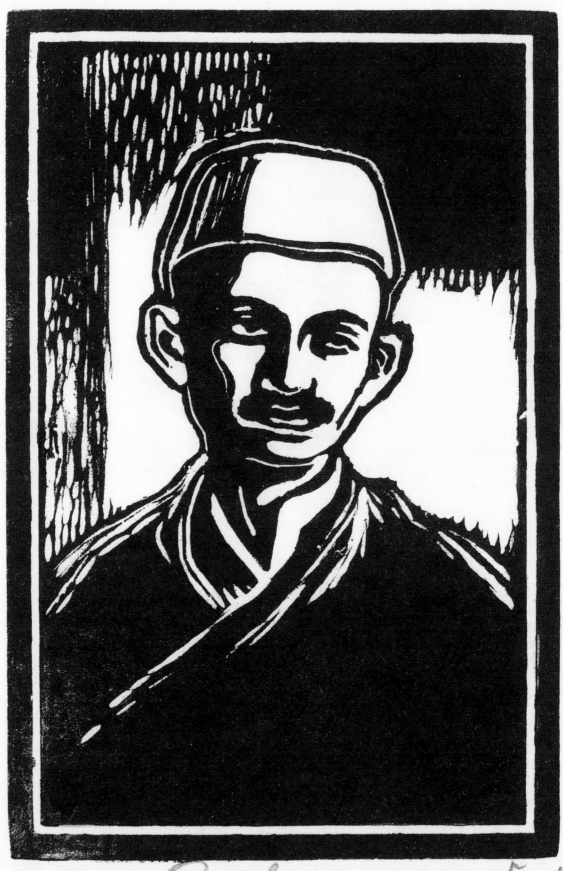

Mohatma Gandhi Fw.Lew

caricatures circulated across India, as Gandhi himself noted with disapproval.[12] (In June 1931, Gandhi wrote pungently against 'a horrible portrait representing me as lying stretched on the coil of the thousand-mouthed serpent with the roll of non-cooperation in one hand and the spinning-wheel suspended on the other arm. My poor wife is massaging my legs.'[13])

He was not the only one in his circle who voiced disapproval. 'The country is flooded with bad pictures of him,' observed the Gandhian, Urmila Devi, who was assigned to take care of painter and writer Frieda Das (1886–1974), née Frieda Hauswirth, when she travelled to Cuttack in December 1927 with the desire 'to sketch Gandhiji.'[14] Born in Switzerland and briefly married to Sarangadhar Das, the freedom fighter and politician, Frieda arrived in India in 1920 to discover Gandhi's influence even 'in the most unexpected out-of-the-

way places.'[15] By no means an outright admirer of the Mahatma, she nevertheless sought him out through family connections, and was clearly transformed by her artistic encounter with him as recorded in her memoir, *A Marriage to India*.[16] Her first impression of the man himself in the flesh is recorded thus in her diary:

> A rather short and slim bony man. He wears a white khaddar loin cloth that leaves his skinny legs bare; another cloth is thrown over his shoulder, together with a woollen wrap... Gandhiji is ugly. A shaven but bristly scalp with a wispy top knot, a protruding red-blue underlip, big gaps where teeth are missing, large ears standing out almost at right angles. But I see his smile and think him beautiful... (177)

Figure 1.4 - Frieda H. Das, *Mahatma Gandhi*, 1927. Printed frontispiece to the artist's memoir, *A Marriage to India* (1930).

Although she had heard that Gandhi did not pose for artists, and had 'neither time nor desire' for the arts, Frieda writes that she was determined 'somehow to win out' (173). And 'win out' she did, arguably the first known female artist – and a foreign one at that – to sketch Gandhi, producing a charcoal drawing and a watercolour, which was subsequently printed as the frontispiece of her memoir, with the title *Mahatma Gandhi: Sketched from Life by the Author, December 1927, at Cuttack, Orissa*, and signed Frieda H. Das (Figure 1.4).[17] The painting shows Gandhi seated on a carpet, deeply absorbed in spinning at his wheel, a pair of clogs and a spittoon the only other objects in the room. From Frieda's description of how she came to portray him thus, we get both a tantalizing glimpse of how and why the artist was drawn to Gandhi's presence:

> Gandhi sits utterly self-absorbed. He has shifted his head so that I can continue with it. But for all the world I cannot bring myself to break the silence. I content myself by sketching body and wheel. For about twenty minutes there is absolute silence about us. I am too busy to think, but somehow a hush and gladness pervades the room and my soul as I search line for line. This touching, great simplicity (181).

Frieda was clearly nervous in capturing 'line for line' such 'great simplicity,' especially under the watchful eyes of that most ardent of Gandhians, Mirabehn (Madeleine Slade) who too insisted, like Urmila Devi, 'I wish we could get a good sketch of him; none has been made as yet' (182).[18] Under such pressure, Frieda confesses, 'It is not easy to draw when Gandhi so often shifts his pose, moves his head, and when dozens of eyes are on my work, judging nascent line by line. And I want so immensely to succeed, for I consider this the most interesting sketch I have ever attempted' (182). And succeed she did, winning the approval of Gandhi's followers, Urmila even insisting, 'It's wonderful! It's wonderful! I want to run away with that sketch at once' (183). Another declared, 'It is the best sketch any artist has yet made of him' (184).

Figure 1.5 - Claire Sheridan, Mahatma Gandhi, 1931. Bronze bust, 75.5 x 58 x 38 cm. With permission of CSMVS, Mumbai.

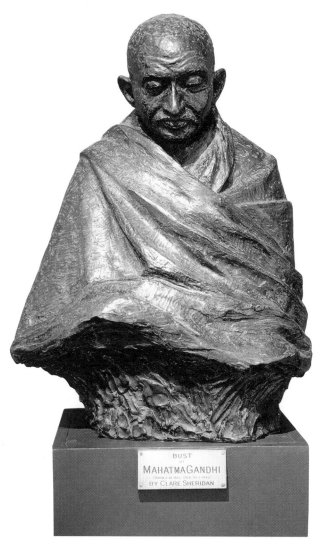

And the sitter himself? What was his response? 'He looked at it, shyly, I felt, and then turned to me. "Why did you put so much clothing on me?"' (187).

Frieda Hauswirth was not the only foreign or female artist to note that Gandhi was the most interesting figure they encountered. A few years later, at the very heart of the empire, another made a similar confession. Her name was Clare Consuelo Sheridan (1885–1970), and she was already an established sculptor, having produced busts of men of stature such as Vladimir Lenin and other Soviet luminaries when she met Gandhi on his visit to London in 1931. Sheridan was also a cousin of Winston Churchill, about whose complex relationship to Gandhi, I write

about in the next chapter.[19] She was introduced to Gandhi by her 'friend Sarojini Naidu,' whom we recall had also introduced Mukul Dey to the Mahatma. 'I cannot pose, you must let me go on with my work, and do the best you can,' were the words with which he assented to her desire to create a bust (273) (Figure 1.5). He 'squatted' on the floor and read and spun while she sculpted, and when she showed him her work and asked what he thought of it, he reportedly declared, 'I don't know – I cannot judge my own face,

and I know nothing about Art – but you have worked well!' (274)

Sheridan was not the only sculptor to be allowed into Gandhi's presence on this occasion, for the American artist Jo Davidson (1883–1952) was also accorded the same privilege, thanks to the intervention of a fellow American, the Associated Press journalist, James Mills, whom Gandhi had befriended a few years earlier.[20] Both Sheridan and Davidson agreed that Gandhi stood out amongst all their sculptural

Figure 1.6 - Haku Shah, *Charkha*, 2014.
Oil on canvas, 60.96 x 60.96 cm.
With permission of the artist's family.

subjects.[21] In her words, 'In his grandiose simplicity the little bare-legged man, wrapped around in his "Khaddar," is deeply impressive. So impressive is he, such is the respect that he inspires, that I reverently kissed his hand at our final parting' (275). Long after they parted, a statuette of him sitting in a cross-legged position – 'a Buddha in contemplation' – had a place of honour on her writing table:

> I am able to say, in perfect truth, seven years afterwards, when emotion has faded and memory is like a dream, that through knowing Gandhi something was changed in me. Life was just a shade more worth living. Something which, for want of a better word we call Inspiration, had entered in (280).

Her fellow sculptor Jo Davidson was similarly moved:

> I have met and "busted" all kinds of people in my life, but this is the first time I have ever met such a one as this. He merely allowed himself to be "done." And in the end it is I who was "done"... For all the heartaches that I had with the Mahatma, I look back at these sittings with the realization that I had the privilege of recording in clay one of the greatest figures of our time.[22]

Sheridan's Gandhi bust had an interesting afterlife.[23] She sold it to the Maharaja of Darbhanga in 1940 who gifted it to Viceroy Lord Linlithgow who in turn loaned it to the Prince of Wales Museum in Bombay where it was put on display on a wooden pedestal some 4.5 feet high in the central hall, 'calmly' facing a statue of Napoleon.[24] 'The bust is attracting an unequally large number of visitors,' reported the *Simla Times* on 31 July 1940. Sometime after that, the bust seems to have disappeared from public view and ended up in deep storage, to be retrieved and restored only around 2012 when prompted by author Jonathan Black who was completing a book, ironically, on artistic takes on Gandhi's nemesis, Winston Churchill.[25]

No account of artistic encounters with the Mahatma can be complete without a consideration of Nandalal Bose (1882–1966), the only well-known painter whom Gandhi openly favoured, and whose name (foreshortened to Nanda Babu) occurs quite often in his writings.[26] Although Bose claimed, not surprisingly, that 'language is not my *métier*,' he wrote two short but illuminating recollections, published in 1940 and 1944, in which he declared that it was 'love' and 'friendship' that attracted him to the Mahatma rather than 'admiration' per se.[27] And yet decades later we can still sense awe in his visual perception of Gandhi on the occasion of meeting him in 1936:

> He was sitting in the room sparsely clad, brown-skinned, simplicity itself. His dress consisted of a small piece of khaddar cloth worn tightly round the waist, from which was dangling a small watch; a pleasant smile was always playing on his lips. As I looked on him[,] he appeared to me like a sword of fine temper, kept unsheathed, having all the attributes of the sword save that of *himsa* [violence], and able to cut through the dark depths of human ignorance.[28]

To compare the body of a man dedicated to non-violence to a sword of fine temper is paradoxical indeed, and something we might want to keep in mind as we later consider two of Bose's most iconic works (Figures 3.20 and 3.21).

Opinions vary on when Bose had his first sighting of Gandhi in Santiniketan where he was the first director of the famed Kala Bhavan from around 1921/22 to 1951.[29] As we will see in Chapter 3, he was first moved to paint him in early 1930 when Gandhi was at his most formally disobedient, producing in the process an image of the Mahatma that is arguably the most reproduced to this day (Figure 3.21). In early 1936, Nandalal was summoned by Gandhi to set up an exhibition of paintings at the Lucknow session of the Congress Party. 'What compelling power was in that call! I dare not refuse,' he recalls his response.[30] This was likely his first face to face meeting with the

Mahatma. 'I was gratified to meet Bapu personally and at being able to see those paintings as well. I had been told before that Bapu did not have much interest in fine arts. I realized the mistake when I found him going round the Lucknow Exhibition and noting each painting with the critical interest of a connoisseur.'[31] In October 1936, pleased with what Nandalal had achieved at Lucknow, Gandhi invited him to his ashram at Sevagram to discuss plans for a similar project later that year in Faizpur. Once again, it is hard to miss the awe in Bose's tone when he later recollected the moment:

> In the cottage at Sevagram, face to face with that great man, I squatted on the floor. "Come closer," he insisted. Knees touched knees. I took the dust of his feet. He did not object, rather willingly accepted it. His pity melted my heart into heavenly love. His eyes were clear, as if probing the depths of one's heart. I felt an urge to lay open my heart for his inspection and to tell him all I wanted to tell. His heavenly smile could melt the heart even of a confirmed villain.[32]

In such an enchanted state, Bose went on to decorate the Faizpur exhibition, and attained even greater acclaim for his work at the Haripura Congress in February 1938.[33]

While scholars have lavished considerable attention on Bose's work for these Congress exhibitions, especially the one at Haripura, little attention has been paid to a quiet but evocative untitled sketch dated 8 June 1937 that Nandalal did (among others) of his powerful patron when the latter was visiting the seaside hamlet of Tithal in Gujarat and the artist spent several days with him on his invitation (Figure 1.7). Even in the crowd of men and women (and a couple of children), it is possible to identify Gandhi, for Bose paints him in a manner that has become so recognizable, as a slight figure, clad in a white dhoti, a shawl partly covering his upper body, and walking barefoot with his companions, staff in one hand, a watch dangling from the waistband. Dinkar Kowshik,

a student of Nandalal's, reports an unusual moment in the evolving friendship between the Mahatma and the painter by this time. 'Nandalal had left his sandals on the beach and had gone for a long walk. On his return, he found Gandhiji keeping watch over his footwear. "I knew these were Nanda Babu's sandals, and did not like some stray dog should chew one away and leave the other to regret over!" After that incident, Nandalal gave up wearing sandals for a long time.'[34]

The many and extended professional and personal encounters with the Mahatma led Bose to push back against those who argued that Gandhi had no appreciation for art, insisting not only that 'Mahatmaji is a patron of artists,' but that he was 'indeed an artist and his creativity finds expression in the building up of his own self, in his attempt to transform himself from a man into a divine being, as also guide others in that direction.'[35] Writing in 1944, he even declared Gandhi as 'the true artist.'[36] Fifty-five years later, Mumbai-based Atul Dodiya (b. 1959) similarly conferred upon Gandhi the title of 'an artist of non-violence,' and produced a series of fourteen evocative watercolours in visual affirmation.[37] Similarly, Haku Shah (1934–2019) – a Gandhian in his personal life, and producer of numerous luminous images of the Mahatma (Figures 1.6, 2.1, and 2.20) – insisted in 2014, 'Each and every moment for Gandhiji was creative.'[38] As K.G. Subramanyan (1924–2016) – a student of Nandalal's and a major artist in his own right who produced some stunning images of the Mahatma (for example, Figure 1.8) – charmingly confessed in 2007, it was impossible to escape his presence and charm. 'Gandhi was in the air.'[39]

Such words, images and encounters begin to give a sense of why artists from his time until ours have responded to Gandhi in the way they do: they see him as a kindred spirit and as a fellow artist. Like them, he is a maker of creative objects, such as the spinning wheel (*charkha*), and a practitioner of inventive acts, such as non-violent disobedience (satyagraha). These too emerge as works of art in their own right with an aesthetic charge and appeal that is simultaneously meaningful but also mysterious.

Figure 1.7 - Nandalal Bose, Untitled [inscribed in Bengali, *Tithal, 8.6.37*]. Pencil and watercolour on postcard, 14 x 8.8 cm. With permission of NGMA, New Delhi.

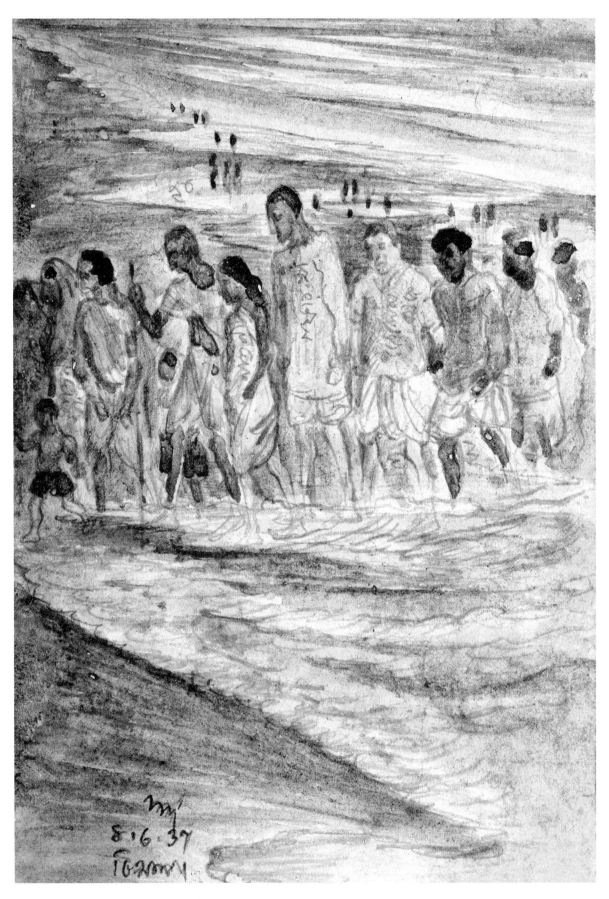

THE ARTFUL MAHATMA

Yet, why did Gandhi himself insist over and again that he was not an artist and no judge of fine art? 'God has given me the sense of art but not the organs to give it shape,' he reportedly declared in a speech in December 1936 at the opening of the Khadi and Village Industries Exhibition in Faizpur, which he had invited Nandalal to organize and execute. 'For [Nandalal] is a creative artist and I am none.'[40] Twelve years earlier, he had insisted in a wide-ranging interview in October 1924 (from which perhaps we get the most elaborate sense of his evolving ideas on this subject) with the Santiniketan-trained Gandhian G. Ramachandran, 'My functions are different from the artist's and I should not go out of my way to assume his position.'[41] And yet, on at least three occasions, when he wished to demonstrate something new that he had wrought, he felt compelled to turn to the visual medium, drawing objects of general utility: sandal straps (drawn on or around 4 February 1911), a carding bow (drawn on 25 May 1930), and a round bathtub (drawn on 6 December 1937).[42] In fact, he wrote in his autobiography that the child should 'first be taught the art of drawing... Let the child learn his letters by observation as he does different objects, such as flowers, birds, etc., and let him learn handwriting only after he has learnt to draw objects.'[43]

Not just in deed but in discourse as well, Gandhi frequently likened many of his activities to art (*kala*), or is credited with having done so (especially when his Gujarati or Hindi words are translated into English). In addition to 'the art' of spinning, of carding cotton, and of weaving, and the art of making sandals (and of skinning dead cattle to make these), he wrote of 'the art' of speaking, learning, writing letters, and addressing people, of rearing children, of bringing up daughters, and of taking care of one's health, of 'labouring for one's bread' and of 'working without attachment.' 'Sweeping,' he wrote in Hindi to his protégé Devi Prasad, is 'a great art. Where to keep the broom, how to handle it, should there be one broom or different brooms for different jobs, should one stand erect or bend while sweeping, should one raise dust or sprinkle water before sweeping, does one sweep the corners, pay attention to the walls and the roofs – all these questions should occur to an artist (*kalakar*). Only then would he find beauty in sweeping.'[44] Undergoing suffering was an art, sacrificing oneself for a cause was an art, and 'to preserve one's peace of mind even in the midst of a conflagration is also an art.'[45] Indians thus had to learn 'the art of civil or voluntary obedience,' only then would they be successful at 'the art' of disobedience.[46] Soon after performing one of his most disobedient acts when he broke the colonial state's salt laws, he observed in April 1930, 'One is required to master the art of getting killed without killing, of gaining life by losing it. May India live up to this mantra.'[47] A few years later, in 1934, he was reported in the *Bombay Chronicle* as stating, 'If the country learns the art of going to prison and the art of practising non-violence... we should be within easy reach of swaraj.'[48] In 1938, at the inauguration of the Khadi and Village Industries Exhibition in Haripura (at which Nandalal's luminous artworks were on display), he declared, 'I can say that purity of life is the highest and truest art.'[49] As there was an art to living, there was an 'art' to dying, especially for faith and country. Indeed, he had been practicing both arts over the course of his career.[50]

Despite being credited with such pronouncements, there is little doubt that when Gandhi spoke of art qua art, he found it quite inferior and inadequate 'compared with the eternal symbols of beauty in nature.'[51] Indeed, nature itself was the 'great artist,' and 'true art consists in learning from nature without struggling against it.'[52] Defending his ashram's bare walls, he insisted that if it had been possible, he would have even dispensed with its roof, 'so that I may gaze out upon the starry heavens overhead that stretch in an unexpanding expanse of beauty. What conscious Art of man can give me the panoramic scenes that open out before me, when I

look up to the sky above with all its shining stars?'[53] At other times, he suggested that God is 'the mysterious artist' who had painted the world ('a supreme work of art') in a manner 'known only to the artist and will ever remain unknown to us.'[54] Such statements betray an intense suspicion of the mediating role of art – and especially of urban artists. Thus, speaking at the Gujarati Sahitya Parishad in October 1936 (when he also expressed the desire to appreciate art 'through the eyes of the villager'), he insisted that good art could speak for itself.[55] That artists chose not to be overtly obvious, or that they pursued art for art's sake rather than as a spiritual quest is what rendered both art and artist less than legitimate in his eyes. 'I know that many call themselves as artists, and are recognized as such, and yet in their works there is absolutely no trace of the soul's upward urge and unrest.'[56] If art is divorced from 'truth,' it was not art at all,[57] and indeed, 'much that passes for art and beauty is, perhaps, neither art nor beauty.'[58]

In an intensely chromophilic culture, Gandhi's preference for white compelled lifelong Gandhians like Raihana Tyabji to accuse him of taking colour out of their lives (despite his experiments with colour dyes in his *ashram*). 'It did a lot of harm because we are people who need colour.'[59] Indeed, in a conversation late in his life and career with British reformer and friend Agatha Harrison, he recalled the beauty of 'the speckless sky,' the brilliant colours of a rainbow being 'mere optical illusion.'[60] In the same conversation, he pithily summarized his philosophy of art. 'We have been taught to believe that what is beautiful need not be useful, and what is useful cannot be beautiful. I want to show that what is useful can also be beautiful.' Influenced as he was by Leo Tolstoy (whose *What Is Art?* he had translated into Gujarati and enjoined upon his followers to read), art for Gandhi had to be part of the fabric of everyday life, and contribute

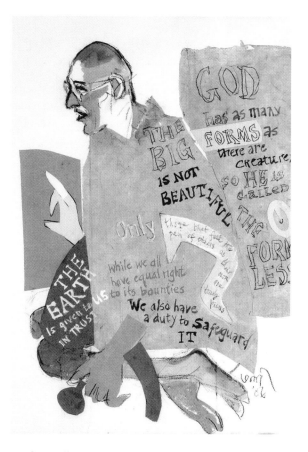

to the well-being and ethical betterment of society, serving to build moral character.[61] He apparently had little time for art other than for this utilitarian, even instrumentalist, purpose.

So, what then do we make of those artists of India who, in sheer admiration of the man, and who, moved by his artfulness, produced works of great beauty, frequently filled with vibrant colours in all shades and hues? And what of those who might not be interested in producing 'useful' art, and are indeed, champions of art for art's sake? Are they, in fact, producing canvases of disobedience in their very visual praise, ironically, of Gandhi's artful disobedience?

Figure 1.8 - K.G. Subramanyan, Untitled, 1986. Mixed media on paper, 76 x 57 cm. Collection of Vijay Kumar Aggarwal.

CAUGHT ON CAMERA

A vast majority of the artists who were drawn to sketch, paint, and sculpt Gandhi and are a focus of this book did not see him in the flesh, or meet him in person. Instead, and most often, he arrived in their lives in the much-mediated form of an image. And more often than not, that image is a photograph. This is not surprising because Gandhi was the most photographed Indian of his time and a vast photographic corpus accumulated over the course of his lifetime. As did painters and sculptors, the photographer also frequently complained about Gandhi as a difficult subject. 'He does not stand for a minute in front of a camera. Generally, he would walk very fast. Moreover, people would be standing around him all the time and would stretch their necks towards the camera hoping to get a snapshot with Gandhiji. Most cameramen were not admitted into Gandhiji's cottage. Despite these tremendous odds a few wonderful shots of Gandhiji's life have been recorded.'[62]

Such 'wonderful shots' and others serve as the principal public visual memory of the father of the nation, rivalling even the vast corpus of written and reported words enshrined in the *Collected Works of Mahatma Gandhi*. In the historical scholarship on Gandhi, these photographs are invariably drawn upon and reproduced, frequently without a comment, as source, evidence, and illustration. However, the very conditions under which they were produced have been barely scrutinized, nor has Gandhi's relationship to the instrument that produced them been examined.

The camera, industrial modernity's exemplary image-making technology, relentlessly followed him seemingly everywhere from the time he appeared on the Indian national stage in 1915 until his violent death in January 1948, creating a simulacral body that outlived the flesh and blood Mahatma.[63] There was little freedom from the so-called eye of history, to invoke American photographer Mathew Brady. We know something about some photographers and the circumstances of their photographic encounters with Gandhi – N.V. Virkar, Jagan Mehta, Braj Kishore Sinha, Homai Vyarawalla, Kulwant Roy and Sunil Janah among Indians, for example, and Walter Bosshard, Margaret Bourke-White, Henri Cartier-Bresson and James Mills among foreigners. Cousins Kanu and Navin, the Mahatma's grandnephews raised under his exacting care in his various ashrams, also became avid amateur wielders of the camera, perhaps through interactions with the numerous photographers and photojournalists who pursued Gandhi. Navin, for instance, is credited with the much-circulated photograph of the last meeting in 1940 of Gandhi and Rabindranath Tagore that was repurposed as a much-reproduced painting by Bengali artist Jamini Roy (1887–1972) (Fig. 1.1). All the same, a large number of photographs were taken by men (and possibly some women) we know nothing about yet, attached as they were to various local and global news media, the Congress Party, and presumably also the colonial state's extensive surveillance apparatus.

Regarding the Mahatma's ambivalence towards the camera, we know a little more since Gandhi expressed a range of opinions on this revolutionary image-maker. A few weeks after his death, his youngest son Devdas recalled, 'Never in his life did Bapu care to be photographed. The only possible exception would be his student days in London when he had to send a picture of himself home. In South Africa, the chances of being hunted by cameramen were few. But when he returned to India in 1914 [sic] he found he had to sit for group photographs several times a day. Exasperated, he took a vow not to pose for photographs any more.'[64]

Prior to 1915 and his meteoric rise to visibility, Gandhi was actually quite invested in photography in his South African days, despite the son's observation that his father never sought out the camera. He collected photographs of friends and people he

admired, including (and only seemingly paradoxically) of both the British sovereign *and* the Indian nationalist Dadabhai Naoroji.[65] He published photographs of people and places, including his role model Leo Tolstoy, in *Indian Opinion*, the newspaper with which he was associated from 1903.[66] Like others of his time, he also seems to have subscribed to the efficacy of the photograph, urging his fellow Indians, for example, to hang a framed photograph of Naoroji in their homes so that 'by seeing it, we should call to mind our duty afresh every day.'[67] Decades later, he recalled that in South Africa, his father's photograph (*chabi*) hung in his office, drawing-room and bedroom. Further, 'when I used to wear a chain, it had a locket which contained small photographs of my father and elder brother. I have now put them away.'[68]

Despite his son's later-day assertion, Gandhi also posed for the camera in studio settings during his years as a Johannesburg barrister. One such photograph, dated to 1906 and credited to B. Gabriel, has been repurposed in subsequent artworks, including a recent painting by Ahmedabad-based Manhar Kapadia (b. 1965), in which he appears in a black suit, stiff collar, and striped tie, his arms confidently folded and his eyes steadily gazing at the viewer, the epitome of the white Englishman who he aspired to be for a number of years from his London days (Figure 1.9). A version of Gabriel's photograph with the caption 'M.K. Gandhi' was printed in 1909 as the frontispiece to a book by Joseph Doke, a white Baptist preacher, although Gandhi wears a dark Kashmiri cap despite the Reverend's specific request for 'a good cabinet photograph of yourself – without your hat.'[69] Given Gandhi's investment in having this early biography written, published and circulated, it is likely he chose the frontispiece in which he tempers his 'expensive Western appearance' with a touch of 'native' defiance.[70]

Earlier in February 1908, when Gandhi was convalescing in Doke's house (after surviving an assault by a former client, Mir Alam Khan), the Reverend himself photographed him, sitting in a chair, and wearing a much humbler look (although still clad in casual European-style trousers and jacket). Repurposed more than a century later by Kochi-based Riyas Komu (b. 1971), this photograph as well secured an afterlife as an artwork (Figure 1.10). Komu enlivens Doke's grainy black and white photograph with fresh paint and a bright red background, adding a very important detail. In his painting, the object that Gandhi holds in the photograph now has a key date inscribed on it, *9/11/1906*, the day in Johannesburg at the Empire Theatre which cemented his public career as a disobedient activist with his defiant call to resist the so-called Black Act.[71] With this inscription, a colonial-era photograph is turned into a canvas of disobedience.[72] Similarly, another photograph, attributed to M. Fine and taken in Durban in late 1913/early 1914 when Gandhi first donned the garb of a humble indentured labourer, has been repurposed recently by Nawal Kishore (b. 1977). More than a century later and through the intervention of a young artist, the subaltern activist stands incarnated as an angelic saviour (see frontispiece).

All the same, alongside the embrace of this new technology which caught the imagination of the world and to which he obviously succumbed in some measure, Gandhi also worried about its capacity for harm even as he was forging his own brand of civil disobedience that he christened 'satyagraha'. So as early as 1903, he began to rail against the photograph as a 'new engine of torture,' which was subjecting his fellow Indians to the new surveillance state being put into place in colonial South Africa.[73] He argued repeatedly that the photographic identity card which was required of all Indians reduced them to the status of criminals. In this regard, it was like the fingerprint, in fact more insidious.[74] Indeed, his resistance from around 1903 to the photographic pass is a harbinger of Gandhian-style disobedience.[75] Writing, for instance, against the Cape Immigration Act in early 1907 in *Indian Opinion*, he insisted, 'We would advise the leaders of the Cape to fight out the question of the photograph without losing time. It was a mistake that they allowed the Act to be passed in the first place.

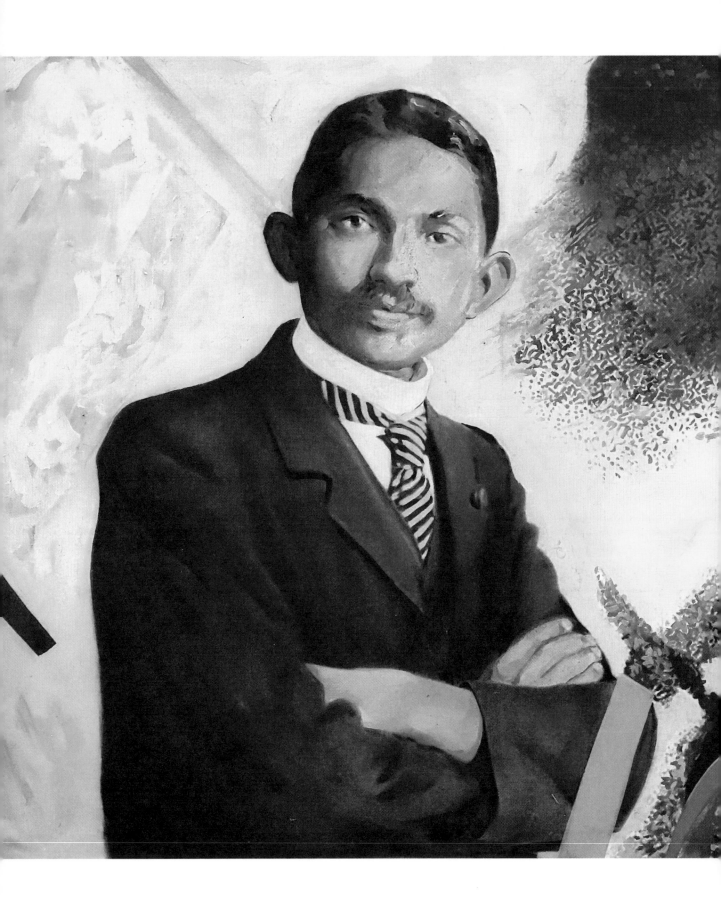

Figure 1.9 - Manhar Kapadia, *Memoir*, 2015. Mixed media on canvas, 121.91 x 152.4 cm. With permission of Archer Art Gallery, Ahmedabad.

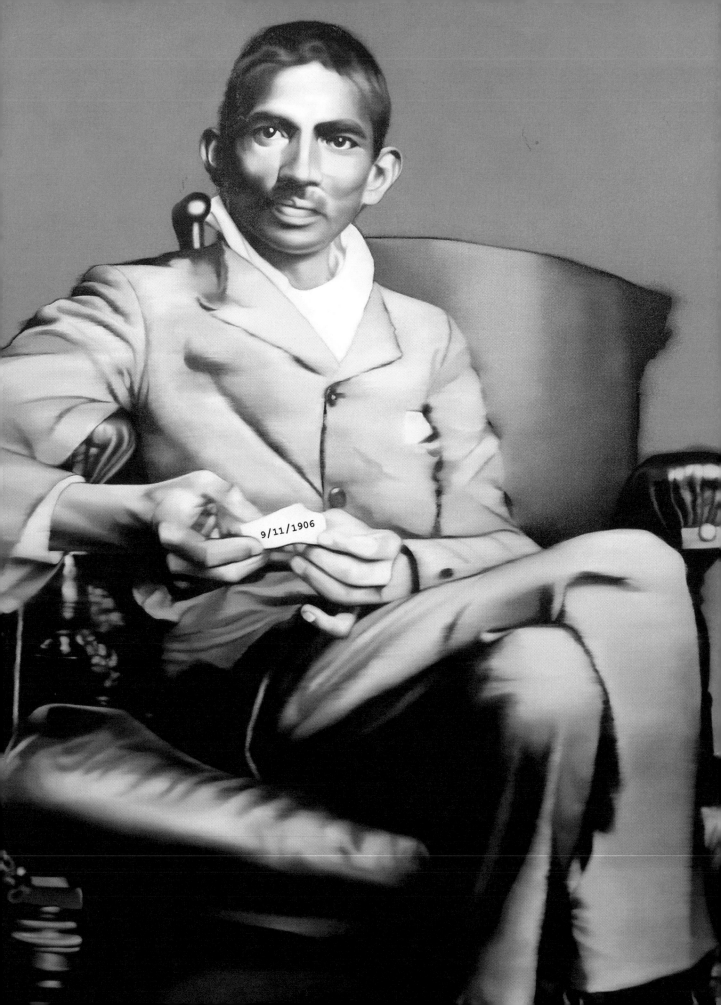

But we will regard it as a major crime if the clause requiring a photograph remains.'[76]

As Devdas Gandhi observes, and as his father himself repeatedly noted, the Mahatma refused after 1915 to pose or sit for the camera. Thus, when the Swiss photo-journalist Walter Bosshard (1892–1975) sought him out around 7 April 1930, he retorted, 'I have sworn never to "pose" for a photographer! Try your luck it may even turn out well.'[77] Obviously Bosshard's 'luck' held out, for his camera yielded some of the most intimate of images of the Mahatma from a critical moment in his life and career (for example, Figure 1.11).[78] Nonetheless, Gandhi insisted to those who wrote to him from far and wide for a copy of his photograph that he did not possess even a single print of himself. He was quite clearly annoyed that unauthorized 'snapshots' of him circulated in the bazaars and streets of India, for they were 'misprints' and 'caricatures.'[79] Indeed, when asked in November 1927 whether such snapshots had actually been made from drawings rather than the live subject, he reportedly snapped back, 'only the photographers know it.'[80]

Gandhi was particularly caustic about press photographers hounding him, apparently remarking on one occasion in Simla in August 1931, 'I have no time and I cannot stand your tyranny any longer.'[81] In April 1945, the *Bombay Chronicle* reported his annoyance at an event, where the sound of camera clicks was so disturbing that he asked the photographers present to give him a little respite, adding, 'Photography out of time and place [is] not art but vulgarity.'[82] On another occasion, he wrote to a colleague, 'I have often said that the journalists deserve to be shot. The beauty of it is that no one was shot nor did anyone imagine he would be shot. They took my remarks in good humour. The cameraman handed [the camera] to an old man like me and then took it back. I took it from him deliberately. I did well in doing so. Both gestures were non-violent.'[83] If the camera was 'the new engine of torture,' its wielders were 'torturers.'[84]

All the while, though, he happily rejoiced over photographs sent to him of friends, followers and family, even asking them to send him these. He promised his devoted grand-niece Manu to pass along his photograph.[85] When he learned that his eldest son Harilal wanted to gift his own son Kanti with a camera, he did not stop the latter from accepting it.[86] To another grandson, Kanam (the son of Ramdas), he even offered a camera as reward for good behaviour.[87] He persuaded the millionaire G.D. Birla – and a votary – to make a cash gift to a grandnephew who went to purchase with it his first Rolleiflex camera and a roll of film. Over time, that grandnephew, Kanu Gandhi (1917–1986), emerged as one of the most faithful of his photographers, producing luminous images of his granduncle that have also become the basis of numerous artworks, especially in the hands of famous painters of our time, such as Atul Dodiya, as I discuss later.

Even though late in his career he is reported to have declared that photographs and the like 'have no place today' in our public places and spaces,[88] Gandhi did acknowledge earlier in his life that those who 'sought to refresh memories of their parents through photographs do nothing wrong.'[89] And he was astute enough to realize that the camera's productions could become a revenue stream for his movement, signing autographs on his photographs, often in exchange for cash donations to his pet causes. In fact, despite claiming that he never posed for the camera and despite fussing at photographers who 'hunted' him, Gandhi recognized the power of the photograph in our times, and of the news media that circulated and recirculated his image. Indeed, such news media photographs, many grainy, others published without attribution, were the principal visual sense that many had of the Mahatma in his own lifetime. This is even truer since his death. Recently and rather eerily, Tushar Gandhi, a great-grandson, has written that his photographs were also used in target practice in Hindu nationalist training camps.[90] In the aftermath of his assassination in 1948 – at the hands of one such Hindu nationalist – the Indian state and numerous Gandhian organizations began an extensive programme of memorialization, at the heart of which lies the photograph. This is not surprising, given late modernity's trust and investment in the realism

Figure 1.10 - Riyas Komu, *9/11/1906*, 2016. Oil on canvas, 182.8 x 137.16 cm. With permission of the artist.

of the photograph by virtue of its famed indexical capacity to capture and certify presence: 'the referent adheres,' in French literary critic Roland Barthes' famous formulation.[91] Be it in Gandhian Vithalbhai Jhaveri's massive project for Gandhi Smriti (the so-called Martyrdom Site of the Mahatma in New Delhi), the museum in Sabarmati Ashram in Ahmedabad, or elsewhere across India, most photographs that posthumously enshrine Gandhi in such sites are poorly reproduced and inadequately contextualized. And yet they have come to consolidate and stabilize our visual sense of the Mahatma in both public memory and across numerous media.

The arrival of the camera in Europe apparently produced a crisis in that continent's visual landscape, with the upstart technology of photography pitched against the hallowed art of painting. On the other hand, in iconophilic India – with its love not just for the image but for the reworking of the image, endlessly – this crisis was not experienced as such, and indeed, from the very start, the two collaborated in very many interesting ways. In fact, as I discuss in the chapters that follow, the historical photograph of Gandhi is repurposed repeatedly by artists working across various media. Such artists have moved beyond 'thinking of photographs and their archives simply as passive "resources" with no identity of their own.' Instead, in their artful hands, the historical photograph has been rendered 'actively "resourceful" – a space of creative intensity, of ingenuity, of latent energy, of rich historical force.'[92] In doing so, these artists bring to bear complex responses to the photograph ranging from documentary reverence and playful irreverence to rebuke, whimsy, deep irony, but also cheeky humour. There is certainly in such repurposing a sense of what curator Peter Nagy has called 'the awe of awakening to history,' but I would also argue, the weight of the burden of filial responsibility that the artist-as-inheritor bears towards the father of the nation reduced and recycled over the past century in and as photograph.[93] In such works, the historical photograph of the father of the nation is mobilized in a manner that affirms 'the archival impulse' that seems to motivate many contemporary artists across the world.[94] There is undoubtedly melancholia and despondency in some of these works, but also joy and fun, and not least, the possibility of exhuming hope from the photographed Gandhian past that arrives in the present with all the complications that inevitably accompany an inheritance.

In November 1930, Gandhi wrote to his daughter-in-law Nirmala about a new granddaughter whom he was yet to meet in the flesh. 'It is as well that Sumitra knows me only by my photograph. In a way, it is a pleasant game. If one gets annoyed with a photograph, one can tear it up, one can even beat it up and, if one feels so inclined, one can bow to it. Moreover, a photograph will have only as many virtues as we imagine it to have. Who knows what the original is like?'[95] This is a remarkably perceptive (dis)avowal of the photograph · and its work in his own time – let alone in ours – given the power that we have granted to the camera's production as serving as a proxy for presence. Over the course of his lifetime, as I have already underscored, Gandhi worried over being turned into an image, was critical of idolatry (murti puja), and fussed at painters and sculptors who wanted him to sit for his portrait, not to mention photographers who hounded him at every turn. Writing in 1925 in Navjivan, also published by him, Gandhi insisted that 'the image is not God. Man, however, projects godliness on it and makes it an object of rapt contemplation.'[96] And yet even in his own lifetime but more especially in the aftermath of his violent death, Gandhi's image, as it circulated in paintings, posters, print, and as photographs, has assumed for his adherents the status of divinity. The Mahatma, we can be sure, would not have been pleased with this outcome, but then, he had already anticipated it, worried over it, and could do little to stop it. Indeed, he seems to have been resigned to it, reportedly remarking (with characteristic humour) when he was shown a photograph of him taken in 1946 (while he slept through a near-accident), 'I see now how splendid I shall look when I am dead. I have already known how I shall look before my death. Such is this lucky age!'[97]

Figure 1.11 - Walter Bosshard, *Gandhi Reading the 'War Correspondences', Dandi, April 7, 1930*. Photograph © Fotostiftung Schweiz / Archiv für Zeitgeschichte (ETH Zürich).

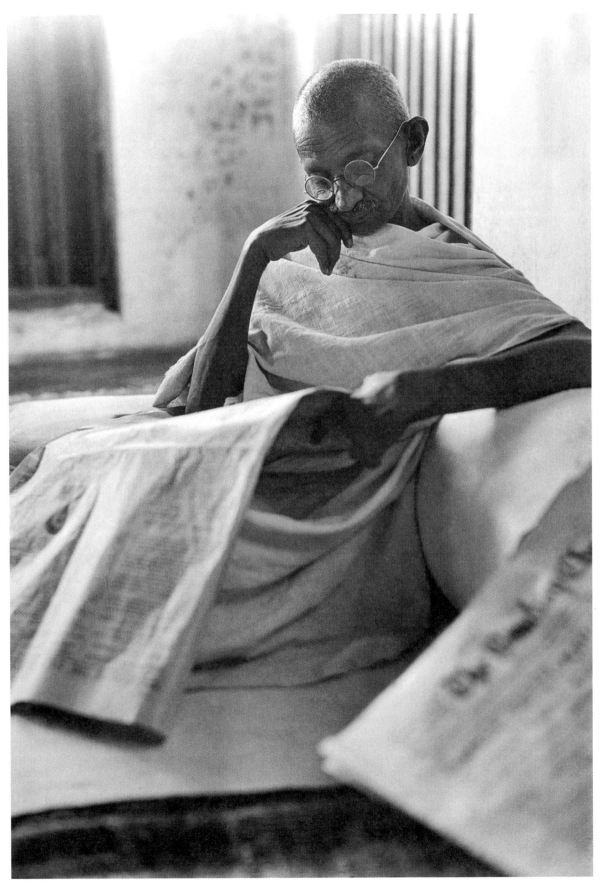

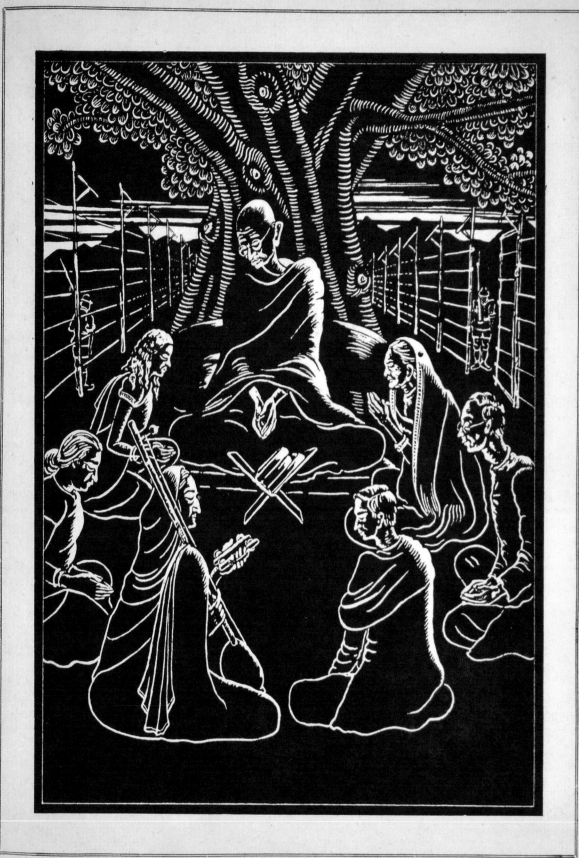

WAITING ON GOD

" Prayer is a yearning of the heart to be one with the Maker ; an invocation for His blessings."—
GANDHIJI

PICTORIAL PENALTY

In his foreword to a series of evocative pencil portraits by Dhiren Gandhi, a grandnephew some of whose works I consider in this book (Figures 1.12, 2.26 and 2.27), the art critic G. Venkatachalam sharply commented on the burden borne by Gandhi whom he labels 'the most written about and caricatured man in the world.' Sought after by artists, high and low of every ilk, Indian and Western, the Mahatma worked hard to evade, resist and spurn their gaze and their pleas to pose for him. Venkatachalam observes that many artists 'had to sneak in, steal their way into his room, and unobserved[,] make quick sketches in pen, pencil or brush and make a hasty retreat before they were caught in their nefarious act.' In Venkatachalam's reading, the 'tragedy' of the Mahatma's encounter with this 'nefarious' artistic world is that, with the exception of Nandalal Bose (and Dhiren Gandhi), most of the men and women for whom he served as muse reduced him to 'caricature,' failing to 'reveal his soul.' Venkatachalam sadly concludes that this is 'the penalty' Gandhi has paid 'for being what he is.'[98]

Despite Gandhi's reluctance to pose for them, and notwithstanding the art critic's scepticism about their capacity to reveal his soul, India's 'nefarious' artists have worked intensely and imaginatively to keep the Mahatma's memory alive at a time when his words have all but disappeared from the everyday consciousness of the Indian citizenry. Indeed, it is likely that the average Indian, especially in our times, has a better sense of Gandhi's visual persona rather than a recall of his words or even actions. On display everywhere – from the humblest tea stalls and street hoardings to the lofty corridors of government, from grand museums to elite gallery spaces – the Mahatma looms large across the Indian landscape, thanks to those artists who have been moved to paint him on their canvases, cast him as a bust or statue, engrave his silhouette, or just plain draw him on a piece of paper. In the chapters that follow, I explore three vectors of this intensive aesthetic investment to consider the import of the payoff and to argue that an indifferent artist's model though he might well have been, Gandhi has passed into Indian visual history as an inspiring muse like none other of his time – or since.

Figure 1.12 - Dhiren Gandhi, *Waiting on God,* 1943. Print from woodcut, 35.56 x 27.73 cm. Anil Relia collection, Ahmedabad.

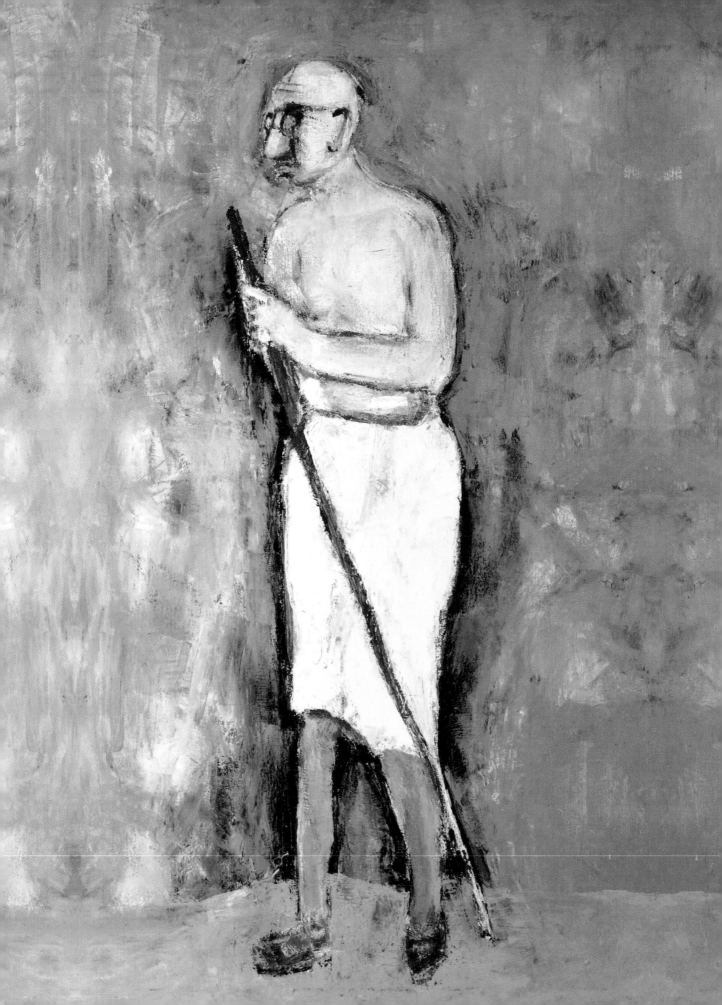

2
THE
ART OF
BARING

'Clothes make the man. Naked men have
little influence on society.'[1]
– *Mark Twain*

THE LITTLE NAKED MAN OF INDIA

On the chilly afternoon of 17 February 1931, a critical meeting transpired in New Delhi between a British Viceroy and an Indian Mahatma, the first of several more to follow over the course of the next three weeks. Viceroy Irwin, a tall slender figure at six feet five, commented later in a letter to the King-Emperor George V on his guest's 'physical endowment, which indeed is unfavourable. Small, wizened, rather emaciated, no front teeth, it is a personality very poorly adorned with this world's trimmings.' Clad in his undyed white cotton dhoti and a shawl, Gandhi did cut a strange figure in the splendid marble halls of the viceregal mansion. 'And yet,' Irwin added, 'you cannot help feeling the force of character behind the sharp little eyes and immensely active and acutely working mind.'[2]

Not everyone was equally impressed. In distant England, Winston Churchill, Member of Parliament, famously excoriated on 23 February the encounter between the King-Emperor's representative and 'this malignant subversive fanatic' with words that have come to be invoked ad nauseam but are still worth recalling:

> It is alarming and also nauseating to see Mr. Gandhi, a seditious Middle Temple lawyer now posing as a fakir of a type well-known in the East, *striding half-naked up the steps of the Viceregal palace,* while he is still organizing and conducting a campaign of civil disobedience, to parley on equal terms with the representative of the King-Emperor. Such a spectacle can only increase the unrest in India and the danger to which white people there are exposed.[3]

More than a decade later in July 1944, Gandhi responded to Churchill, by then Prime Minister, with characteristic humour: 'You are reported to have a desire to crush the simple "Naked Fakir" as you are said to have described me. *I have been long trying to be a Fakir and that naked – a more difficult task.* I therefore regard the expression as a compliment, however unintended.'[4]

It is important to note that Gandhi was not entirely correct in his recall of Churchill's words, for the Englishman had not accused him of being wholly 'naked,' but only 'half-naked.' This is not just semantic quibbling, for this chapter builds on what historian Sean Scalmer has deftly characterized as 'the arithmetic of undress,' to ask why the figure of a 'half-naked' native man sitting down with a British Viceroy should have caused such 'alarm' on the part of Churchill (and others like him).[5] Why, in fact, did it produce such a visceral reaction to the point of 'nausea'? What was it about 'the spectacle' offered by 'half-naked' native flesh that put 'white people' in 'danger' in Churchill's estimation? As I ponder these questions, I remain mindful of Gandhi's own confession years later to Churchill (of all people) of the challenges he had faced in going completely naked, more difficult in his own words than becoming a fakir and hence also an unintended 'compliment' that pleased him.[6]

Gandhi is the only man among the great public figures and fathers of the nation of the long twentieth century to make such a *public* spectacle of his partly clad body, putting it on display for visual consumption repeatedly and without any concession to the occasion. In so doing, the Mahatma was undoubtedly practising a form of sartorial disobedience against a Victorian cultural formation in which bare flesh was denigrated as savage and uncivilized, a sign of lack of respectability and virtue.[7] Confronted with the bare brown torsos and exposed limbs of their Indian subjects, especially servants, the British expressed a range of sentiments, including disquiet and anxiety, some erotic desire, but also a good bit of horror and disgust that led them to

Figure 2.1 (pg 36) - Haku Shah, *Gandhi,* 2014. Oil on canvas, 121.92 x 76.2 cm. With permission of the artist's family.

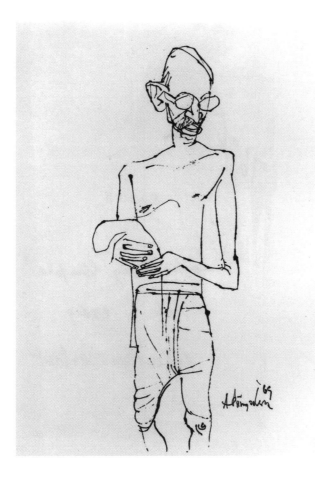

zealously clothe the native (in Manchester-produced cloth, no less). Gandhi responded in a characteristic manner to such sartorial imperialism. Dismissing in June 1921 'the European-style' of clothing as 'ugly' and 'utterly unsuitable' for India, he observed, 'Only their insularity and unimaginativeness have made the English retain the English style in India, even though they admit that it is most uncomfortable for this Indian climate.'[8]

By then, he himself had begun to respond with great imagination to the ruling class's apparent lack of imagination. From around 1913, he progressively shed his black suits, stylish ties, and polished shoes for a European-style worker's outfit and the indentured coolie's attire (see also frontispiece).[9] He also retreated from his earlier squeamishness about human nakedness, *Indian Opinion* even reporting him as stating, 'In fact, Nature has provided man with the best

dress in his skin. It is altogether wrong to think that the nude body is ugly. The finest pictures we see are of the naked body. By covering up the normal organs of the body, do we not, as it were, suggest that Nature has made a mistake?... If custom had not perverted our outlook, we would easily realize that man appeared at his best and enjoyed the finest health in his naked state.'[10]

This admiration for nature's 'best dress' did not lead Gandhi to go fully naked himself in public. After several hesitant steps, he settled in September 1921 for the paltry garb of the poor peasant who inhabited the Indian countryside. Nevertheless, India's artists, and indeed admirers elsewhere, began to take heed of his new bare and spare look, and continue to do so to this day (Figure 2.1). They do so possibly out of a sense of awe that the Mahatma had accomplished something that they themselves are unable to do, in

Figure 2.2 - K.M. Adimoolam, *Looks Very Simple*, 1969. Pen and black ink on paper, 56 x 34 cm. With permission of K.M. Adimoolam Foundation.

decolonizing his bourgeois body and stripping down to the minimum, even and especially so in public, but also perhaps from the recognition that it is in the visual realm that the near-naked human body, or the nude, has the most potential to elicit pleasure but also unease.

Gandhi's struggles with going wholly naked are worth underscoring. I recall here his likely playful but possibly wistful reaction when he saw Frieda Hauswirth's sketch of him in Cuttack in December 1927: 'Why did you put so much clothing on me?' (Figure 1.4). Frequently, from at least 1919, he also held out the possibility that his followers 'should be ready to go naked,' like the poor 'naked' peasant who stood abandoned by the leaders of their country.[11] Nevertheless, despite believing by 1913 that 'the finest pictures we see are of the naked body,' he did not shed *all* his clothes in public, but instead presented himself partly clad in various ways, offering tantalizing glimpses of different surfaces of his body. Hence also the confusing manner in which he comes to be variously described (especially in the West) sometimes as 'half-naked,' at other times as 'three-quarters naked,' and in still others as 'stark naked.'[12] Can his much-touted charisma be traced to this in-between state of stripping down completely, *but not quite*?

As anthropologist Adeline Masquelier has remarked, 'Undress...has been remarkably under-theorized outside art history and psycho-analytic theory.'[13] I am mindful that 'what constitutes a state of unclothedness is fluid and unstable,' especially in a place such as India, where the calculated display of skin is not scandalous in the same manner as it might be in other parts of the world, particularly the imperial West.[14] Nonetheless the *surface* of Gandhi's bare and spare body has a history to tell and an aesthetic to reveal. Hence my interest in exploring the art of baring as it is made visible through the work of artists invested in reproducing Gandhi's body in various states of public, fleshly displays (Figure 2.2).

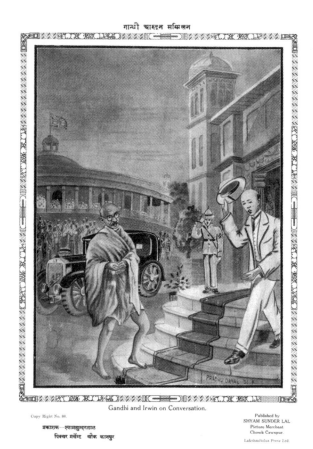

गान्धी आरूइन सम्मिलन

Gandhi and Irwin on Conversation.

Copy Right No. 66.

प्रकाशक—श्यामसुन्दरलाल
पिक्चर मर्चेण्ट चौक कानपुर

Published by
SHYAM SUNDER LAL
Picture Merchant
Chowk Cawnpur.
Lakshmibilas Press Ltd.

As I do so, I underscore that while the Mahatma may have aspired to total nakedness in the eyes of God and as a seeker of Truth, settling for the almost-there-but-not-quite state out of consideration, most likely, for his (middle-class) colleagues, he *never* enjoined it for the women of India. On the contrary, the typical Gandhian woman, more so than her compatriots, was covered from head to toe with barely any part of her body visible. In surviving photographs in which the Mahatma is surrounded by his wife, female members of his family, or women followers, their fully clothed look only further accentuates the tantalizing bareness of his male body on display, redirecting our gaze to it in all its singular masculine sparseness.[15]

Figure 2.3 - Prabhu Dayal, *Gandhi Irwin Sammilan: Gandhi and Irwin on Conversation, c.* 1931. Print published by Shyam Sunder Lal, Kanpur, 23.5 x 17.5 cm. Collection of Erwin Neumayer and Christine Schelberger, Vienna.

THE ARITHMETIC OF UNDRESS

To start with, I remind my readers that by his own standards, Gandhi was actually overdressed for his meetings with Viceroy Irwin, taking place as they did in a New Delhi winter. Some surviving photographs show the Mahatma arriving at the viceregal palace, his torso swathed in a shawl, the only part of his body left exposed (other than his head) being his thin legs shod in simple sandals. Such photographs also find a visual echo in a black-and-white print that shows Gandhi alighting from a car and walking up to meet Irwin, his upper body almost completely covered although his legs and feet are bare (Figure 2.3). The Viceroy wears a customary suit, but interestingly, as he walks down the steps to greet the Mahatma, he takes off his hat in greeting, a gesture of obvious respect for his esteemed visitor. Another print by Prabhu Dayal also shows Gandhi covered up, only his bare legs discreetly visible, as the artist sought to visualize the 'parley on equal terms' behind closed doors between the British Viceroy and the Indian Mahatma.[16]

When these February meetings culminated in the Gandhi–Irwin Pact signed on 5 March 1931,[17] the *Illustrated London News* printed on its front page – for the consumption largely of its British readers – a photograph of Gandhi taken on the occasion of one of his visits with the Viceroy which shows him, contrary to Churchill's irate characterization, completely covered (Figure 2.4). Given that the Mahatma did not really show up 'half-naked' for his meetings with the King-Emperor's representative, it is all the more revealing that Churchill chose to portray him as such. And, as Sean Scalmer notes, he was not alone in this regard, and phrases such as 'almost naked,' 'stark naked,' even 'nude,' began to proliferate in the Western media in descriptions of Gandhi from around this time, one journalist pithily summarizing him as 'the little naked man of India.'[18] Not all such comments were necessarily uncomplimentary. For instance, American journalist William Shirer, who visited India around this time

and spent quite a bit of time with Gandhi, wrote to his editor, 'The little old man may look weak and sickly and have only two teeth and *almost no clothes* – but he's strong, powerful and able, very able.'[19]

Such characterizations only picked up steam a few months later when, as a result of his several 'parleys' with Irwin, Gandhi arrived in London to attend the Second Round Table Conference on 12 September 1931, and stayed on in the country until 5 December, impressing all and sundry with displays of good health and high energy, but also a considerable amount of brown flesh.[20] It was his fifth and final trip to the Empire's capital, but he had not visited Europe since adopting the loincloth in 1921. So, this was really the first occasion on which Gandhi's differently clad body became visible in London and optically available to onlookers. He took up residence in Kingsley Hall in the poor end of the city with a temporary office in Knightsbridge, a more fashionable section of town, where, a witness recalled, 'in every corner of the room, there were famous artists and sculptors trying to get a model of or a picture of this elusive man.'[21] Photographs of the conference show him as a modest figure amongst 'the knights brown and white, turbans and shining pates,' his upper body wrapped in a shawl.[22] Still, many contemporaries were impressed that even in the face of the inclement English weather, he continued wearing his cotton dhoti, his legs bare and his feet in sandals. He showed up thus for his meeting with the new Secretary of State for India, Sir Samuel Hoare, when he was invited to sit by the fire to dry himself. 'He...looked even smaller and more bent than his pictures showed him,' Hoare recalled many years later. 'His bony knees and toothless mouth would have made him ridiculous if they had not been completely overshadowed by the dominating impression of a great personality.'[23]

Bony knees, barely clad feet and all, but still, with his torso entirely covered, Gandhi made numerous public appearances, which surviving photographs have

THE ILLUSTRATED LONDON NEWS

The Copyright of all the Editorial Matter, both Engravings and Letterpress, is Strictly Reserved in Great Britain, the Colonies, Europe, and the United States of America.

SATURDAY, MARCH 14, 1931.

Figure 2.4 - 'The Indian Principal in the Conversations
Which Culminated in the Indian Settlement: A Photograph
Taken on the Occasion of a Visit to the Viceroy at New Delhi.'
The Illustrated London News, Saturday, 14 March 1931.

captured. Although Churchill did not meet him on this occasion, the King-Emperor himself reluctantly agreed to have tea, along with thirteen other delegates from India, on 5 November with 'that little man with no proper clothes on, and bare knees.'[24] For his part, 'the rebel fakir' refused to make any concession to the palace dress code while his people were 'still naked' on account of British policies, and reportedly quipped, 'His Majesty the King-Emperor had enough on for both of us.'[25] In turn, artists in India had fun imagining this encounter behind closed doors between these two famous men, one underclad and the other overdressed. Colourful contemporary lithographs show the British monarch festooned with all manner of baubles, along with his elaborately bejewelled consort, greeting the Mahatma, simply dressed in white but almost totally covered except for his bare limbs (Figure 2.5). On the other hand, consider a cartoon titled 'Experiment with Mahatma Gandhi' published in the *Daily*

Express whose staff 'photographed Gandhi's head and transposed it upon the shoulder and body of an Englishman attired in [a] spruce morning coat and top hat.' The accompanying caption informed the viewer, 'In view of Mahatma Gandhi's pronouncement that it will be an insult to his Majesty the King if he appears in any dress other than his loincloth, this American camera-trick shows him as he will not appear.'[26]

I pause here to consider that piece of attire widely labelled as the loincloth, made notorious by Gandhi. Much has been written about the moment in Madurai on 22 September 1921, when Gandhi first appeared in public in a garment that one of his followers noted (with some disquiet) was 'not more than a cubit in width round his loins.'[27] Not least of the Mahatma's claims to fame is the fact that he was the first – and possibly only – man to visit Buckingham Palace wearing this questionable garment. Gandhi himself explained to a journalist

Figure 2.5 - *Mahatmaji Meeting the King-Emperor in Buckingham Palace*, *c.* 1931. Chromolithograph, publisher unknown, 27.5 x 20.5 cm. Collection of Erwin Neumayer and Christine Schelberger, Vienna.

from the *News Chronicle* on his sartorial choice in the following manner: 'In India several millions wear only a loincloth. That is why I wear a loincloth myself. They call me half-naked. I do it deliberately in order to identify myself with the poorest of the poor in India.'[28] Later that month, he wrote in an article published in the *Daily Herald*, 'The loincloth, if you so choose to describe it, is the dress of my principles.'[29] It is not entirely clear why Gandhi settled on the phrase 'loincloth,' 'a term implying a scandalous combination of holiness and undress,'[30] to describe in English the garment he fashioned for himself, for technically it is better described, as anthropologist Emma Tarlo correctly notes, as a 'short dhoti' that more or less modestly covered him from waist to bony knees (although it had a tendency to occasionally ride up his

skinny thighs, exposing them in the process). If he had truly adopted a loincloth (or *langoti*), only his genitals would not have been exposed. A photograph that Tarlo reproduces in her marvellous ethnography (with the caption 'Gandhi at his most naked...') does show him in one, but that is a rare public image of the Mahatma at his absolute barest minimum, captured on camera after he had taken a public bath in the ocean before breaking the colonial salt laws in April 1930.[31] Decades later, Atul Dodiya incorporated this photograph into a luminous painting titled *Sea-Bath* (Figure 2.6), as does fellow Gujarati, Bansi Khatri, who lives and works in Ahmedabad (Figure 2.7). While Khatri's work is more or less faithful to the black-and-white photograph, Dodiya's radically supplements it with the figure of a man pulling off his shirt, a citation from Pierro della

Figure 2.6 - Atul Dodiya, *Sea-Bath (Before Breaking the Salt Law)*, 1998. Watercolour on paper, 55.8 x 76.2 cm. With permission of the artist.

Francesca's *The Baptism of Christ* (c.1440).[32] Gandhi's sea bath at Dandi, Dodiya appears to suggest, is akin to the spiritual rebirth of Jesus, who we are used to seeing in artworks as a barely clad man.

Such images are rare though, and they only underscore that the steps Gandhi took towards adopting his short dhoti were gradual, hesitant and filled with apprehension. Taken apparently in the spirit of showing his sympathy for the peasants of India dying of hunger and nakedness, his sartorial turn towards the loincloth was also meant to be a temporary measure until freedom would miraculously cover the bare body of the Indian. The fact that many of his closest followers tried to stop him shows how nakedness was not just a British dread and source of disquiet, but a middle-class Indian anxiety and embarrassment. Revealingly, almost none among Gandhi's closest supporters followed suit, so to speak, and start appearing in public in imitation of their Mahatma, a sustained exception in his own lifetime being Vinoba Bhave. On the contrary, as Tarlo documents, reactions ranged from 'puzzlement to fear and misapprehension,' Abbas Tyabji, a close associate, even observing, 'See, Mahatmaji has turned mad, but not merely that; he has devised a way of making others mad too.'[33] Arousing alarm and nausea on one continent, triggering lunacy on another, Gandhi's experiment with shedding everything, but not quite, proved to be enormously productive for both discourse and also image-making, as artists lavished their attention on sketching, painting, and sculpting the contours of his bare brown flesh.

Figure 2.7 - Bansi Khatri, Dandi March, 2005. Acrylic on canvas, 50.8 x 60.96 cm. With permission of the artist/ Archer Art Gallery, Ahmedabad.

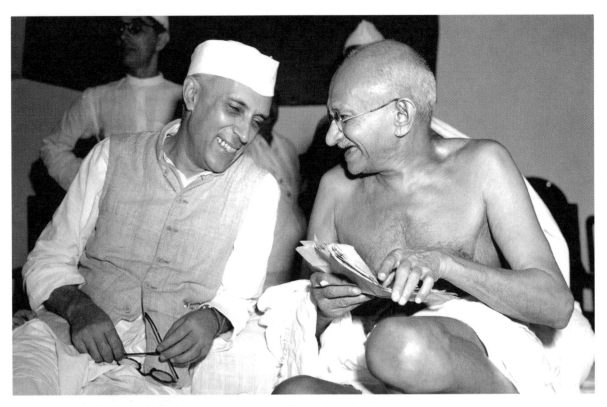

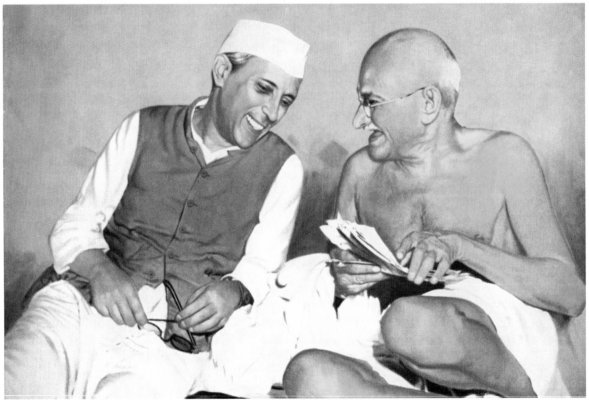

Figure 2.8 (above) - Max Desfor, Nehru and Gandhi at
the All-India Congress Committee Meeting in Bombay,
6 July 1946 © AP Images.

THE CHEMISTRY OF COLOUR:
BARE AND BROWN

Amongst Gandhi's closest followers who did *not* sartorially follow in his footsteps was his political heir-apparent Jawaharlal Nehru, who observed thus about his mentor: 'In spite of his unimpressive features, his loincloth and bare body, there was a royalty and a kingliness in him which compelled a willing obeisance from others.'[34] The debonair Jawaharlal had willingly and obediently shed his own tailored Western clothes to adopt the new 'uniform' of the Indian national movement as exemplified by his attire in a photograph (also subsequently reproduced on a postage stamp in 1973) credited to the Associated Press photographer Max Desfor, dated 6 July 1946, when Gandhi and he shared a moment of obvious joy in spite of the gathering storm of Partition (Figure 2.8). The ambient light reflects off the surface of the Mahatma's exposed body to cast a glow about him. The photograph offers a demonstration of how bare(d) flesh can provide a surface from which impressions of 'royalty' and 'kingliness' could be extracted by the devoted viewer of the lightly clothed figure of the Mahatma 'in spite of his unimpressive features.'[35]

Indeed, one such devoted viewer appropriated the photograph in a print produced for the mass market (Figure 2.9).[36] In the print, the sheen of the greys, blacks, and whites of the photograph is punched up by the brown tones of Gandhi's flesh, much more arresting than Jawaharlal's khadi-covered body. The folds of the Mahatma's flesh are reproduced exactly from the photograph, but the use of colour and shading allows what was purely surface in the photograph to assume depth. As anthropologist Christopher Pinney notes about such chromolithographs, which are based on the black-and-white photograph of the Mahatma, 'Colour simply enhances a truth already present in the photographic image: the humility and truthfulness of Gandhi's androgynous corporeal rebuke of the brutal masculinity of colonial oppression.'[37]

India's artists, in fact, seem to revel in the Mahatma's brown torso, painting and colouring it with great relish. Consider two paintings by Maqbool Fida Husain (1915–2011), India's most famous Modernist, who painted Gandhi numerous times as an elegant spare figure, his body a rich chocolate brown in stark contrast to the undyed whiteness of his dhoti.[38] In a 1969 painting, his dark brown torso is seared through with vermillion and orange, his bony legs supporting his lean body (Figure 2.15). A single brown hand stands out against the blue background, the very arrangement of the five bony fingers recalling the 'abhaya mudra' of classical Indian sculpture, a gesture that stands for fearlessness, tranquillity and the protection afforded by a deity. For Husain, who frequently bestowed the same gesture upon Hindu deities in numerous works, Gandhi is surely the new brown god of his people.

These elements are repeated – with a difference – in another canvas in which the Mahatma's lean, brown body is placed against a black and golden yellow background, a solitary goat his only companion (Figure 2.14). The angular lines of the pale dhoti and shawl underscore the brown sparseness of his body, the single visible hand, coloured a startling fleshly pink, once again sketched in the abhaya mudra, the brilliant purple staff held as if by magnetic force against the body. Lines radiate out of the faceless head to form a halo around it. From the 1940s, Gandhi was inevitably painted with a large halo around his head in the colourful chromolithographs of Indian street art, suggesting that he was indeed a hallowed soul. Husain's intent may have been to connect with such images, but these lines also recall the spokes of the

Figure 2.9 (facing page, below) - Nehru and Gandhi, n.d. Chromolithograph based on Max Desfor's photograph. Priya Paul Collection, New Delhi.

MAHATMA GANDHI

(28th Jan. 1948)

Mahatma's spinning wheel at which he sat patiently every day, cultivating a habit and practising an art that was so critical to his ethic of disobedience.[39]

The Mahatma's bare brown body also features prominently in mass-produced calendar art at the other end of the artistic spectrum from Husain's modernism. C.N. Row's *Mahatma Gandhi* exceeds the black-and-white 'snapshot,' which it repurposes by liberally using various shades of brown to paint the surface of Gandhi's body (Figure 2.11). Similarly, in D.B. Mahulikar's *Mahatma Gandhi in Yeroda Jail* [sic], Gandhi sits cross-legged at his spinning wheel, the undyed white of his dhoti only deepening the hue and sheen of the brown flesh, but also highlighting the sparseness of the bony chest on display (Figure 2.18). In or after 1948, Roopkishore Kapur appropriated a black-and-white photograph credited to William L. Shirer from 1931, and liberally painted Gandhi's body brown, adding texture to its folds (Figure 2.10).

All this is not to say that artists are only interested in the Mahatma's partly clad body. On the contrary, many art works show him fully clothed in the white khadi that he also made famous (for example, Figures 1.1 and 1.3), including an exquisite watercolour by Abanindranath Tagore, among the first attempts by an Indian artist to paint the Mahatma (Figure 2.12). The work likely documents an early meeting in Calcutta on 6 September 1921, between the artist's famous poet-uncle Rabindranath and Gandhi, a few weeks before the latter's act of baring himself in Madurai. In art historian R. Siva Kumar's description of this work:

> The meeting took place against the backdrop of Gandhi's call for non-cooperation [with the British], and Rabindranath's apprehensions about the boycott turning into exclusionary nationalism. The only other person who was present on the occasion was C.F. Andrews and what transpired between them was not revealed by any of them. Abanindranath, though he was not generally involved in nationalist politics, grasped the emblematic and

dramatic significance of this encounter. In his painting, oblong like a hand scroll, the three who were present at this meeting are shown against an undefined space, punctuating it and giving it definition like rocks in a Zen garden. Rabindranath appears at the right end of the painting, Gandhi sits facing him with some space between them, and Andrews sits behind Gandhi as a witness to their discourse in communion. Rabindranath, his long green dress rendered as one bold flat shape, sits imperious; his eyes lowered and his hand on his chin, he appears exercised and troubled, and deeply in thought. Gandhi, dressed in white, slight-bodied and less weighed down, looks straight and expectantly at Tagore, and the more substantial figure of Andrews behind him, in an ochre dress that almost dissolves into the yellow of the paper, is thoughtful

Figure 2.10 (facing page) - Rupkishor Kapur, *Mahatma Gandhi (28th Jan. 1948)*, 1948? Chromolithograph published by Shyam Sunder Lal, Kanpur. Priya Paul Collection, New Delhi.

Figure 2.11 (above) - C.N. Row, *Mahatma Gandhi Born 2nd October 1869 (From the Latest Snapshot Study)*, c. 1920s? Chromolithograph published by Gaya Press, Calcutta. ACSAA/Artstor.

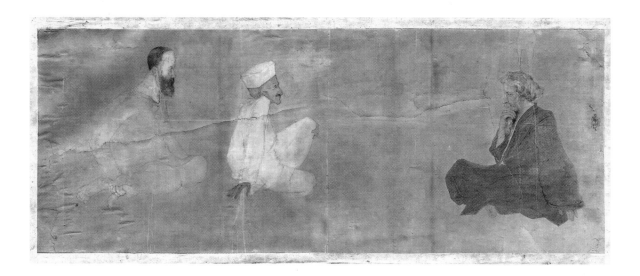

and apprehensive. They sit connected not by conversation but by pause and silence – as Daoist saints often do in Chinese paintings.[40]

Decades later, Abanindranath's slight-bodied and fully clothed Gandhi makes a recurrent appearance in numerous luminous works by the Baroda-based Gulammohammed Sheikh (b. 1937), including *Gandhi and Gama* (Figure 2.13). In this rich and evocative painting which premiered at the 2014 Kochi-Muziris Biennale, Gandhi shares the stage with luminaries from the world historical stage such as the Buddhist monk Xuanzang, mystic poet Kabir, and the Portuguese explorer Vasco da Gama who 'discovered' the route to India from Europe in 1498. As the art historian Chaitanya Sambrani writes, the work asks us to ponder: 'What if, by some sleight of space-time, the young Gandhi – about to embark on his anti-colonial struggle – were to encounter Vasco da Gama at the point that the latter inaugurated the European conquest of Asia?'[41] Gandhi's lightly clad body also offers a rich contrast to the European explorer's sumptuous overdressed form, compelling the viewer to reflect on the Mahatma's predilection for minimalism.

Such examples notwithstanding, Gandhi's exposed brown torso stands out in the visual and media culture that has emerged since the 1920s, signalling the artist's collaboration with the Mahatma in what I call the art of baring. In the racialized empire of colour where white ruled the roost, and black was at the very bottom, brown occupied a more ambiguous and ambivalent place. While not as reviled, the brown skin of the native, especially of the servile class, was treated with some amount of derision. No wonder then that the educated and Westernizing Indian elite aspired to the new standards set by whiteness, although always falling short, precisely on racial grounds.[42]

Gandhi, too, in his early years trafficked in this aspirational politics of whiteness, as he touchingly confesses in his memoirs. But he became painfully aware after suffering repeated indignities in law courts in colonial South Africa that 'the colour of one's skin was as much part of one's costume as a frock coat.'[43] This insight led him to artfully and systematically practise shedding such clothes, and getting more comfortable with and in his own (brown) skin. Over

Figure 2.12 - Abanindranath Tagore, Tagore, Gandhi, Andrews, 1921. Watercolour on paper, 45 x 119 cm. With permission of Kala Bhavan, Visva-Bharati University, Santiniketan.

time, his sartorial *and* somatic disobedience meant that the barer he got, the browner he appeared as more and more of his body's surface is (made) visible in the works of artists as they portray him sitting with his chest uncovered and knees and legs exposed, writing, reading, spinning, speaking, walking, and so on. Indeed, if white is the colour of imperialism, such works remind us that brown emerges as the colour of anti-colonial resistance. With his parading of all that bare(d) flesh, Gandhi made the colour very popular indeed, as a recent exhibition held in New Delhi and titled 'BROWNation' also testifies. [44] Among other works on display was Vishal K. Dar's *Travels of That Strange Little Brown Man*, its title a riff on an early biography (written by an admirer no less), *That Strange Little Brown Man*, by Fredrick B. Bishop (1932). Similarly, when *Time* magazine featured Gandhi as its Man of the Year in 1931, its editorial described him as 'a little half-naked brown man,' although the Walter Bosshard photograph (Figure 1.11) on which the cover art is quite clearly based has him quite clothed. [45]

It is one thing for such artists – Indian and male – to lovingly paint all of this bare(d) brown flesh on their canvases, but what can we conclude when such a body

engaged the gaze of a woman who was not Indian? This is also a question that lurks behind my discussion in Chapter 1 of the encounters of artists like Frieda Hauswirth and Clare Sheridan with the Mahatma. Three years after he adopted the loincloth, Gandhi observed, 'Sisters come to bless me with their darshan [sight], love me and give their blessings. There are both Hindus and Muslims among them. I am sure they do not come to look at my body (*sharir*) at all. I have never felt they ever watched it. This is but right. A man or a woman should never look at the body of his or her friend. If one happens to do so unwittingly, one should immediately take one's eyes off it. One is free to look at another's face only.' [46] Nevertheless, from the camera work of the *Life* magazine photographer Margaret Bourke-White (1904–71), it is clear that she looked at more than his face only, but without alarm or nausea.

Bourke-White first visited India in March 1946 with some degree of scepticism about the Mahatma, but was eventually charmed (at least in her published writings) by 'the symbol of simplicity.' [47] In her varying accounts published after Gandhi's death, she writes with some humour of her trials and tribulations before being allowed to photograph the Mahatma, including

Figure 2.13 - Gulammohammed Sheikh, *Gandhi and Gama*, 2014. Acrylic on canvas, 288 x 624 cm. With permission of the artist.

Figure 2.14 (facing page) - Maqbool Fida Husain, *Gandhiji*, 1972. Oil on canvas, 255.27 x 113.03 cm. © The Estate of Maqbool Fida Husain, image courtesy of Peabody Essex Museum.

Figure 2.15 - Maqbool Fida Husain, *Gandhi: Man of Peace*, October 1969. Oil on canvas, 166.8 x 143.8 cm. © 2009 Christie's Images Limited.

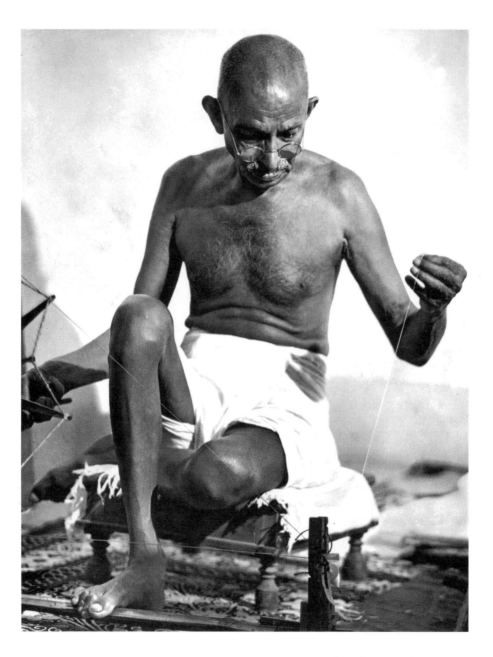

Figure 2.16 - Margaret Bourke-White, Gandhi Spinning,
1946. Gelatin silver paint, 27.8 x 35.7 cm.
Image courtesy, The Museum of Fine Arts, Houston.

Figure 2.17 - Gopal Swami Khetanchi, *Spinning Alive*,
2010. Oil on canvas, 106.68 x 106.68 cm.
With permission of the artist.

learning how to spin, practising sitting cross-legged, and being denied the use of a flash. After some amount of pleading that she needed some light in the dark depths of the Mahatma's hut, she was allowed three peanut light bulbs (two of which did not work properly). She recollected her first sighting on his weekly silence day with some wonder: 'There sat the Mahatma, cross-legged, a spidery figure with long, wiry legs, a bald head and spectacles. Could this be the man who was leading his people to freedom – the little man in a loincloth who had kindled the imagination of the world? I was filled with an emotion as close to awe as a photographer can come.'[48] Several years after her first encounter, she described him as 'an odd little man in a loincloth,' but there is no recoil expressed

over seeing his bare(d) brown male flesh on such ample display – in contrast, say, to Churchill.[49] In a volume published almost two decades later, dedicated to the 'heroes of our times,' she wrote, 'Many people have asked me if I could tell, when in the presence of Mahatma Gandhi, that this was a great man. The answer to that is *Yes*, one always knew. There seemed to be an aura hanging over Gandhi. A touch of magic clung to this little brown man with his squeaky voice which influenced opinions around the world.'[50]

Her photographs of the Mahatma, widely admired in her own time in the United States, have subsequently captured the attention of India's artists.[51] Thus, Jaipur-based Gopal Swami Khetanchi (b. 1958) repurposes a photograph – to which, on the eve of his

Figure 2.18 - D.B. Mahulikar, *Mahatma Gandhi in Yeroda Jail*, 1933. Chromolithograph, Priya Paul Collection, New Delhi.

murder, the Mahatma added his signature – that has
Bourke-White's famous sitter engrossed in one of his
disobedient practices, spinning at his wheel (Figures
2.16 and 2.17). Whereas in Bourke-White's black-and-
white photograph, the bare(d) surface of his elderly
body has a sheen to it, despite the wrinkles and sags
of the aging skin, in Khetanchi's recreation in colour,
the luminous brown form is also delicately overlaid
with the warp and woof of the Mahatma's disobedient
act of spinning. On the other hand, Ravikumar Kashi
(b. 1968) makes a very different use of Bourke-White's
most reproduced photograph of the Mahatma, taken
as he sits absorbed in another of his favourite pastimes,
reading, and described by one of her biographers thus:
'Margaret has composed an icon for a secular saint,

humble, meditative, graced by light and accompanied
by his symbolic spinning wheel much as Western saints
are accompanied by their emblems.'[52] Kashi flips this
famous photograph so that it returns to us reflected
on the surface of several mirrors (Figure 2.19). *Back-
and-Forth 1* belongs to a series called 'Reconstructing
Bapu' in which the Bengaluru-based artist repurposes
a number of widely circulated photographs of Gandhi,
and subjects them to a process of wavy disturbance,
as when a pebble is cast into still water. Is the artist
trying to liberate the Mahatma from the clutches
of photographic freezing and iconicity? Or is he
suggesting that in our times, the image of Gandhi
circulates as a distorted, even crumbling, version of his
former coherent self?

Figure 2.19 - Ravikumar Kashi, *Back and Forth-1*,
2011. Oil on canvas, 91.44 x 121.92 cm.
With permission of the artist.

The Physics of the Self:
Austere & Ascetic

In the closing chapter of his autobiography (completed at the near peak of his political career in the mid-1920s), Gandhi bid 'farewell' to his readers by declaring that while his experiments and experiences so far had sustained him and given him great relish, he still 'had a difficult path to traverse. I must reduce myself to zero.'[53] Around the same time, he elaborated in a 1927 letter:

> TRUTH and LOVE have been the jointly the guiding principle of my life... LOVE can only be expressed fully when man reduces himself to a cipher. This process of reduction to [a] cipher is the highest effort man or woman is capable of making. It is the only effort worth making, and it is possible only through ever-increasing self-restraint.[54]

Upon his long-time associate and translator Mahadev Desai (who died in August 1942), Gandhi bestowed what was perhaps his best compliment: 'The greatest characteristic I can think of about Mahadev Desai was his ability to reduce himself to zero, whenever [the] occasion demanded it.'[55] In early January 1947, he wrote to Mirabehn at a particularly trying moment in his – and in the nation's – life, 'If I succeed in emptying myself utterly, God will possess me. Then I know that everything will come true but it is a serious question when I shall have reduced myself to zero.'[56]

Gandhi's desire to reduce himself to zero has been variously interpreted by scholars, including those who argue that it refers to the Mahatma's struggle with self-effacement and the overcoming of ego, as noted in a 1945 letter: 'Greatness lies in becoming small and smallness in assuming greatness. We should therefore only serve by becoming as small as dust particles.'[57]

Such sentiments draw attention to a key aspiration that Gandhi pursued since at least 1906 when he formally took his vow of celibacy and also decided for various reasons (including as a retort to the materialism that was spawned by industrial capitalism) to adopt a life of simplicity and freedom from excess (*aparigraha*, lit. non-possession). In a 1931 speech at the Guildhouse Church in London (in what was likely his longest exposition of his idea of 'voluntary poverty'), he even declared, 'The only thing that can be possessed by all is non-possession, not to have anything whatsoever. In other words, a willing surrender.'[58]

His 'willing surrender' to a life of aparigraha and simplicity is visually celebrated in several artists' works in which he is shown with the humble goat, in contrast to the tigers and lions with which the British colonizer and the Indian royal alike had themselves painted and photographed (for example, Figure 2.14).[59] His minimalism is highlighted in a sketch by Tamil artist K.M. Adimoolam (1938–2008) titled *Looks Very Simple* (Figure 2.2). The artist has drawn Gandhi's dhoti-clad body free of any accessory other than a pair of spectacles. He is not even wearing his beloved waist-watch. This is a bourgeois body like none other of his time; hence, the likely fascination with which it is beheld in bourgeois art.

Gandhi is also famously credited with having declared to a customs official in Marseilles en route to London in September 1931, 'I am a poor mendicant; my earthly possessions consist of six spinning wheels, prison dishes, a can of goat's milk, six homespun loincloths and towels, and my reputation which cannot be worth much.'[60] The force of the visual culture that has emerged around the Mahatma, especially since his passing, has turned such quotidian objects into works of art, or those deemed deserving of being in art, as in *Gandhi and His Things* (Figure

2.20). Painted with great devotion by Haku Shah, a Gandhian in his personal life, the work renders for aesthetic contemplation the Mahatma's glasses, waistwatch, staff, and sandals. Similarly, the landmark 1995 exhibit, 'Postcards for Gandhi' (which I discuss in the concluding chapter) bears testimony to the fascination of India's artists with Gandhi's success in shedding dependence on material affordances of life, provoking the production of numerous paintings and sketches devoted to what I call the art of aparigraha (for example,

Figure 3.42).[61] In such works, a handful of mundane objects – his spectacles and walking stick, his sandals and spinning wheel, the statuette of three monkeys 'speaking hearing seeing no evil,' and occasionally his pen – stand in for an absent Gandhi. His beloved watch, a 'possession' that he found difficult to shed in real life, has also captured the artist's attention, some even, as in a painting by Priyaprasad Gupta dated to the day of Gandhi's murder, painstakingly pinpointing the time of his death (Figure 4.5). In Gulammohammed

Figure 2.20 - Haku Shah, *Gandhi and His Things*, 2013. Oil on canvas, 60.96 x 60.96 cm.
With permission of the artist's family.

Sheikh's stunning *Ahmedabad: The City that Gandhi Left Behind,* the viewer is invited, as if on a treasure hunt, to search for Gandhi's paltry possessions (Figure 2.22). These include his eating bowl, his pen and its case, and his waist watch registering the time of his killing (Figure 2.23). The Mahatma though as figure and person is utterly absent from this city that he called home from 1915 after his return from South Africa but to which he did not return after 1936. The very emptying of his physical presence, the artist seems to suggest, casts a ghostly pall over the city, leading ultimately to riots and death.

After Gandhi's death, the replicas of his paltry personal possessions were enshrined in numerous Gandhi memorial museums across India, even as outrage erupts on periodic news updates regarding the theft or the disappearance of the originals. In Ravikumar Kashi's *Everything He Touched,* the art of aparigraha moves from melancholic recall and celebration to critique, even as the work reveals the artist's own fascination with such objects, which become the focus of his aesthetic contemplation (Figure 2.24). Kashi notes that the work was provoked by a visit to museums across the nation where an absent Mahatma is summoned back to the present through his material possessions (and grainy photographic reproductions of these). As we turn the pages of his exquisite artist's book, we confront the objects that the Mahatma had handled, even the commonest of them becoming hallowed by virtue of the fact that he had actually 'touched' them, such as his *lota,* a safety pin, his staff and his sandals (See also Figures 3.39 and 3.42). As in an earlier work *Gandhian Garbage* (1969) by A. Ramachandran (on whom I say more later), the official celebration of such objects is implicitly undercut by artistic reprimand on the last page of the book: 'The range of objects kept in these museums range from his books to cups and utensils he used to his dentures, objects he touched when he visited some place, like a microscope or lab equipments to pens to piece of cloth. While it reveals the great respect the nation placed on him, it also reveals a trend to capture him in objects and forget the spirit of his life and words. A fetish for objects substituting the actual person [sic].' Such a reprimand only serves to underscore the relic culture – not unlike the veneration of remains of hallowed figures such as the Buddha – that has emerged around the few extraordinarily ordinary objects with which the Mahatma continued to associate himself.[62] As the furore that followed the 2009 sale-via-auction of some such subjects reminds us, the property of the father of the nation, however paltry, is still deemed the nation's patrimony to be claimed and defended (even if the ideals that they embody are forsaken and forgotten).[63]

An aspiration to reduce himself to zero also led Gandhi to live from around 1904 in austere communal homes built to reflect his political ethics, but most certainly on his return to India in 1915, to also mimic the precarious living conditions of the Indian poor. He was almost alone in the political leadership of the Indian national movement in so doing, ironically aestheticizing lived precarity in the process. Foreign visitors – of which there were numerous over the decades – were invariably struck by the stark frugality of Gandhi's homes, including the absence of paintings, decoration or artworks. But these Gandhian living spaces have nevertheless captured the imagination of India's artists, in particular, Satyagraha Ashram on the banks of the Sabarmati river about four miles from the centre (then) of Ahmedabad. Occasionally, it even becomes the intense focus of aesthetic attention, as in some beautiful sketches by Elizabeth Sass Brunner in the 1930s, or more recently, in Gigi Scaria's video installation *Sabarmati* (2008).[64] In another work, revealingly titled *Flyover* (2011), Scaria places the ashram in the shadow of a mammoth overpass,

emblematic of a neo-liberal India in love with monumentality, not to mention automobility (Figure 2.25). Yet, the serene beauty of the simple thatched structure that Gandhi called home for about thirteen years from 1917 shines luminously against the grey backdrop of an India that is literally flying over and past it.

But, of course, it was in his own person – his body – that Gandhi most consciously sought to reduce himself to 'zero' and to 'dust,' especially through diet and denial. As early as 1909 he insisted, 'Strength lies in the absence of fear, not in the quantity of flesh and muscle we may have on our bodies.'[65] The artist's challenge is to show strength in sparseness, turning to the force of the line and other formal techniques to do so. Thus, in M.F. Husain's numerous canvases, the skeletal dominates, as the artist, supremely conscious of the immense sacrifice that Gandhi's body underwent on behalf of the nation and its starving millions, draws our attention to this fundamental fact by using his own mastery of the line to sharply delineate its angles and joints.[66] Similarly, in what is arguably the most well-known of Gandhian works of art, Nandalal Bose's *Bapuji 12-4-1930*, 'Gandhi literally becomes a white line, striding forth across a seemingly unfathomable, infinite "yawning" space of black; his body, save for its grave outlines, merges with this space for struggle and redemption' (Figure 3.21).[67] In another pen-and-ink work, certainly completed before 1949 and possibly sparked by the artist's response to Gandhi's Noakhali peace march (see chapter 3), Bose depicted a wiry ascetic bathed in a halo of fiery power (*tejas*), human skulls strewn around his feet (Figure 2.21). As Gandhi's favoured artist, could Bose have been striving to visualize his muse's aspiration to achieve zero status and the fierce ordeals he undertook in this pursuit?

Another contemporary, and a grandnephew of the Mahatma no less, the artist Dhiren Gandhi produced

a series of six woodcuts in 1943 (see also Figure 1.12), two of which stand out for the starkness with which he depicts his grand-uncle's body, reduced to its skeletal frame, literally, as Gandhi 'sacrificed' himself for humanity even while attempting to reach zero on behalf of the self and nation (Figures 2.26 and 2.27). In the words of critic G. Venkatachalam, Dhiren's woodcuts offer 'a glimpse into the soul

Figure 2.21 - Nandalal Bose, Untitled, *c.* 1946. Pen and ink, reproduced as frontispiece, 14.5 x 8.4 cm. With permission of Rakesh Sahni, Gallery Rasa.

Figure 2.22 - Gulammohammed Sheikh, *Ahmedabad: The City Gandhi Left Behind*, 2015-2016. Casein and pigment on canvas, 202.2 x 353.6 cm. With permission of the artist.

of a *tyagi*, the martyr that is Gandhi. It is a moving record of the mortification of the flesh for a great cause and its ultimate triumph. He revealed to us the ascetic Gandhi, the man of prayer and fasts. The dark silhouette studies of an agonized soul, surrounded by sorrow-stricken followers inside a guarded prison camp, are soul-stirring in their appeal.'[68] The artist himself observed that his art was a visual response to Gandhi's twenty-one-day 'fast to capacity' – a rare one undertaken against the colonial state, for having impugned his non-violent motivations – while detained in the Aga Khan Palace in Poona in 1943. A witness to this 'epoch-making' event, Dhiren experienced the urge 'to capture with my pencil the magic and miracle of some of the aspects of Gandhiji's fiery ordeal. But, again and again I was overwhelmed by the immensity of the subject, which coupled with my state of wonder made my pen refuse to move.'[69] Nevertheless, the pen did move and produced some dramatic images. Thus,

Love: The Sustainer (Figure 2.27) draws the very moment when Gandhi – nothing but bones – ended his fast, visually amplifying contemporary reports:

> Mahatma Gandhi broke his fast at 9:34 a.m. IST (and 8.34 a.m. according to time maintained at Aga Khan Palace)... Besides the doctors only inmates of the detention camp were present...The earliest to arrive...was Dr B.C. Roy, and at 9 a.m., the Surgeon-General to the Government of Bombay, Maj. Gen R.H. Candy, Lt. Col. M.G. Bhandari and Lt. Col. B.Z. Shah drove in. The inmates...sang... "Vaishnava jana to" and two stanzas from...*Gitanjali*. "Lead Kindly Light" and the Koran were also recited. After prayers, those present observed a five minutes' silence. With folded hands, Mahatma Gandhi was seen to close his eyes and to be in meditation.

Figure 2.23 - Gulammohammed Sheikh, *Ahmedabad: The City Gandhi Left Behind* [detail], 2015-2016. Casein and pigment on canvas, 202.2 x 353.6 cm. With permission of the artist.

Prayers over, Kasturba…handed him a glass containing six ounces of orange juice. He is reported to have taken twenty minutes to sip the juice.[70]

Although at death's door, Gandhi reportedly had no desire to die; on the contrary, he was keen to demonstrate his capacity to offer penance (*tapasya*), as Dhiren sought to visually capture in his *Sacrifice for Humanity* (Figure 2.26).[71] In the work, the Mahatma is aesthetically assimilated into a long tradition of meditating monks and self-abnegating ascetics, as he sits in the *padmasana* or lotus pose, the ribs on his torso stark and visible, his frame skeletal but his gaze steadfast.

The 1943 fast was only the latest – some quite draconian with a pledge 'unto death' – that Gandhi periodically undertook from 1914 onwards for various reasons, many with obviously political intent. He did so publicly and sometimes for causes that were apparently obscure, such as the 'to death' fast that he went on in early March 1939 in Rajkot which has attracted the eye and brush of Atul Dodiya in several canvases (for example, Figure 2.28), repurposing photographs of this event by Kanu Gandhi.[72] Why, we might ask, would Dodiya invest so much artistic energy on this one fast, which was not even one of Gandhi's most controversial or remembered? I suggest he does so because this is one well-known occasion during which the Mahatma spoke of his penchant for fasting (which he frequently likened to a weapon, to prayer, even sacrifice), as an art form, even conferring upon himself the status of an 'artist' in a statement to the press. 'The weapon of fasting, I know, cannot be lightly wielded. It can easily savour of violence unless it is used by one skilled in the art. *I claim to be such an artist in this subject.*'[73] Gandhi indeed did make an 'art' of this particular form of self-purification and self-

Figure 2.24 - Ravikumar Kashi, *Artist Book: Everything He Touched* (cover page), 2011-2012. Conte, ink and photocopy transfer on Japanese raka stained Hanji paper, 36.83 x 30.48 cm. With permission of the artist.

V

सन्तो भूमिं तपसा धारयन्ति।

महाभारत।

SACRIFICE FOR HUMANITY
" *Service of His creation is the service of God.*"—GANDHIJI

Figure 2.25 (pgs 66-67) - Gigi Scaria, *Flyover*, 2011.
Inkjet print on Epson enhanced matte paper, variable
dimensions. With permission of the artist.

Figure 2.26 - Dhiren Gandhi, *Sacrifice for
Humanity*, 1943. Print from woodcut, 35.56 x
27.73 cm. Anil Relia collection, Ahmedabad.

VI

LOVE—THE SUSTAINER

" *I do not know why Providence has saved me on this occasion ; possibly it is because He has some more mission for me to fulfil.*"—GANDHIJI

Figure 2.27 - Dhiren Gandhi, *Love-The Sustainer*,
1943. Print from woodcut, 35.56 x 27.73 cm.
Anil Relia collection, Ahmedabad.

suffering, distracting us possibly from regarding it as a form of auto-violence, as literary critic Parama Roy observes in a critical analysis of the modern world's most famous 'hunger artist.'[74] The artist in turn is attracted by Gandhi's 'gastroaesthetics,' the style with which he performed abstinence, experimented with seemingly bizarre diets, and grew ever more emaciated with each punishing fast.[75]

Not surprisingly, a team of doctors weighed the Mahatma regularly, and reports of his weight loss (or occasional gain) punctuated nationalist discourse as indeed, his own correspondence with friends and followers.[76] This is where, once again, art appears to make us look again at the mundane and the everyday, and show it in a new light. Consider an enigmatic work completed in 1998 by Baroda-based artist Surendran Nair and titled *The Unbearable Lightness of Being* (Figure 2.29). Like other works I discuss

in these pages, this too repurposes a photograph from 1945 of Gandhi standing on a weighing scale in Bombay, having his body mass checked under the watchful eye of his doctors (and the photographer Kanu).[77] In Nair's canvas, note again the brown body clad in the short white dhoti, the gaunt limbs, the body punctured by salt crystals and sand recalling the famous March of 1930. By titling the work as he does, with a nod to Milan Kundera's existential novel, what is Nair trying to tell us about Gandhi's experiments in austerity and askesis? For whom are these 'unbearable'? For the Mahatma himself? For his followers who are compelled to watch these as they are conducted before their eyes? Or, is this all truly unbearable for the vast millions of India who, without aspiring to zero status, were indeed forced to lead bare lives, instead of performing bareness as Gandhi did so very artfully?

Figure 2.28 - Atul Dodiya, *Fasting in Rajkot* (From *The artist of Nonviolence Series*), 1998. Watercolour on paper, 114.3 x 177.8 cm. With permission of the artist.

Figure 2.29 (facing page) - Surendran Nair, *The Unbearable Lightness of Being, Corollary Mythologies*, 1998. Oil on canvas, 180 x 120 cm. With permission of the artist and Sakshi Gallery.

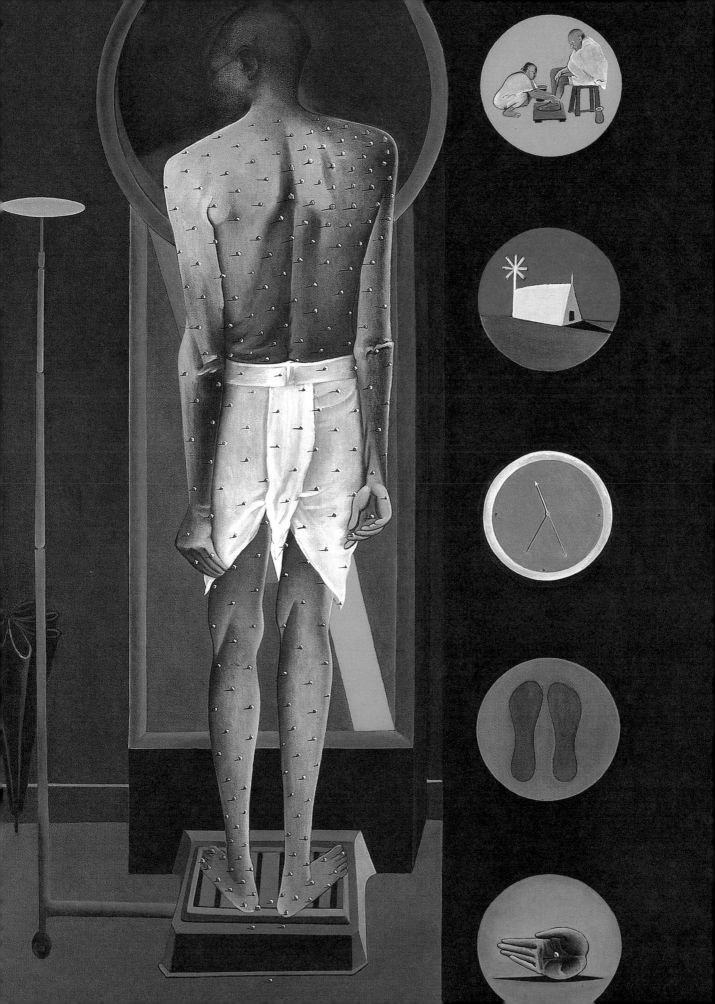

Figure 2.30 - *Shrimad Rajchandra Nijabhyas Mandap*, n.d.
Print published by M. Wadilal & Co., Amdavad. Reproduced in
Adhyātma Yugapurush Srimad Rajchandra. Image courtesy
Mani Bhavan Gandhi Sangrahalaya, Mumbai.

SKELETAL AESTHETICS

In his quest for reducing himself to zero, Gandhi had some illustrious predecessors in the ascetic traditions of India reaching back into the past and across its many religions and regions. In his own lifetime, he had the obvious example of Raychandbhai Mehta (1867–1901), or Rajchandra, a Gujarati jeweller-turned-spiritual master who was one of the 'three moderns' whom Gandhi specifically named as having left 'a deep impression' on him and 'captivated' him 'by his living contact.'[78] Scholars have noted Rajchandra's catalytic role in Gandhi's spiritual quest and yearnings, his dietary experiments, and his embrace of celibacy.[79] In popular hagiography, Rajchandra has emerged as the Mahatma's 'Mahatma.'[80] While serving a jail term in Yerwada in 1922, Gandhi started – but did not finish – assembling some reminiscences about this 'rare being.'[81] When Rajchandra died, Gandhi wrote to a friend, 'Rightly or wrongly, I was greatly attracted to him, and I loved him deeply too. All that is over now.'[82]

Hardly noted is the likelihood that Gandhi might well have followed in his mentor's footsteps in the sartorial transformations he progressively undertook to the point of stripping down to the bare minimum (Figure 2.30). Photographs of Rajchandra as a partly clad man in a short dhoti, the ribs on his torso stark and visible, find a visual echo in Gandhi's bare and spare loin-clad look from some years later. As a (reformed) Jain, Rajchandra had the potential example to emulate of the *digambara* ('sky-clad') monks of his faith who observe total nudity in private and public, drawing on theological principles to sustain their 'habit.' And yet Rajchandra did not embrace total public nudity, and neither did Gandhi (despite his yearning in this regard).[83] The Surrealist philosopher Georges Bataille has reminded us in another context, 'Stripping naked is the decisive action. Nakedness offers a contrast to self-possession, to discontinuous action.'[84] Gandhi stopped short of this 'decisive'

step, and in doing so, opened up a conceptual space between 'bareness' and 'nudity' that, I am arguing, allowed him to shuttle between ascetic withdrawal and worldly engagement.

There is also a long tradition in India of sculpting, drawing, and painting the human body that has subjected itself to mortifications of the flesh of which modern artists are surely aware, including Lord Shiva in numerous yogic manifestations, Vaishnava holy men, Jain tirthankaras, and the fasting Buddha (another religious figure whom Gandhi held in high esteem). In such images, the skeletal form of the ascetic is lovingly dwelt upon, with attention paid to the gaunt limbs, the hollow eyes, the concave midriff and the frame of the rib cage. Through the production and repeated circulation of such images, an aesthetic of the skeletal developed across the many artistic traditions and media of the subcontinent.[85] Modern and contemporary images of Gandhi's spare and bare body across different media draw upon such art works, and in turn contribute to the aesthetic of the skeletal that sustains them. Though Gandhi was not an aesthete per se, he put his own minimalist body on public display in ways that connected to the aesthetic of the skeletal in order to demonstrate his philosophy of minimalism and his critique of the excesses of industrial capitalism and the regimes of consumerism that it spawned. This was especially so when he was photographed fasting, his entire appearance (seemingly) serene and composed, his resolve written into the very form of the displayed body.

But it was not just Indian and Indic traditions of asceticism alone that appealed to Gandhi. Indeed, the skeletal body he most likely admired was none other than that of Jesus Christ, the Mahatma's paradigmatic satyagrahi, whom he variously described as 'the prince of passive resisters,' and 'a supreme artist.'[86] On his return in late 1931 to India from England, where he had showed off his 'half-naked' body to such effect for

the first time in Western Europe, Gandhi stopped in Rome on 12 December with an explicit desire to meet the Pope (and Mussolini). Although unsuccessful in securing an audience with Pius XI, he visited the Vatican art galleries (which were specially opened for him). 'Their art treasure greatly interested him. He spent two hours in St. Peter's. The Sistine Chapel held him rapt in awe and wonder. Tears sprang to his eye as he gazed at the figure of Christ. He could not tear himself away.'[87] In a letter to his devoted disciple Prema Kantak a few weeks later, Gandhi wrote that he enjoyed seeing the art on offer, 'but what opinion can I give after a visit of two hours? What is my competence to judge? And what is my experience in these matters? I liked some of the pictures very much indeed. If I could spend two or three months there, I would go and see the paintings and sculptures every day and study them attentively. I saw the sculpture of Jesus on the Cross. I have already written and told you that it was this that attracted me most.'[88] Speaking again five years later to a gathering of the Gujarati Literary Society in Ahmedabad, he reminisced, 'I saw in the Vatican art collection a statue of Christ on the Cross which simply captured me and kept me spellbound. I saw it five years ago but it is still before me. There was no one there to explain its charm to me.'[89] Mirabehn recalled the same encounter between Gandhi and the crucified figure of Christ, in a manner

that offers a rare glimpse of the Mahatma's reaction to an image:

> In the Vatican, Bapu's eyes fell on a very striking life size crucifix. He immediately went up to it and stood there in deep contemplation. Then he moved a little this way, and that way, so as to see it from various angles, and finally went around behind it and the wall, where there was hardly room to go, and looked up at it from the back. He remained perfectly silent, and it was only when he left that he spoke, and then as if still in contemplation – "That was a very wonderful crucifix" – and again silence. So deep an impression did that scene make on me that it stands out all alone in my mind, and I remember nothing else of the visit to the Vatican.[90]

In the absence of photographs of the moment, it is impossible to tell which figure of Christ or sculpture of his crucifixion 'spoke out' to the Mahatma, filled him with joy, held him spellbound, and reduced him to tears. Nevertheless, such images would have been undoubtedly similar to any number across Christendom of the skeletal form of a dying Christ, the bloody wounds on his body visible for all to see and contemplate.[91]

Figure 2.31 - Chittaprosad, *Halisahar, Chittagong, 1 August 1944*. Brush and ink on paper, 24.6 x 35.6 cm. Private collection (With permission of DAG, New Delhi).

THE SCANDAL OF THE SKELETAL

In colonial India, of course, one did not have to go to a museum or a gallery to see skeletal bodies on display, malnourishment being the state of being for a vast majority of the populace, not least as a consequence of colonial policies, as Gandhi repeatedly emphasized. In fact, a critical reason for decolonizing his body and reducing himself to zero is because he sought to mirror the poverty of the Indian peasant in his own (bourgeois) self, giving it a potent visibility that the poor themselves were unable to command.[92] This is the ethical dimension to the art of baring undertaken by the Mahatma. At the same time, bare life was not antithetical to creativity as in his astonishing challenge to his listeners at the opening of the Khadi and Village Industries Exhibition in Lucknow in April 1936 as reported later in *Harijan*: 'Do you know Orissa and its skeletons? Well, from that hunger-stricken impoverished land of skeletons have come men who have wrought miracles in bone and horn and silver... See how the soul of man even in an impoverished body can breathe life into lifeless horn and metal.'[93]

All the same, Gandhi's attempts to aestheticize the bare and spare look and the work of artists who then circulate such images, run the risk of appearing as travesty when one considers the millions of skeletal bodies for whom such a look was not a matter of choice, taste, or aesthetics, but a result of want and deprivation. In fact, amongst the most notorious images to emerge out of British India and circulate especially in the West were photographs (but also sketches and illustrations) of the victims (human and animal) of the numerous horrendous famines that ravaged the subcontinent under colonial rule. Such famished and ravaged bodies also came to the visual attention of Zainul Abedin, Gopal Ghose and others, including Chittaprosad Bhattacharya (1915–78) (Figure 2.31). Based on travels and reporting, which resulted in a powerful illustrated pamphlet titled *Hungry Bengal* (1943), Chittaprosad drew attention to 'bodies that yesterday fought for our freedom and today are being literally eaten by dogs and vultures,' and asked, 'Is this the tribute a nation pays to its fighters?'[94]

It is important to underscore the role played by such art as 'testimony' and the artist as 'activist.'[95] Nonetheless, there is also something *not quite* right, even scandalous, when the skeletal comes to be so aestheticized. The Mahatma's bare and spare look is quite complicit in this scandal. This chapter also risks partaking of this scandal. Nevertheless, I have persisted in exploring the art and aesthetics of baring as it manifests itself in the image work around Gandhi because it forces us to attend to the ethics of the visual display of the male body (albeit the exceptional body of the father of the nation). Scholars of Indian visual culture, at the forefront of discussing the politics of the female body as it becomes the subject of art and the gaze, have been unusually reticent in this regard. 'The curious timidity when it comes to male images' in the study of South Asian visual culture that art historian Vidya Dehejia noted more than two decades ago, continues to prevail.[96] And yet as I hope this chapter has demonstrated, there is much to learn when we explore how Gandhi became – and remains – the subject of (desirous) looking, even as his sparsely clad body is offered up in numerous media as a vehicle for public meanings, including the power and peril that follows from going naked but not quite.

'Non-violent' activist and a practitioner of an ethical politics of the soul though he might have been, Gandhi considered his material body as a mighty weapon to wield against the juggernaut that was industrial capitalism, for, as he revealingly observed in 1918, 'The point of it all is that you can serve the country *only* with this body (*deha*).'[97] To strip away the mystique that had developed around capitalism especially in its collusion with empire, he subjected his body-as-weapon to various measures of stripping away/down, which included practices of austerity, deprivation and freedom from want, but also critically for my argument, of undress *but not completely*. Despite the widely circulating characterizations of him, especially in the West, Gandhi was not really a 'naked' Mahatma, but one who went through a process of baring himself, progressively making more and more of his body's surface visible, and yet not completing the path to total public nudity. That he did so under the full gaze of the national – and increasingly, the global – media is what makes this particular act of (male) baring so spectacular. That he put such a body to test by taking repeatedly to the dusty roads of British India and through its desolate villages is what I next consider as I explore the art that has emerged around a bare and spare Mahatma on the move.

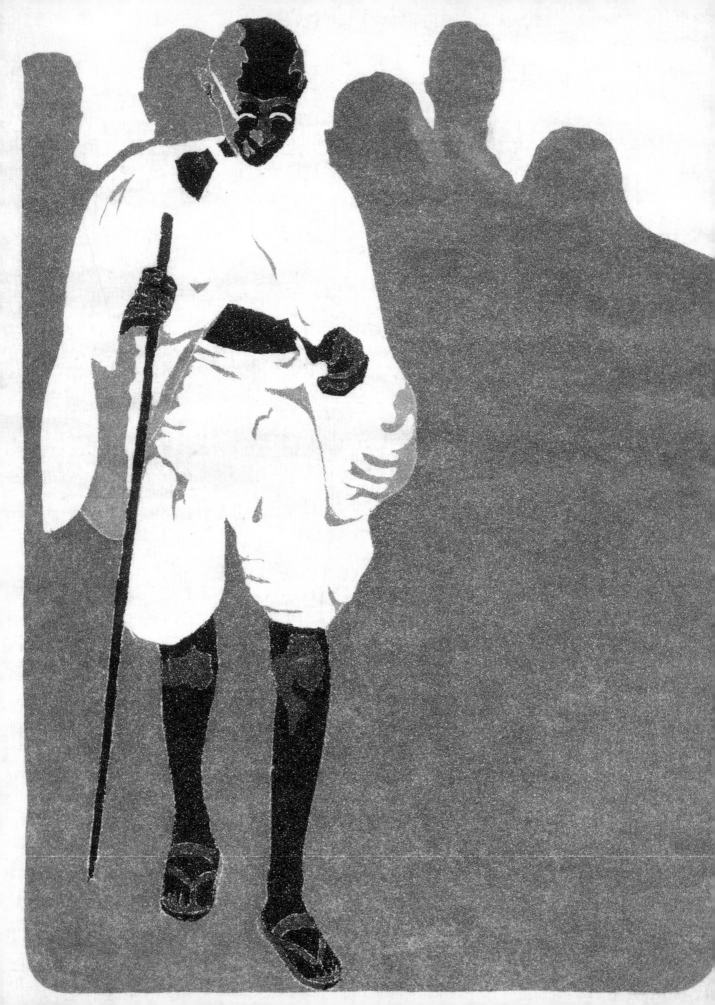

3
ARTFUL WALKING

'The power of the nonviolent march is a mystery. It is always
surprising that a few hundred [oppressed] marching can
produce such a reaction across the nation.'[1]
- *Adapted from Martin Luther King, Jr.*

Pedestrian Politics

In 1969, on the occasion of the Gandhi centenary celebrations in the nation's capital, a magnificent mural by A. Ramachandran (b. 1934) was unveiled in a new museum space called Gandhi Darshan (Figure 3.2). Titled *Gandhi and the 20th-Century Cult of Violence*, the mural – likened in contemporary media accounts to Pablo Picasso's famed *Guernica* (1937) – is a dramatic oil painted on wooden panels crowded with varied and complex imagery: a headless soldier spiking a bloody embryo suspended in the sky; an ominous war machine bristling with murderous weapons and painted with the faces of murderous men (like Hitler); a blue-robed Pieta clasping in her bone-thin arms a wretched skeletal figure; and a veiled woman holding a skull.[2] Amidst these scenarios of violence and death, indeed placed almost dead centre of the mural, is a single human leg, pink flesh and white bone, in a posture of striding. The mural's title confirms the identity of the figure to whom that leg belongs. The artist himself reconfirmed this some years later when he wrote, 'I painted Gandhiji without his head in his typical Dandi March stride as if he was stepping out of the mural.'[3]

While this complex painting is open to multiple interpretations, a single question emerges from it which anchors this chapter. How has the art world imagined the Mahatma's imagination of walking as a disobedient practice and as a counter to what he insisted was 'the organized violence' of the British government in India?[4] His body might have seemed fragile, but this did not stop Gandhi from a life of intense physical mobility, ranging as he did on foot across the various lands he inhabited, performing what I am calling artful walking.[5] Artists in turn emerge as critical collaborators in this Gandhian project, their aesthetic preoccupations with line and form extending the aura of art to the Mahatma's ambulatory activities (Figure 3.3). Although he frequently took trains, buses, cars and ships to get his message out and his work done (and has been photographed and painted doing so), walking remained Gandhi's favoured mode of transportation. A 2019 seminar, 'Gandhi and Health@150,' even proudly noted that between 1913 and 1948, the Mahatma walked some 79,000 kilometres, calculated as equivalent to walking around the Earth twice. In commemoration, New Delhi-based Arpana Caur painted Gandhi striding across a graph of his ECG reportedly taken on 28 October 1937 (Figure 3.5). A daily regimen of walking, sometimes solitarily, at other times with his followers or with family, was indeed critical to the production of Gandhi's disobedient body, enabling a lifetime of 'fitness and frugality' (Figures 3.4 and 3.6; see also Figure 1.7).[6] As he observed in 1909 in *Hind Swaraj*, 'God set a limit to man's locomotive ambitions in the construction of his body.'[7] Years later, in the course of a momentous march that made him globally famous, he insisted, 'The rule is, do not ride if you can walk,' and described walking as 'justly …the prince of exercises.'[8]

Such statements and sentiments also propel the artist's predilection for a striding Mahatma, clad in his trademark dhoti, staff in hand, a watch dangling from the waistband, his bare feet thrust into a pair of simple sandals. This is especially the case with public statuary both in India and across the world (Figure 3.8; see also Figure 3.28). Thus, the Polish sculptor Fredda Brilliant (1903–99), whose 1969 statue of a meditating Mahatma adorns London's Tavistock Square, described a maquette that she produced around 1951: 'In the walking figure, Gandhi, with long strides, was hurrying to get to the end of British rule. Neither foot rested completely on the ground. As

Figure 3.1 (pg 76) - A. Ramachandran,
Dandi March Stamp, 1980. Original etching,
38.1 x 27.94 cm. With permission of the artist.

Figure 3.2 (facing page) - A. Ramachandran,
Gandhi and the 20th-Century Cult of Violence,
1969. Oil on wooden panels, 365.76 x 548.64 cm.
With permission of the artist.

one foot is on the heel, the other on the toes, a sort of transition of the country is suggested, from Raj rule to Self-rule! People admired the walking figure, which is very dramatic; it makes one want to participate in the walk for freedom!'[9] (Figure 3.7)

Walking for freedom was critical as well to Gandhi's disobedient critique of capitalist and industrial modernity, an emphatic declaration of autonomy from dependence on its infrastructure, and an insistent assertion that satyagraha was most definitely not passive, but instead a form of *active* resistance (Figure 3.3). Walking also offered him an opportunity to artfully display his body – however bare and spare – in motion and action. As the Jesuit ethicist and peace activist Simon Harak suggests, 'Walking is such a good means for non-violent ends because it shares so many of the characteristics of nonviolence – in its gradual approach to things, in its time for reflection, in its building of community, in its communion with the earth, and in making the walker available, even vulnerable, to others on the road to peace.'[10] Gandhi couldn't have agreed more, as he honed this particular somatic activity into his own brand of pedestrian politics (which was anything but pedestrian), perhaps most vividly on display during the so-called Harijan 'walking pilgrimage' in 1934 in Orissa.[11] As he wrote, in a typical Gandhian vein, to G.D. Birla in the course of this particular pilgrimage, 'Every day makes me stake all on this walk.'[12]

Undertaken for about a month from 8 May (with a brief interruption when he perforce had to take the train to a Congress meeting in Patna), Gandhi was quite

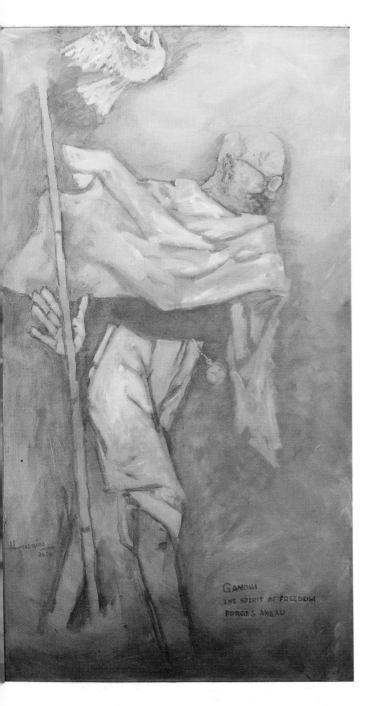

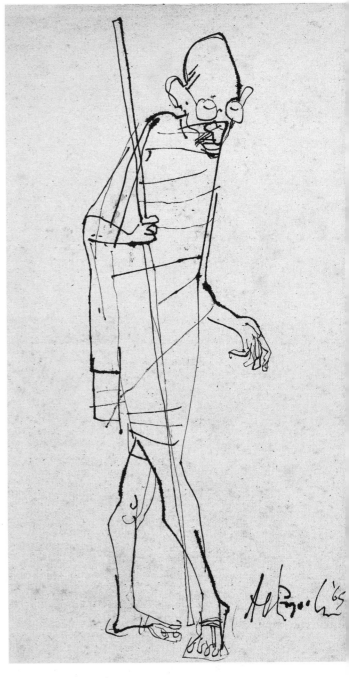

Figure 3.3 - Maqbool Fida Husain, *Gandhi: The Spirit of Freedom Forges Ahead*, 2000. Oil on canvas, 149.86 x 91.44 cm. Photo courtesy William J. Clinton Presidential Library, National Archives and Records Administration.

Figure 3.4 - K.M. Adimoolam, *Walk Towards Navkali*, 1969. Pen and ink on paper, 40.64 x 32 cm. With permission of K.M. Adimoolam Foundation.

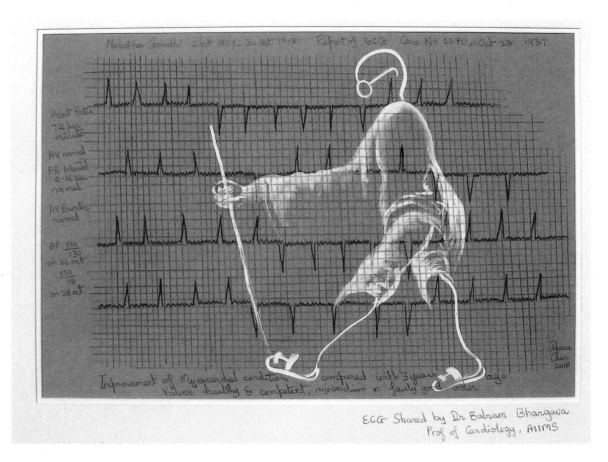

Figure 3.5 - Arpana Caur, *Gandhi and Health*, 2019. Pencil and Gouche on Pastel Paper, 31.75 x 41.91 cm. With permission of the artist.

clearly in a state of ecstasy in the course of walking about 156 miles across the Orissan countryside, even though confronted daily by the darkness of untouchability and violence directed towards Harijans. On the eve of setting out, he issued a press statement in which he declared, 'The idea is growing on me that I should finish the balance of the Harijan tour by walking as far as it may be possible... It is likely that if my message comes from the heart, it will travel faster on foot than by rail or motor.'[13] A week later, he observed, 'A tour on foot is an old aspiration of mine. I would even like to give up completely travelling by rail or car. That time has not come yet, but my mind is working in that direction. I, therefore, have often declared that

I regard railway trains, cars, etc. only as a necessary evil. I have never taken pleasure in travelling by them. *Dharma does not use even a bullock cart (bailgaadi).*'[14]

On this occasion as in similar others, he referred to his ambulatory exercise as a 'sacred pilgrimage' and his fellow walkers as 'pilgrims.' Walking indeed was a sacred activity (dharma), and especially so when it had a stated political-ethical goal, prayers and other rituals punctuating the practice. The Harijan walking pilgrimage also elicited one of the most eloquent of statements from the Mahatma on why walking was such a powerful weapon against the 'shock' of industrial modernity. In an article published in *Harijan* on 20 July 1934, Gandhi quoted at length from a letter he

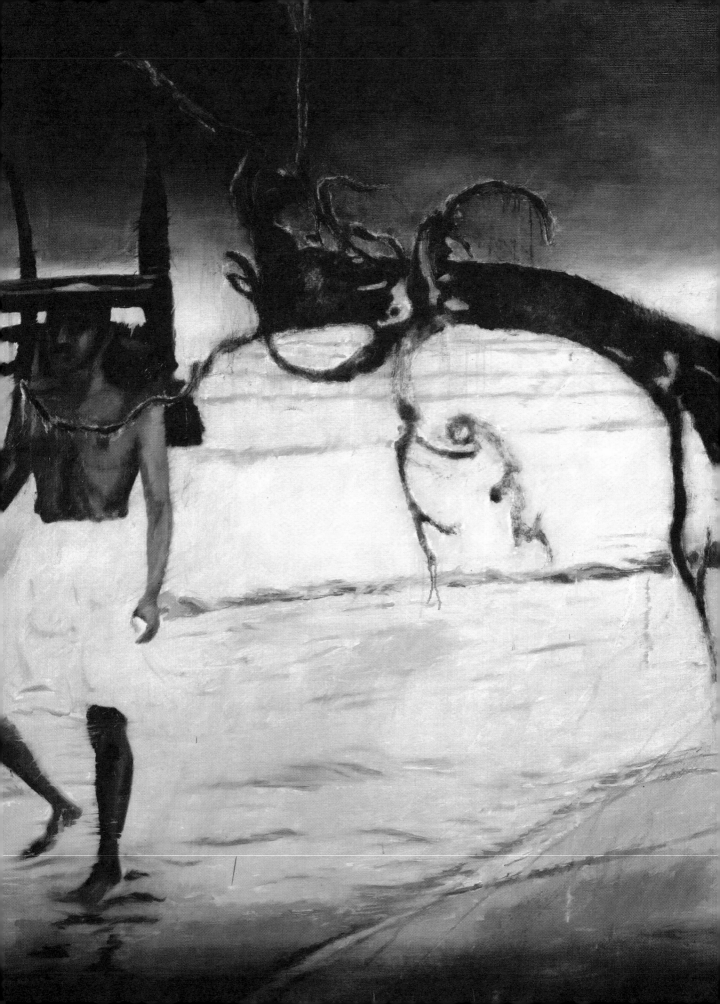

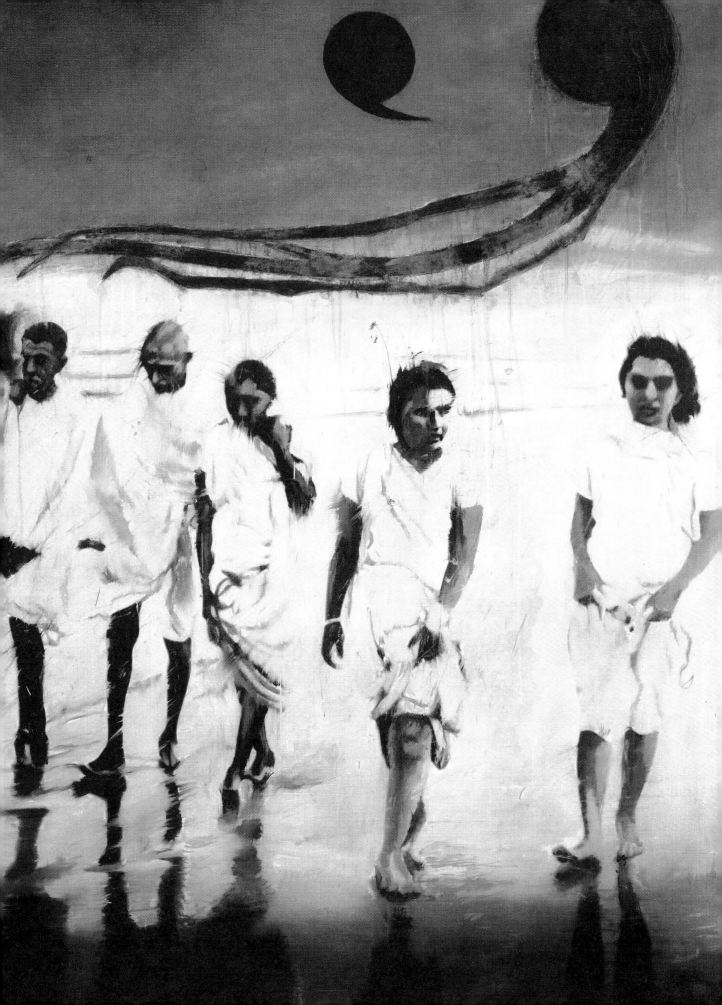

had received from an admirer, clearly overjoyed with the Mahatma's ambulatory performance:

> Your pilgrimage makes my heart sing. It is a *yajna* (sacrifice) worthy of those for whom you perform it. Forgive my presumption! But I feel all aglow when I think of it. Somehow your rushing about in a motor-car in the cause of Harijans seemed to be queer, incongruous. I see this as a wholly spiritual problem, and that you should approach it *on foot*, as a true pilgrim, satisfies me through and through like perfect music, or a magnificent sunset. So, I feel, should *Daridranarayana* (the starving millions) be approached. Forgive me, my words are an involuntary exclamation of a musician, in ecstasy over a *tambura* flawlessly in tune. People say, "But how many villages can he cover on foot?" My heart says, "Yes, but how many *souls* he will touch!" Surely, souls matter more than villages and one pilgrim is worth a thousand propagandists.

The overjoyed admirer is then held up by Gandhi as exemplary for his readers:

> How I wish other fellow-workers realize the beauty and the necessity of pilgrimages on foot for Harijan work. People's hearts cannot be touched by a mad rush through space. They can be by quiet, personal, intimate contact with them. Rushing in motor cars and railway trains dazes one and makes one powerless for clear thinking for the time being. But hardly has he recovered from the shock when he has to prepare to receive another. And so there is no chance of recovery, either for the occupant or for his victims.[15]

Ironically, for someone who was so invested in not rushing about and instead taking it slow so as to 'touch people's hearts,' Gandhi was also severe about those very people's penchant for touching him, as he was about those who pressed upon him to get his darshan. He complained, quite petulantly, that 'the mania for touching my feet is a source of danger to my body. Hardly a day passes when I do not get light scratches from the nails of merit seekers.'[16] The Mahatma might have insisted that 'the habit of touching my feet should be discountenanced,' but such repeated insistence betrays the fact that they were obviously falling on deaf ears.[17] Gandhian-style pedestrian politics, it seems, had its share of perils, not least the fact that the very people for whose benefit it was conducted are perceived by its practitioner(s), as 'a source of danger.'

Figure 3.7 (left) - Fredda Brilliant, *Model of Gandhiji Walking, c.* 1951/1960s. Bronze, 10 x 19 x 29 cm. With permission of NGMA, New Delhi.

A Mahatma on the March

In addition to daily walks and periodic walking tours, Gandhi spearheaded several spectacular marches, beginning his activist career as a mobile Mahatma in November 1913 in South Africa when, likely inspired by suffragettes who he saw on London's streets in 1906 and 1909, he launched a march 'in the name of God' to draw attention to the plight of indentured Indians facing discriminatory legislation.[18] On this occasion, which has yet to catch the sustained attention of Indian artists, he reportedly led a ragtag collective of over 2000 whom he referred to as his Army of Peace, intending to march around 200 miles from Natal across the border into the Transvaal.[19] They were enjoined 'to treat the sky as the roof over their heads and earth for their bed' and to be content on their march 'with whatever is given, in as much quantity as permissible.'[20] Although the march ended rather inconclusively, this was the first occasion in the Gandhian world when walking as an everyday habit prepared the ground for marching as spectacular disobedience.

Over thirty years later, Gandhi ended his mobile career with his poignant walks for peace as 'a lone pilgrim' in riot-ravaged Noakhali and Tipperah in rural eastern Bengal in the winter of 1946/47 on the eve of British India's blood-soaked Partition. He was just past seventy-seven and quite frail. Nonetheless, about six weeks after relocating to the village of Srirampur where he ventured out every day on foot to commune with rioting Hindus and Muslims, refusing to be dissuaded by frequent hostility and abuse, he set out on 2 January 1947 for a two-month march from village to village and hut to hut, traversing a total of around 116 miles.[21] He let it be known that he wanted none but God to be his walking companion. In the end, he was accompanied by a handful of chosen followers, a squad of policemen, a few journalists, and some photographers.[22] Also in a notable raising of stakes, he walked the entirety on bare feet, for reportedly, 'The earth of Noakhali was like velvet and the green grass was a magnificent carpet to walk on. It reminded him of the soft English grass he had noticed in England.'[23]

In the words of the American journalist Phillips Talbot who travelled from New Delhi over five days by air, rail, steamer, bicycle and on foot in order to walk with the Mahatma and sit at his feet, 'The Gandhi march is an astonishing sight. With a staff in one hand and the other on his granddaughter's [sic] shoulder, the old man briskly takes the lead as the sun breaks over the horizon. He usually wraps himself in a handwoven shawl... but he walks barefooted despite chilblains. This is a fashion he started in order to relieve a blister, but continued because he liked the idea of walking as Indian pilgrims normally travel... Here, if I ever saw one, is a pilgrimage. Here is the Indian – and the world's [sic] – idea of sainthood: a little old man who has renounced personal possessions, walking with bare feet on the cold earth in search of a great human ideal.'[24]

Although the march itself had limited immediate impact, Gandhi's Noakhali feat has caught the eye of numerous artists of his time and since, with moving works, among others, by Nandalal Bose, K.M. Adimoolam, Jogen Chowdhury, Jatin Das, Kamal Roy, Antonio Piedade da Cruz and Atul Dodiya, many drawing upon iconic photographs of the lone Mahatma, staff in hand, walking on bare feet with a preoccupied air (Figure 3.9; see also Figure 3.4). Such works also visually resonate with Rabindranath Tagore's words from a song that was a favourite of the Mahatma's, '*Jodi tor dak shune keu na ase tobe, ekla chalo re,*' 'If no one responds to your call, go your own way alone.'[25]

Sandwiched between Transvaal and Noakhali is the ambulatory performance that Gandhi is most known for – the Dandi Salt Satyagraha (Figure 3.10).[26] At precisely 6.30 a.m. on 12 March 1930, the sixty-one-year-old Mahatma set out from Sabarmati Ashram, punctual as always, accompanied by seventy-eight chosen followers – all hand-picked people – on the

Figure 3.8 (facing page, above) - Devi Prasad Roy Chowdhury, Gandhi on his way to Dandi, 1959. Bronze, Marina Beach Road, Chennai. Author's photograph.

Figure 3.6 (pgs 82-83) - Atul Dodiya, *Evening Walk on Juhu Beach*, 2017. Oil on canvas, 137.16 x 198.12 cm. With permission of the artist.

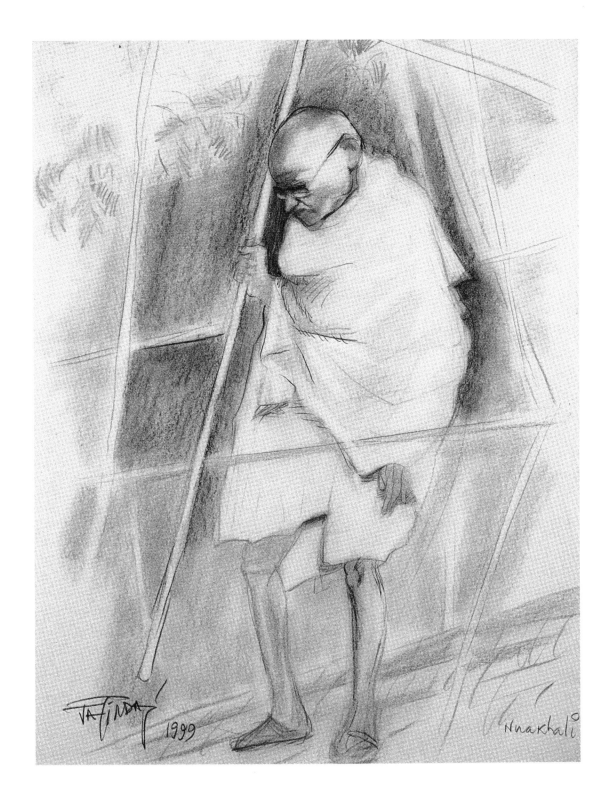

Figure 3.9 - Jatin Das, *Noakhali*, 1999, Study for the Mural
at Parliament Annexe, *Journey of India: Mohenjodaro to
Mahatma Gandhi* (2001). Conté on paper, 75.0 x 55.4 cm.
With permission of the artist.

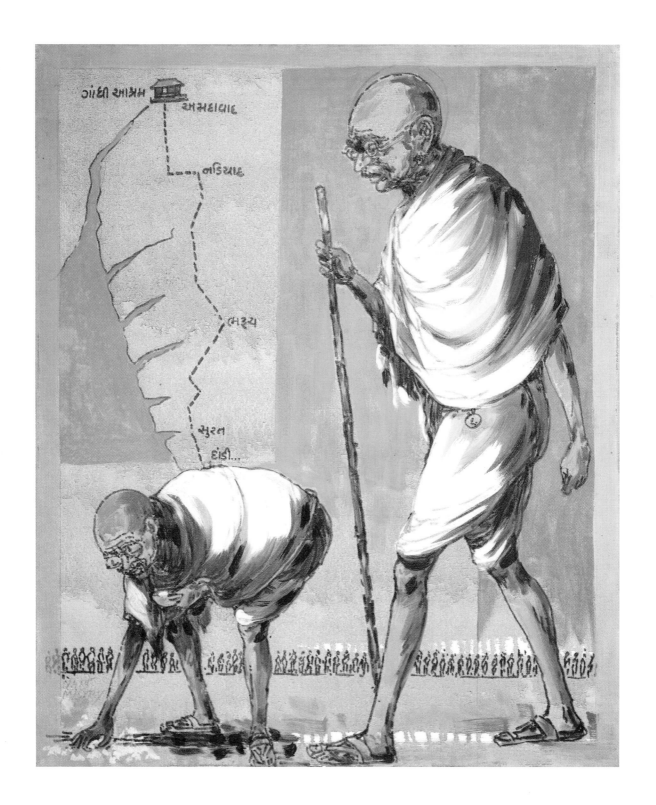

Figure 3.10 - Natu Mistry, *Gandhi-Dandi Satyagraha*,
2005. Oil on canvas, 60.96 x 50.8 cm.
Anil Relia collection, Ahmedabad.

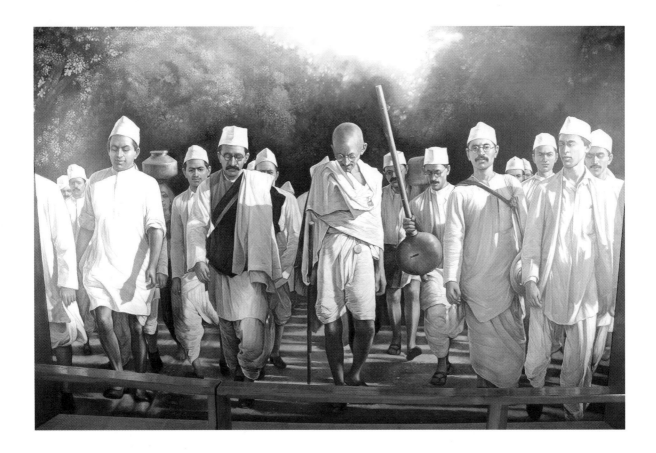

241-mile march to the seaside hamlet called Dandi.[27] A much-reproduced photograph, attributed to Balwant Bhatt, shows him in the company of fellow marchers, some walking alongside and others trailing behind. The photograph captures the Mahatma mid-stride, staff in hand, face down, a light shawl wrapped around his bony body. He is wearing simple sandals, and his waist-watch is clearly visible, as are two shoulder bags.[28] This iconic photograph has been subsequently repurposed many times in oil paintings, watercolours and prints, not least Bansi Khatri's canvas, on whose surface are inscribed words reportedly uttered by Gandhi in Bhatgam on 29 March 1930, 'I will die the death of a crow; I will die the death of a dog. But without swaraj, I will not set foot in the ashram' (Figure 2.7).[29] Gandhi never did reside again in Sabarmati Ashram, but today of course, it is a major centre for memory-making, relying on historic photographs and modern artworks. The latter include oil paintings and dioramas based on

Bhatt's iconic photograph, but without the indexical limitations imposed by the camera (Figure 3.11). Interestingly, another iteration of the work in Figure 3.11 – also photographed by Doranne Jacobson, but two decades earlier, in 1991 – showed Gandhi in the company of men who did *not* march the entire route with the Mahatma, but who became important for the life of the nation subsequently as leaders of the ruling Congress Party, such as Sardar Patel, Khan Abdul Ghaffar Khan, Babu Rajendra Prasad and Jawaharlal Nehru (Figure 3.12).[30]

In the historical scholarship, the Salt March is invariably analysed as a classic Gandhian-style satyagraha, the highlight of Gandhi's career as a non-violent activist and nationalist at the core of whose practice was disobedient walking. Consider biographer D.G. Tendulkar's capacious description of the power of the Mahatma on the march with his band of faithful followers:

Figure 3.11 - Satyagraha: Dandi March—Pledge for Independence, 12.3.1930, photograph by Doranne Jacobson of oil painting in Gandhi Ashram at Sabarmati, 2016. With permission of Doranne Jacobson.

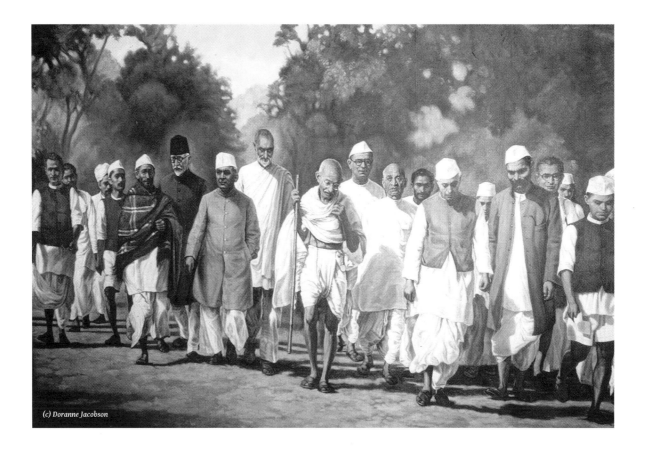

(c) Doranne Jacobson

Gandhiji's energy at the age of sixty-one was amazing. Every day he walked ten miles or more and addressed meetings. The ashram routine of prayer, spinning, and writing up the daily diary was incumbent on every marcher. "Ours is a sacred pilgrimage," he said, "and we should be able to account for every minute of our time." He retired at nine still talking to people and giving interviews until he fell asleep. Long before his comrades were up, he awoke and began correspondence. At four in the morning he was seen writing letters by the moonlight as the little lamp had gone out for want of oil and he would not wake up anybody. At six, there was the call to morning prayers. After the prayer he delivered a sermon to the pilgrims on the march, and answered questions. The march commenced every day at 6.30 a.m.[31]

This routine was more or less followed over three weeks, with Mondays declared as rest days, when Gandhi discovered that his fellow marchers were tiring. On 5 April, on reaching the seashore and on the eve of breaking the colonial moratorium on Indians making salt, he issued the much-quoted pronouncement, 'I want world sympathy in this battle of Right against Might,' words which also subsequently captured the artist's attention (for example, Figure 3.13. See also Figure 3.22).[32]

Statements like these – uttered by a puny little man whose following of a handful swelled into the thousands as the days advanced, including women and children – also helped secure the Mahatma's global reputation as a peace pilgrim. This reputation was produced and consolidated through the extensive

Figure 3.12 - Gandhi leading Salt March, photograph by Doranne Jacobson of painting in Gandhi Ashram at Sabarmati, 1991. With permission of Doranne Jacobson.

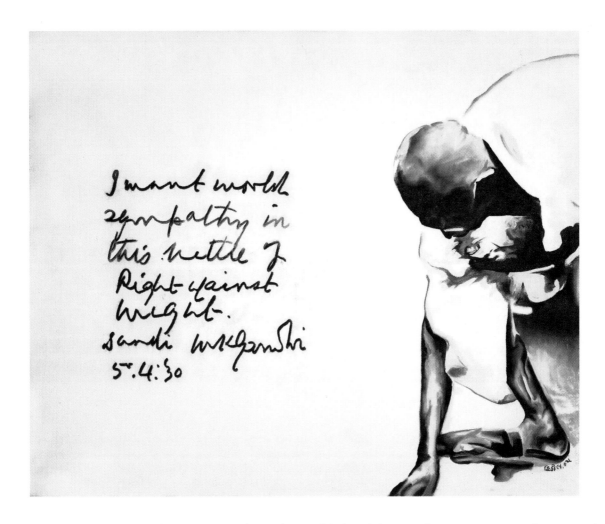

media coverage that the Mahatma consciously sought for the march and received, across the print media, in film, and in photographs, both nationally and internationally (although not for want of trying on the part of the colonial state, which censored the news about the Mahatma's seemingly quixotic act).[33] In particular, the march was 'a watershed' moment for the US media, which began to consciously heed Gandhi, who in turn assiduously courted American reporters.[34] Thus, *Time* magazine featured him on its cover two times in 1930–31, even as 'Man of the Year,' one of the images repurposing a Walter Bosshard photograph (Figure 1.11). Yet another measure of Gandhi's new

global visibility was his appearance on the cover of the *Münchner Illustrierte Presse* on 18 May 1930, with detailed coverage, complete with intimate portraits of him eating, conversing, spinning, shaving and sleeping, based on Walter Bosshard's photographs.[35]

Bosshard's memorable image of Gandhi, totally absorbed in reading a newspaper (taken the day after he broke the salt laws), has also been repurposed in a striking new work by Atul Dodiya in which it is paired with an iconic 1928 painting by the French Surrealist René Magritte titled *False Mirror* (Figure 3.14). What is Dodiya seeking to convey with this intriguing pairing? Magritte's work with its focus on

Figure 3.13 - Hindol Brahmbhatt, 'I want world sympathy in this battle of right against might. Dandi M.K. Gandhi, 5.4.30,' 2005. Acrylic on canvas, 50.8 x 60.96 cm. Anil Relia Collection, Ahmedabad.

'an enormous lashless eye with a luminous cloud-swept blue sky filling the iris and an opaque dead-black disc for a pupil,' has been interpreted as a commentary on modernity's ocularcentrism: what is not seen never happened, such is the hold of visual empiricism since the birth of the modern.[36] Dodiya's repainting of Bosshard's Gandhi as he reads a newspaper, his right hand hanging loosely rather than supporting his face as in the Swiss photographer's image, reminds us of the Mahatma's careful daily monitoring of the news cycle over the course of the march, and underscores the fact that his most spectacular ambulatory performances were both very worldly and highly mediatized. Art critic and curator Gayatri Sinha interprets Dodiya's work as highlighting Gandhi's refusal to engage with the camera, and his growing displeasure with having become the object of darshan.[37] The composite work also highlights his continued reliance on a 'modern' accessory, which he never quite shed – his spectacles, in themselves an indelible part of his iconography and his look, a relic object in the aftermath of his passing, and a frequent focus of artworks (for example, Figures 3.42 and 4.30). Not least, Dodiya's work is a reminder that a life of ceaseless mobility was also punctuated by great moments of stillness spent reading, writing, praying and sleeping.

Figure 3.14 - Atul Dodiya, *Reading a Newspaper at Dandi, 1930*, 2019.
Left panel: oil on canvas, 91.44 x 91.44 cm; right panel: archival digital print on hahnemuehle rag paper, 91.44 x 66.4 cm. With permission of the artist.

A Pilgrim's Progress

And yet, in most artworks that take on the Salt Satyagraha for aesthetic contemplation, it is not his eyes nor his stillness that attract the artist's attention, but Gandhi's mobility and his legs. Over the years since 1930, numerous shows have been dedicated to the theme, including 'Freedom to March' (2011), 'Salt Prints' (2013), 'In Search of Gandhi' (2013) and most recently, 'Dandi Yatra' (2018–19) featuring the recently discovered drawings of Dalit artist Chhaganlal Jadav (1903–87), himself part of the advance team (Arun Tukdi, 'Sunrise Unit'), which cleared the ground for the others.[38]

Some of this work is celebratory in nature, but as is the wont of so much contemporary art, much is also offered as critique, drawing disobediently on this paradigmatic Gandhian moment of disobedience to lament the irrevocable loss in post-Gandhian India of the core values and ideals dear to the Mahatma. Thus, Brijesh Patel (b. 1972) recreated in his project 'Salt/ Land & People' (2010–14), the Mahatma's ambulatory performance by retracing his journey from ashram to seashore. Armed with his camera and over a period of two years from 2009, the British-Indian artist mimicked Gandhi's habit of walking in the early hours of the morning and the evening, but laments that the Mahatma's vision was nowhere to be seen in the place from where he shook the roots of a mighty global empire. A series of evocative images in *Salt (Artist's Book)* amplifies a statement by Gandhi, 'So be not lifted off your feet, do not be drawn away from the simplicity of your ancestors.'[39] In contrast, New York-based Joseph DeLappe drew upon Second Life (an online virtual world) in 2008 to re-enact the Dandi March as 'M Gandhi Chakrabarti,' the digital project also yielding two monumental statues of Gandhi cast in the familiar iteration of the Mahatma with staff in hand. We have come a long way indeed from the Mahatma's ambulatory performances using the power of his own sovereign limbs. [40]

Whether offered in a celebratory vein or the transgressive, much of this art is anchored in what I call *an aesthetic of the ambulatory* that has developed around the figure of the mobile Mahatma since the time of this paradigmatic march. Alongside a focus on the labour of walking, this aesthetic is preoccupied with Gandhi's rustic staff (lathi), his bony legs and sandal-clad feet, indeed the sandals themselves and even his footprint. The aesthetic develops, I argue, in response to the fact that despite his ambivalence towards modern art, Gandhi's ambulatory performances, including his march to Dandi, were themselves *art works in the making*. As with so many other Gandhian acts, there was much about the Dandi Satyagraha that was intuitive and instinctive, including the insight to break the colonial salt laws ('like a flash it came,' Gandhi reflected some years later).[41] And yet, there was also much that was highly choreographed and engineered, as worthy of a spectacle that aimed to destroy the mighty British Raj, an empire that did much to present itself as a work of art in which spectacle, theatricality and ceremony were essential to the drama of domination and subordination. Indeed, one of Gandhi's early biographers, Louis Fischer, recognized this clearly:

> Had Gandhi gone by train or automobile to make salt, the effect would have been considerable. But to walk for twenty-four days and rivet the attention of all India, to trek across a countryside saying, 'Watch, I am about to give a signal to the nation,' and then to pick up a pinch of salt in publicized defiance of the mighty government and thus become a criminal, that required *imagination, dignity, and the sense of showmanship of a great artist*.[42]

Figure 3.15 - Chittaprosad, *Dandi Chalo*, 1939. Watercolour
on paper, 52 x 46 cm. Collection of Vijay Kumar Aggarwal.

It is thus as an *artistic* act of great 'imagination' and 'showmanship' that I explore Gandhi's Dandi feat, his most spectacular ambulatory performance. To do so, I pivot from words and discourse to art and images that recognize the aesthetic charge of the Mahatma's pedestrian politics through their own aesthetic of the ambulatory.

In fact, the iconic image of the striding Mahatma as a mobile man on display everywhere around the world had its birth in 1930 around this moment and movement. Despite pleas by numerous others, including women, Gandhi stringently restricted the actual march to a chosen group of men. But over the weeks and especially after 6 April, thousands, including women, got caught up in illegally manufacturing and selling salt across British India, transforming a march of the few into a movement of many that finally forced

the colonial state to act. The energy of the many is beautifully captured by Chittaprosad who painted in 1939 his *Dandi Chalo* (Let's Go to Dandi), the very title anticipating another important call a few years later by fellow Bengali Subhas Chandra Bose, 'Chalo Dilli' (Let's Go to Delhi).[43] A bare-bodied, sandal-wearing and staff-carrying Gandhi leads the way purposefully, the multitude behind him stretching into the horizon (Figure 3.15). Closer to our time, public statuary, such as Adwaita Gadanayak's *Dandi March – Salt Satyagraha* (2005), erected on the grounds of the National Gandhi Museum in New Delhi, commemorates the multitude which made the Mahatma's movement possible, even including a female figure in the ensemble (Figure 3.16).[44] The National Salt Satyagraha Memorial, endorsed and funded by the Ministry of Culture, Government of India, similarly celebrates the collective

Figure 3.16 - Adwaita Gadanayak, *Dandi March-Salt Satyagraha*, 2005. Black Marble, on the grounds of National Gandhi Museum, New Delhi. Author's photograph.

The seeker after truth should be humbler than the dust. The world crushes the dust under its feet, but the seeker after truth should so humble himself that even the dust could crush him. Only then, and not till then, will he have a glimpse of truth.

DANDI - 0 km

SPEED BREAKER

Figure 3.17 - Atul Dodiya, *The Arrival* [open view], 2011. Enamel paint on metal roller shutters and acrylic and marble dust on canvas, 274.3 x 185.4 x 35.6 cm. With permission of the artist.

Figure 3.18 - Atul Dodiya, *The Route to Dandi*, 1998.
Watercolour, marble dust and charcoal on paper,
177.8 x 114.3 cm. With permission of the artist.

(2014–19)[45] as do the exhibits dedicated to the march in the Eternal Gandhi Museum in New Delhi. Over the course of the past three-quarters of a century, a number of paintings have also featured the faithful marchers who accompanied the Mahatma (for example, Figures 3.10 and 3.20).

Yet in other works produced in the aftermath of the historic march, Gandhi is a singular striding figure, the vast collective effort reduced to lone heroic achievement. The multitude drops out to enable the Mahatma to emerge in all his iconic singularity, or if the marchers are present, as in Natu Mistry's untitled work (Figure 3.10), or in A. Ramachandran's *Dandi March Stamp* (Figure 3.1), they are diminished by Gandhi's looming presence. Consider, for example, a luminous watercolour by Atul Dodiya titled *The Route to Dandi*, in which a sinewy pair of legs is drawn on

the map of the route walked by Gandhi and his fellow marchers. Observe that it is only one set of legs that straddles the map, the collective replaced by the singular (Figure 3.18). The lone walker, humbler than the dust under his feet, reaches Dandi in another of Dodiya's works from his much-discussed Shutter Series, *The Arrival*, none of his followers in sight as the artist finds a resonance for the Mahatma's striding figure in Swiss sculptor Alberto Giacometti's *Walking Man* (Figure 3.17). In Gigi Scaria's *In Search of Salt* (2010), the dhoti-clad Gandhi, staff in hand, strides determinedly forward, quite indifferent to the concrete structures that dwarf him, possibly intent on reminding Indians in neo-liberal India of the importance of seemingly humble acts like making salt. He is all alone, however, on his mighty search (Figure 3.19). Even the commemorative postal cover issued by

Figure 3.19 - Gigi Scaria, *In Search of Salt*, 2010. Acrylic on canvas, 121.92 x 121.92 cm, subsequently reproduced as digital print. With permission of the artist.

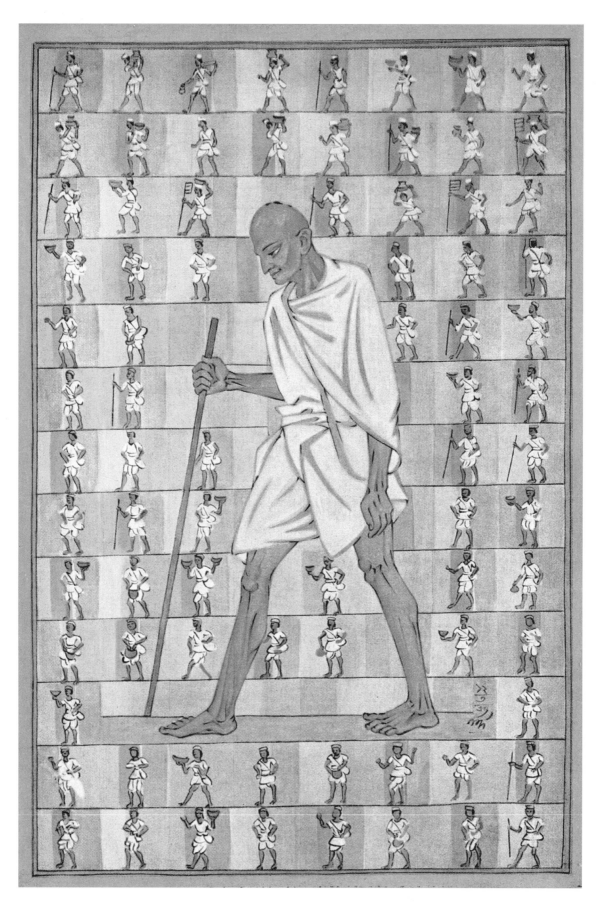

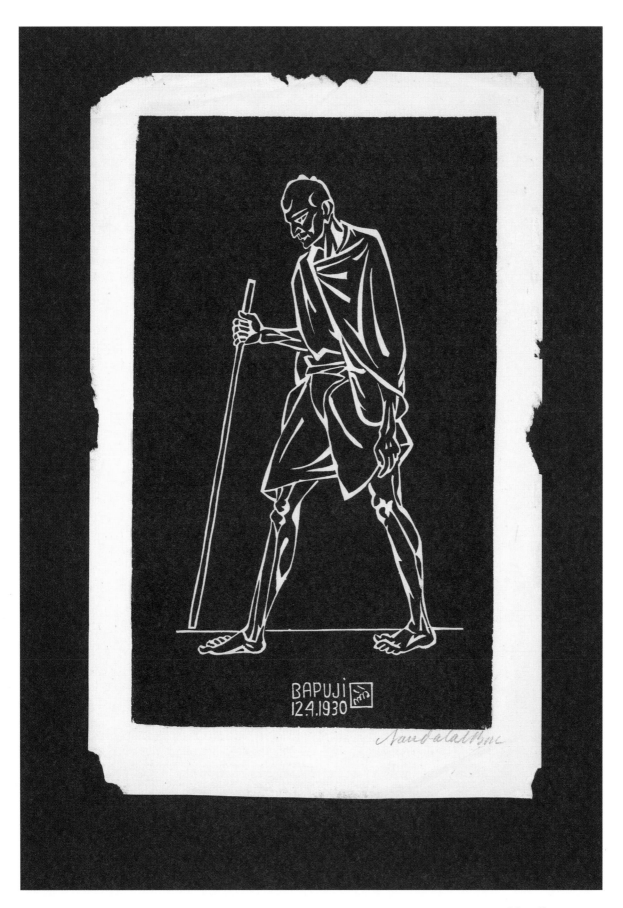

BAPUJI
12.4.1930

दांडी यात्रा DANDI MARCH

I want world
sympathy in
this battle of
Right against
Might.
Dandi MKGandhi
5°.4.'30

the Indian postal department in 1980 on the fiftieth anniversary of the march features only Gandhi's sandal-clad legs, not those of his fellow 'pilgrims' (Figure 3.22).

The pictorial transformation of the collective into the singular begins with two key works by Nandalal Bose, Gandhi's favoured artist, who I introduced in Chapter 1. On the very day of the start of the march, Bose painted a watercolour on paper, subsequently also reproduced, with some difference in detail, as tempera on teak wood (Figure 3.20).[46] He was clearly enchanted: 'What a miracle took place when, yearning for India's freedom, Gandhiji went on the Dandi march! The entire country was roused with confidence in some unique strength. Glory filled my heart. I felt blessed and life became meaningful.'[47]

The artist's enchanted state yields the Mahatma, wooden stick in hand, his legs bare and skeletal, striding across the work. He is placed in the company of fellow marchers, approximating the number

of Sabarmati Ashram residents hand-picked to accompany Gandhi.[48] Bose drew these figures clad in white as agile and mobile, each engaged in quotidian activities in a celebration of manual labour, another Gandhian preoccupation. The majority of the official marchers were in their late teens and twenties, the youngest of them a sixteen-year-old student. Gandhi's second son, the thirty-eight-year-old Manilal and one of his grandsons, the twenty-year-old Kanti, were also among the chosen. The Mahatma reportedly selected these men so that they might withstand the rigours of marching several miles a day across very difficult terrain at a time of the year when it was already hot and dusty. In spite of being carefully chosen, several fell ill and had to take periodic breaks, although the sixty-one-year-old Mahatma himself, despite considerable fatigue and sore feet, kept marching, outpacing his younger followers. As he noted on their arrival at Dandi on 5 April, 'The truth is that in this struggle we have to put with up suffering.'[49]

Figure 3.22 - Charanjit Lal, 'I want world sympathy in this battle of Right against Might. Dandi, MK Gandhi, 5.4.30'. First day cover issued by Indian Posts and Telegraphs Department on the 50th anniversary of Salt March.

HEROICALLY SINGULAR

Yet, what was clearly an event of collective suffering, striving and striding, was transformed into an act of singular heroism in Bose's famous linocut titled *Bapuji 12-4-1930* and produced exactly a month after his earlier work (Figure 3.21).[50] This single work is likely the most replicated image across various media of the mobile Mahatma on his feet, including in the illustrated pages of the Constitution of India.[51] It is dated precisely to 12 April 1930, six days after Gandhi proudly took on his new mantle of 'law-breaker' after making salt on Dandi's seashore.[52] The linocut boldly casts the Mahatma as a white silhouette against a stark black background, his bare legs skeletal but wiry, 'an austere blend of economy and expressiveness.'[53] Although Gandhi wore sandals for much of the march, Bose's Bapuji walks on his bare feet, making direct bodily contact with the earth. This most iconic of Gandhian marches, like many others he undertook, was not a cakewalk. Only some segments of the planned route were paved. Along the way, as they halted for the night, the marchers stayed in makeshift bamboo huts or rested under shady trees, with straw mats as bedding. The path was grimy, and frequently, the marchers had to cover their faces and heads against the dust and the sun. Further, in true Gandhian style, the food consumed along the way was a bare minimum, as detailed by the Mahatma himself on the eve of setting out. [54] There was much that was indeed heroic about it, but it was the heroism of the multitude rather than of the singular individual. Yet, Nandalal Bose's linocut clears the artistic ground for the recasting of the Mahatma as the heroic lone marcher. Something about the 'mystery' of the non-violent march, as Martin Luther King Jr observed in another context (inspired by Gandhi's own paradigmatic ambulatory performance), emerges from the sheer power of numbers, of the multitude converging and swelling, of the righteous camaraderie of the collective. India's artists, however, tend to privilege the exceptional bare and spare dhoti-clad body of the mobile Mahatma and his pair of (bare) marching feet. In portraying him thus, they are complicit with Gandhi's repeated anxieties over 'the dumb millions' who thronged around him, who arguably made his movement possible, and yet, who he repeatedly sought to keep at bay.

In its original conception, there was little to suggest the media – and aesthetic – spectacle that the Salt March did become over time. Colonial officials underestimated the import of the Mahatma's ambulatory performance, Viceroy Irwin even dismissing it as 'his silly salt stunt.'[55] Nationalists like Nehru eventually came to recognize the potential of the Mahatma's pedestrian politics, capturing in the verbal domain what Nandalal attempted visually: 'Today the pilgrim marches onward on his long trek. Staff in hand he goes along the dusty roads of Gujarat, clear-eyed and firm of step, with his faithful band trudging along behind him. Many a journey he has undertaken in the past, many a weary road traversed. But longer than any that have gone before is this last journey of his, and many are the obstacles in his way. But the fire of great resolve is in him and the surpassing love of his miserable countrymen... And none that passes him can escape the spell.'[56]

One contemporary, ensnared by 'the spell' was Rupkishor Kapur (1893–1978), an artist who was generally drawn to patriots who resorted to anti-colonial violence, the very antithesis of Gandhi.[57] And yet he felt compelled to paint Gandhi in his *Rastra ke Sutradhar: Mahatma Gandhi (Dandi Camp Mein)* ('The Nation's Sutradhar: Mahatma Gandhi in the

Figure 3.20 (pg 98) - Nandalal Bose, *Dandi March, March 1930*, 1930. Tempera on Wood, 39.37 x 24.76 cm. Ex-collection Raja Praphullanath Tagore, As reproduced in *An Album of Nandalal Bose, with a Biographical Note* (Calcutta: Santiniketan Asramik Sangha), 1956. With permission of Supratik Bose.

Figure 3.21 (pg 99) - Nandalal Bose, *Bapuji 12-4-1930*, 1930. Linocut on paper, 35 x 22.3 cm. Art Institute of Chicago, Gift of Supratik Bose, 2009.743. Photo credit: The Art Institute of Chicago/Art Resource, NY.

राष्ट्र के सूत्र धार।

महात्मागांधी (डन्डी कंम्पमं)

BABU LAL BHARGAVA,
MANI RAM BAGYA,
Cawnpore.

Dandi Camp') (Figure 3.23). The chromolithograph presents the Mahatma – his bare, bony and brown chest exposed – in a contemplative mood, not walking nor spinning, but reading from a little book (possibly the *Gita*) from which he appears to be looking up momentarily.[58] There is nothing particularly remarkable about this print – indeed the figure of Gandhi (based on a well-known 1921 photograph) has not been rendered particularly successfully – but one of the words in its title (chosen either by the artist or the publisher) is quite revealing. In Sanskrit (and by extension in Hindi into which it passes as such), the term 'sutradhar' literally means 'treatise-bearer' or 'thread-holder,' the latter particularly apposite for a man who was so preoccupied with spinning, the former also a fitting description for a leader who was rewriting the script for the nation.[59] In its extended sense, the word also implies an architect, a director, a stage manager and a chief performer, indeed a puppet master. Thus, the sutradhar is a Master of Ceremonies.[60] In its very title, the print underscores the performative dimension of Gandhi's ambulatory act, reminding us that colonial subject though he may be, the Mahatma was calling the shots, spectacularly setting the stage for what unfolded.

Another contemporary image, also produced for

Figure 3.23 - Rupkishor Kapur, *Rastre ke Sutradhar: Mahatma Gandhi (Dandi Camp Mein)*, 193? Chromolithograph published by Babu Lal Bhargava, Kanpur. Priya Paul Collection, New Delhi.

करादी केम्प में महात्मा गांधी की गिरफ्तारी।

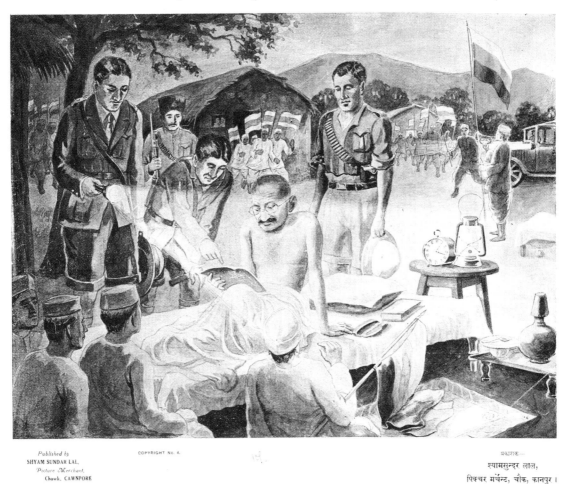

Published by
SHYAM SUNDAR LAL,
Picture Merchant,
Chowk, CAWNPORE

COPYRIGHT NO. 4.

प्रकाशक—
श्यामसुन्दर लाल,
पिक्चर मर्चेन्ट, चौक, कानपुर।

the mass market and published by Shyam Sundar Lal, some of whose prints we encountered in the previous chapter, calls attention with exquisite fidelity to Gandhi's arrest at Camp Karadi a little after midnight on 5 May (Figure 3.24). This was the arrest that Gandhi had been seeking from the moment he had set out at dawn on 12 March from Sabarmati Ashram, but the colonial state had denied him the satisfaction – for close to two months, as he grew more and more impatient – of 'the spectacular martyrdom on which he was counting.'[61] A month after illegal salt-making was reported from across the country, the British eventually detained the Mahatma on the rather benign charge of 'disturbing the peace' (instead of what Gandhi deeply desired, 'sedition,' his new dharma). The anonymous print offers a near-accurate visualization of the events that transpired at the moment of the arrest. Eyewitness (and chosen marcher) Haridas Mazumdar reported that three police officers (two English and one Indian), along with their subalterns, showed up at Gandhi's temporary headquarters in the middle of the night when he was sleeping on a cot under the starry sky. 'Two flashlights are directed upon the face of the occupant of the cot. The Mahatma, half-clad, weary of limb, having had less than two hours' rest, sleepily turns from one side to the other in order to dodge the

Figure 3.24 - *Karadi Kamp Mein Mahatma Gandhi Ki Giraftari* (Mahatma Gandhi's Arrest in Karadi Camp), 193?. Lithograph published by Shyam Sunder Lal, Kanpur. Priya Paul Collection, New Delhi.

dazzling light. Suddenly the words, "Please wake up!" strike his ears...'[62] Note that in the print, the clock on the stool placed next to the cot reads 1.20 a.m., close enough to the time that the policemen entered the makeshift camp around 12.45 a.m. The artist captures the Mahatma as he reads his arrest warrant (although accounts have him requesting the district magistrate to read from the written order). Around 1.00 a.m., he was taken away to Yerwada Central Jail, thus bringing to a formal end his two months of ambulatory disobedience.

His arrest obviously made the headlines next morning and captured the nation's artistic imagination as evidenced in the poster and in another near-contemporary painting by the Santiniketan-trained Vinayak S. Masoji (1897–1977) titled *The Midnight Arrest* (Figure 3.25). Masoji, also a devout Christian who was with the Mahatma in the camp until the previous day, vividly compared the moment to 'the arrest of Jesus Christ at midnight in the garden of Gethsemane by a force of heavily armed ignorant soldiers.'[63] The current whereabouts of *The Midnight Arrest* is not known, but the artist's recollection of having painted it, 'many years later in the solitude of Mount Abu' was subsequently published in 1944. Although not present in Karadi at the moment of the Mahatma's arrest, Masoji captured it vividly, Gandhi himself reportedly agreeing with his rendering when he saw the painting on display in a Congress exhibition. When asked whether 'the painting was a mere figment of the artist's imagination, or whether it had happened like that, Mahatmaji quietly and with a smile replied, "Yes, yes, exactly, exactly. They came like that."'[64]

The spell that the Mahatma's Salt Satyagraha cast over India's artists continued well after the march formally ended. In 1948, in the wake of Gandhi's assassination, the Bengali modernist Ramkinkar Baij (1906–80) produced a masterpiece in plaster, cement, and eventually cast in bronze, of 'the lone pilgrim,' walking with his staff in hand, a stark and austere

Figure 3.25 - Vinayak S. Masoji,
The Midnight Arrest, 1944?
Medium and dimensions not available.

figure lost in thought, his head bowed low (Figure 3.26).[65] Although titled in its various iterations as *Dandi March*, the memory of the Mahatma's lonely walk on bare feet in Noakhali likely haunted Baij's imagination, as did the fact that the pair of walking feet had been stilled forever by 1948.[66] Sometime in the 1960s, responding as well to a commission from the Government of Assam, Baij and his students installed a 13.6-feet near likeness in cement titled *Apostle of Non-Violence* on the grounds of Kala Bhavan in Santiniketan. A striking feature of this statue, not immediately apprehended in the much smaller-scale *Dandi March* where it also appears, is a human skull placed prominently under Gandhi's right foot in full stride.[67]

A decade after Baij's *Dandi March*, the striding Mahatma appeared on a busy Calcutta intersection in an iconic sculpture that follows the canons of academic realism more closely. The work of another reputed Bengali painter and sculptor, Devi Prasad Roy Chowdhury (1899–1975), the statue apparently took two years to complete and at a cost of Rs 60,000, a sizeable sum in 1958 in West Bengal. Writing about its making, historian Tapati Guha-Thakurta notes that Roy Chowdhury 'took recourse to melting a bronze bust he had made of his own father (to meet an acute shortage of metal in the city that year) to correct and repair on time the leg of Gandhi that had been damaged in the process of its lifting on to its pedestal. We are invited to think here of an

affective flow of molten bronze from the figure of Devi Prasad's own father to that of the "father of the nation," also from this original statue, carefully nurtured by its maker, to the replicas that would travel to other cities like Madras' (Figure 3.8).[68]

Roy Chowdhury's iconic striding Mahatma is also incorporated into another impressive sculptural ensemble titled *Martyrs Column* in New Delhi, featuring eleven figures including two women, one of them the first in the column ranged behind Gandhi (Figure 3.28). Commissioned in 1965 in response to pressure from various citizen groups to have a memorial for national martyrs near Raj Ghat (the site of Gandhi's cremation) and formally approved by the government of Indira Gandhi around 1973 (when it was provisionally titled *Freedom Memorial*), the massive work (weighing in at 26 tonnes) was completed sometime around 1982 by Roy Chowdhury's students after his death.[69] The work has been frequently mistaken, even by reputable scholars and especially by artists, as Gandhi leading his followers on the Salt March, although in the sculptor's imagination as it interacted with the government's demand, it was a more general commemoration of Gandhian pedestrian politics as critical to the anti-colonial movement. In the work, Gandhi's body is clearly aging and bony, but he strides forward staff in hand with an air of determination, one sandal-clad foot raised prominently, the other firmly

Figure 3.26 -
Ramkinkar Baij, *Dandi March-II*. 1948. Plaster of Paris, 49 x 23 x 29 cm.
With permission of NGMA, New Delhi.

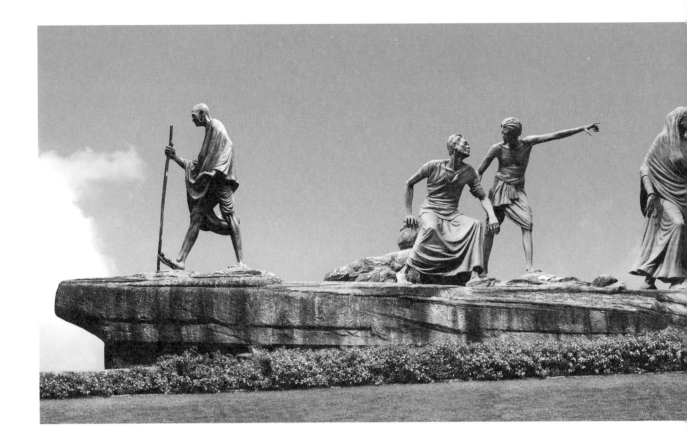

planted on the ground. The ten figures that follow him are meant to represent different communities of India, but in posture and form some appear less resolved than the Mahatma, one of them having to be aided, another bringing up the tail being urged onwards.

The public's encounter with this artistic ensemble, which the sculptor intended to be 'the biggest group composition of its kind in the world,' is renewed in everyday monetary and commercial transactions on account of the fact that Roy Chowdhury's iconic sculpture adorns currency notes issued by the Reserve Bank of India.[70] Numerous artists have also kept the image alive by recalling it in various ways. In neo-liberal India, which has taken to automobility on an astonishing scale (and some would say to devastating limits with irreversible environmental consequences), Roy Chowdhury's *Martyrs Column* also provides the artist with an occasion to lament the total abandonment of Gandhian values, including the art and dharma of walking and communing with the self and the other. In Amlan Paliwal's photographic montage for the Postcards for Gandhi project, the striding figure of Gandhi from the massive sculpture is rendered hazy, aesthetically suggesting the Mahatma (and his marching) have basically faded into the dim recesses of the national collective memory, or imprecisely remembered and wrongly celebrated.[71] In Vivek Vilasani's *Through the Looking Glass* (2010), a veil occludes the purpose and camaraderie of ambulatory exercises that intended to deliver a nation its true freedom.[72] Most strikingly, Gigi Scaria's *Who Deviated First?* uses digital technology to manipulate a black-and-white photograph of the sculpture to offer an enigmatic critique of the fate of Gandhian pedestrian politics in neo-liberal India – is it his followers who have ceased to follow, or is it the Mahatma who has walked away? (Figure 3.27).

Figure 3.27 - Gigi Scaria, *Who Deviated First?*, 2010. Acrylic and serigraph on canvas, 76.2 x 152.4 cm. With permission of the artist.

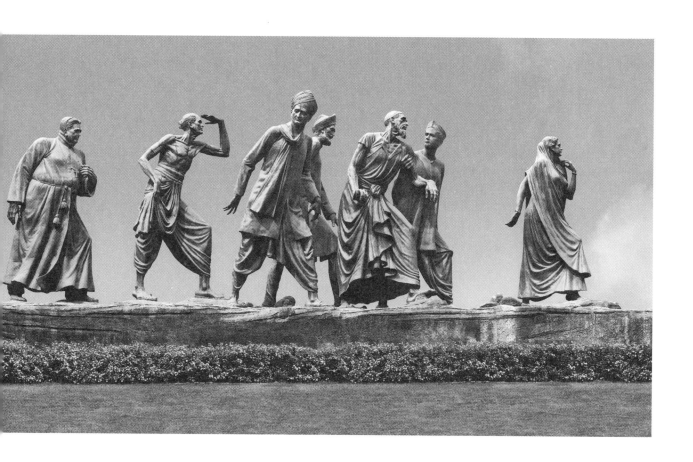

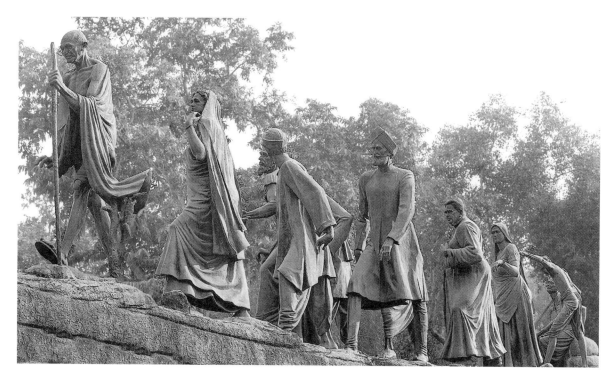

Figure 3.28 - Devi Prasad Roy Chowdhury, *Martyrs' Column*, 1981-82. Bronze, 17.5 feet (height), Sardar Patel Marg, New Delhi. With permission of American Institute of Indian Studies.

SALT AND ITS SAVIOUR[73]

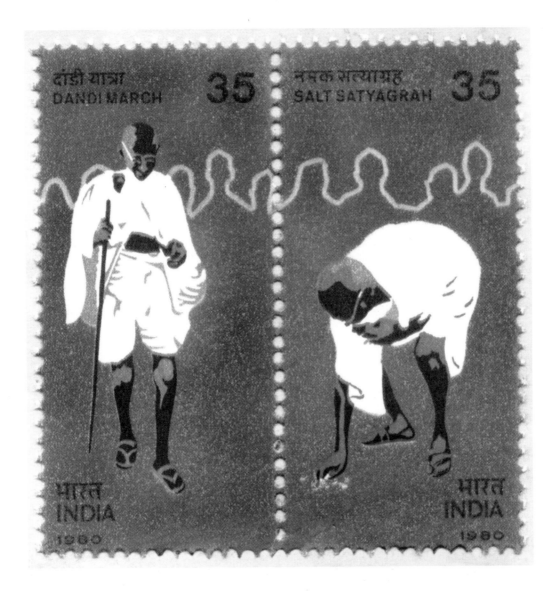

A t daybreak on 6 April 1930, after a bath in the ocean – when, as I earlier noted, a camera caught him at his barest minimum in public (Figures 2.6 and 2.7) – Gandhi began National Week by reaching down to the wet earth and picking up a pinch of salt, catapulting to fame

a substance that was taken for granted, more or less, until Gandhi's 'silly stunt.'[74] Over time, this modest, unostentatious, but life-sustaining mineral has come to be deeply aestheticized in the world of Indian art. In the last chapter, I discussed Surendran Nair's enigmatic work, *The Unbearable Lightness of Being*, in

Figure 3.29 - A. Ramachandran, *Dandi March Stamp*, 1980. With permission of the artist.

which the Mahatma's bare brown body is 'studded with little crystals of salt and sand that spangle his back but also pierce it like nails' (Figure 2.29). As Geeta Kapur goes on to observe, 'He is a martyr. Nair weighs him with the salt of the earth and finds him floating – like an ascending avatar.'[75] The work appears to suggest that the Mahatma had undergone Christ-like suffering on behalf of the nation – also likely, signalled by the flag-like dhoti – with his salt-making disobedience.[76]

In 2018, to mark the 150th anniversary of Gandhi's birth, when Paresh Maity's spectacular *Dandi March* was put on display at the Art NOW exhibit in New Delhi, actual mounds of salt were placed in front of the mixed-media work.[77] Similarly, in Vishal K. Dar's *A Great Deal More Than a Pinch of Salt* (2010), 'desi rock salt, nearly 25 kilos of it, is used to create a 3-feet-high mound piled on a 6-feet-wide weighing balance in fibre glass.'[78] Two miniature sculptures of Gandhi adorn the mound. Salt is also the subject of New Delhi-based Shukla Sawant's mixed-media work from 1995, *Salt of the Earth*, produced to commemorate Gandhi's 125th birth anniversary.[79] Gandhi is totally absent as a figure but summoned in the work through the medium of

the mineral with which he is now indelibly associated. Another female artist, Shelly Jyoti, has an extended multimedia installation work that seeks to 'emulate the brisk walking of Gandhiji.' Titled *Salt: The Great March* (2013), the work brings together numerous elements from Gandhi's Dandi performance: khadi, rural India, and salt.[80] Gandhi as an embodied figure is again not visible, except in one work in fabric in which he is a blue silhouette, a white walking stick in hand, but he is all the same the driving presence.

That supremely disobedient moment when Gandhi reached down and picked up his pinch of salt has also become the subject of numerous artworks, many based on a historic photograph that *apparently* captured it.[81] These works have repurposed the photograph, keeping it visible and available into our times (for example, Figures 2.7, 3.10, and 3.13). On the fiftieth anniversary of the March in 1980, the Indian Posts and Telegraphs Department issued postage stamps based on etchings by A. Ramachandran that reworked the empire-shaking disobedient gesture frozen in the photograph (Figure 3.29; see also Figure 3.22).[82] In Vivan Sundaram's 1995 collage for the Postcards for Gandhi project, a single lean brass arm reaches down, the fingers of the hand splayed in an act of grasping something that eludes (Figure 3.31). The work is not titled, yet no viewer who has been bombarded with images of Gandhi's singular act of bending down and picking up some salt would mistake it for anything else.[83] At that historic moment, Gandhi was barely able to scrape together a pinch of salt (also mixed up with clay and mud) to perform his disobedient act. It is the grandness of the gesture, rather than the actual quantity, which moves the Gandhian Haku Shah to paint *Meethu* (Salt) (Figure 3.30). Instead of looking at his illicit prize (looming quite large in the Mahatma's hand), the artist has Gandhi contemplating and anticipating the 'real' reward for his disobedient performance: yet another stint in what he jokingly referred to as His Majesty's hotel, behind bars and under lock and key.

Figure 3.30 - Haku Shah, *Meethu* (Salt), 2013.
Oil on canvas, 60.96 x 60.96 cm.
With permission of the artist's family.

An Aesthetics of the Ambulatory

In the words of philosopher Ramachandra Gandhi, a grandson as well of the Mahatma: Gandhi's distinctive contribution to modernity as well as to tradition is a philosophy of walking which embodies the spiritual truth of nomadism, forgotten substantially by all civilisations, old or new. Not the going-a-begging of mendicancy, but the vibrant cinematic walking of satyagraha; very Chaplinesque, unanxious and yet fast-forward. Gandhi walks to Dandi and salt finds its saviour, bland politics becomes salted with the truth of walking in truth, a very root meaning of brahmacarya [celibacy]. Gandhi walks up the steps of the Viceroy's palace and extracts from Churchill the "half-naked fakir" sneer – motorised, over-clothed, overfed, one-track, delinquent modern civilisation's deep fear and hatred of the all-directionedness of meandering, looking, loving, challenging be-ing. Monadism's fear of nomadism... "Speed" is not the end of life, Gandhi said. "Man sees more and lives more truly by walking to his duty." ... Vanished nomadic wisdom would concur.[84]

Like the philosopher, is the artist of India also drawn to the vanished 'nomadic wisdom' embodied by and in the figure of the mobile Mahatma? To answer this question, I turn to a fascinating work by Atul Dodiya, *Draw as You Walk*, from his 2011 'Bako series' in which the artist imagines a fictional encounter between a child called Bako and his Bapu (Figure 3.33):

> In my sleep, I take Gandhi Bapu along,
> drawing him with a pencil.
> The moment I draw his feet, they start walking.

"Bapu, stop, let me finish drawing you."
Bapu says, "Draw as you walk."
Tell me, is it possible for anyone to draw while walking?
But he simply refuses to stop
Walking in my sleep.
The moment I touch him with the pencil-point, he surges ahead.
How will I finish drawing him if he doesn't stop?

Figure 3.31 - Vivan Sundaram, Untitled, 1995. Collage with photograph and metal, 14.6 x 8.9 cm. With permission of Sahmat, New Delhi.

Figure 3.32 - Sachin Karne, *Gandhi My Friend*, 2008.
Oil on mirror, 150 x 118 cm.
With permission of the artist.

In my sleep, I take Gandhi Bapu along, drawing him with a pencil.
The moment I draw his feet, they start walking.
'Bapu, stop. Let me finish drawing you.'
Bapu says, 'Draw as you walk.'
Tell me, is it possible for anyone to draw while walking?
But he simply refuses to stop
Walking in my sleep.
The moment I touch him with the pencil-point, he surges ahead.
How will I finish drawing him if he doesn't stop?

Figure 3.33 - Atul Dodiya, *Draw as You Walk* (Bako Series), 2011.
Oil, acrylic, watercolour, oil bar and marble dust on canvas,
198.12 x 198.12 cm. Overall size with stand: 229.87 x 204.47 x 60.96 cm.

It bears repeating that despite Gandhi's repeated emphasis on stillness, as observed during hours expended at the spinning wheel, in prayers, and in reading and writing, or in silence, the Mahatma was among the most active of men of his time, moving across the map of British India which he traversed from one end to the other on his bony legs and sandal-clad feet. The child Bako captures the dilemma, the appeal and challenge posed by the mobile Mahatma to the artistic imagination: 'How will I finish drawing him if he doesn't stop?' All the same, India's artists do 'finish drawing' him – over and again – on paper, canvas, and other media, including the digital in our times. In so doing, they paradoxically still his ever-mobile body, its kinetic energy and movement pacified and subdued in line and form.

That some are aware that their apparent success in seizing and stilling him comes at a cost is apparent from a caustic criticism levelled by Ramkinkar Baij (whose sculpture of Gandhi I discussed earlier; see also Figure 3.26) against a former teacher, Devi Prasad Roy Chowdhury's iconic statue of the Mahatma in full stride (Figure 3.8). Baij argued that the statue 'failed to capture the movement of the Mahatma's march and bring out the force of his personality. One leg came forward in a giant step, but the statue remained static: the *chaddar* [shawl] did not fly with the moving body, it clung limply to the shoulder; and the head drooped far too timidly. Where, he lamented, were the gait and vitality of the Mahatma in his legendary crusade? For Ramkinkar, the Mahatma on his Dandi March, in his windswept strides, seemed to have walked on and away, leaving the sculptor and his statue way behind.'[85]

They may have stilled his mobile body in their works as they sought to capture it for posterity, but the persistence of artists in showing the Mahatma in full stride reminds us of the critical constitutive role of the ambulatory for a Gandhian-style civil disobedience. As such, the aesthetic privileges, as I have noted, Gandhi's

legs and feet, his rustic staff, and his simple sandals. In Atul Dodiya's *The Route to Dandi* (Figure 3.18) or Vadodara-based Sachin Karne's *The Walk: Gandhi the Cartographer* (Figure 3.34), it is the legs and (sandal-clad) feet that matter, the rest of the Mahatma's body left to the viewer's imagination to conjure up. On the one hand, such works connect to a deep preoccupation across numerous Indic art traditions and religious art with the hallowed feet of deities and other revered beings.[86] On the other, they point to the artist's regard for and recognition of the labour of walking that Gandhi undertook on and behalf of the nation, a labour that likely even cost him his life and made him a martyr, like Jesus, as suggested in works by Shuvaprasanna and Surendran Nair in the Postcards for Gandhi series. As the Mahatma himself was to note in late 1946 to his acolyte Nirmal Kumar Bose, 'For men like me, you have to measure them not by the rare moments of greatness in their lives, but by the amount of dust they collect on their feet in the course of life's journey.'[87] Here it is also worth recalling, as Dodiya's *Arrival* does (Figure 3.17), the Mahatma's words from an earlier decade in his autobiography, 'The seeker after truth should be humbler than the dust. The world crushes the dust under its feet, but the seeker after truth should be so humble himself that even the dust could crush him.'[88]

From at least the time of the Dandi March, Gandhi walked with a staff (lathi) in hand, his labour of walking accompanied by this accessory.[89] Among the prayers and songs that were routinely recited in his ashrams is a verse attributed to the medieval saint Kabir (and a favourite of the Mahatma's) that reveals Gandhi's predilection in this regard, 'When one goes about with a mere begging bowl and a staff, one has the whole world as one's kingdom.'[90] On the morning of 12 March as he was about to set out on his historic 'pilgrimage' to Dandi, Kaka Kalelkar reportedly presented him with one such staff, 54 inches long and one inch wide, made out of lacquered bamboo and

iron-tipped.[91] In artworks from the time of Nandalal Bose's iconic images of the march (Figures 3.20 and 3.21), Gandhi is routinely painted with a staff in hand. In some cases, as in Amit Ambalal's beautiful watercolour for the Postcards for Gandhi project, the Mahatma is only partially present, but no visually literate viewer in India would be confused about the owner of the bony hand wrapped around the staff (Figure 3.35; see also Figure 4.26). In the enigmatic *Eraser Pro* (which also adorns the cover of this book, resonating with all three of its principal themes), while the rest of the Mahatma's body is sculpted in a state of disintegration, the staff, sheathed in (faux) bronze, stands whole and unbroken (Figure 3.36). The artist Tallur L.N. (b. 1971) created the fabulous sculpture by 'erasing' life-size statues of Gandhi, staff in hand, that are routinely mass-produced in India. Preoccupied as he is with image construction and destruction, his goal might well have been to reflect on the process by which Gandhi has been systematically transformed from embodied substance into a bio-icon, making visible in the process the hollowness of what lies beneath the surface. That he leaves the staff intact in doing so is a revealing reminder of the importance of this accessory for rendering the Mahatma visually recognizable. This is also the case in an untitled work by one of India's most globally visible and highly paid artists, Subodh Gupta (b.1964), who has transformed the humble bamboo reed that the Mahatma favoured into a stand-alone high-end bronze art object.[92]

Surprisingly, in the copious writings on Gandhi, despite its importance for his ambulatory predilections, there is little reflection on the lathi on which the Mahatma depended, especially as he grew older. An insignia as well of ascetic life, it might also be seen as the non-violent counterpart to the ubiquitous lathi wielded by the colonial police and on full display in the state's response to the raid on the Dharasana salt works in May 1930 in the wake of Gandhi's arrest.[93] Historian Seema Bawa writes of an extraordinary public memory

that survives of Gandhi in 1934 persuading residents of Ghoraghat (about 150 kilometres from Patna) to stop making the heinous lathi with which the colonial state beat up his followers. They gifted him in return with a bamboo lathi. To mark this moment, their descendants reportedly celebrate to this day the Lathi Mahotsav (Lathi Festival).[94] What makes this public memory even more remarkable is that there is no mention of the event in Gandhi's published utterances from that period.

Over the years, and especially from the 1930s as he got older and frailer, there was a distinct feminization of the Mahatma's ambulatory politics, as he took the help of various young women in his entourage who he began to refer to his walking sticks (for example, Figures 3.32 and 3.43).[95] His use of women in this manner gave rise to criticisms in his own time, which the Mahatma felt compelled to explain (away).[96] In his letters he names many of these female walking aids, and writes with affection about them, but also with irritation at times. Over time, his grandnieces Abha and Manu became his special aids in this regard. The art world has taken notice of his reliance on these women in various images that show him in their company and in physical contact with them in a manner that is definitely at odds with any normative practice in the India of Gandhi's own time, and even ours.[97] In Sachin Karne's *Gandhi My Friend* – based on a Margaret Bourke-White photograph from 1946 – the invisibility of these women emptied of all presence as they enabled the Mahatma's ambulatory performance only underscores the female labour of care that was essential to a Gandhian-style civil disobedience (Figure 3.32). [98] In fact, Gandhi's satyagraha might well not have been possible without such tender and devoted (female) attention.

Indeed, these Gandhian women ensured that all that walking did not crush their revered Mahatma, and it is important to remember the tender ministrations they bestowed upon Gandhi's feet, which were washed

Figure 3.34 (pgs 114-15) - Sachin Karne, *The Walk: Gandhi the Cartographer*, 2008. Oil on canvas, 122 x 183 cm. With permission of the artist.

Figure 3.35 - Amit Ambalal, *The March*, 1995.
Watercolour on paper, 14.6 x 8.9 cm.
With permission of Sahmat, New Delhi.

and cleaned daily, and provided with massages and hot soaks at the end of a long day of striding and striving. A photograph taken by Kanu Gandhi of his granduncle's feet being washed and massaged by his grandaunt Kasturba is the focus of a work titled *Family Values* (1998) by Surendran Nair, who includes a similar image as a vignette in his complex *The Unbearable Lightness of Being* (Figure 2.29).[99] Manu's labour of care in this regard are worth recounting. 'As there is a scratch on one of his feet, I applied hazeline [cream] to it...' (Chandipur, 7 January 1947); 'Immediately upon our arrival... I washed his feet. I noted that there were scratches on both the soles, as he had walked barefoot. Usually he keeps them so clean that not a speck of dirt can be seen, and they are so soft too' (Masimpur, 8 January 1947); 'As I was rubbing oil on Bapu's feet, I found that he had cut his soles in several places and that blood was oozing out. I could not check my tears at the sight. I filled the cuts with ghee. There is a specially deep cut at the joint below the great toe. What a difficult ordeal Bapuji has chosen to go through at this stage! How very sad must the plight of Indians be, if they cannot understand this great man' (Fatehpur, 8 January 1947).[100] These are a few among numerous such entries from Manu's dairy, from the time she accompanied him through riot-ravaged Noakhali, where if we recall, he walked daily on bare feet for close to two months, reportedly out of deference to the ground that had been 'hallowed by the innocent sufferings of poor men and women.'[101]

Routinely though, since around 1910 when he was living in South Africa and inspired by his intimate friend Hermann Kallenbach, Gandhi wore sandals which he made himself for himself and for others, writing in 1911 (as his life of political activism took a new turn) to his nephew Maganlal, 'I am mostly busy making sandals these days. I like the work and it is essential too. I have already made about fifteen pairs. When you need new ones now, please send me the measurements. And when you do so, mark the places where the strap is to be fixed – that is, on the outer side of the big toe and the little one.'[102] A drawing, the earliest we know of in the adult Gandhi's hands – which, unfortunately, has not survived – accompanied these instructions.

As eyewitness accounts suggest, Gandhi also possessed wooden footwear (*chakdi* in Gujarati; *khadau* in Hindi), in the style habitually favoured by subcontinental mendicants, which he appears to have worn in domestic contexts: a pair is visible in Frieda Hauswirth's sketch from 1927, perhaps the earliest instance of its appearance in an artwork (Figure 1.4). A pair is also painted delicately on the mat next to the Mahatma's prone figure on the cot in *The Midnight Arrest* by Vinayak Masoji, an artist who clearly saw Gandhi as a saint (Figure 3.25). Over the years, these clogs have continued to attract aesthetic contemplation (for example, Figure 2.29), most strikingly in New Delhi-based G.R. Iranna's *Cuffed Object* (Figure 3.38) and *Naavu* (We Together), recently showcased in the India Pavilion at the 2019 Venice Biennial (Figure 3.37). In the former work, a single pair is bolted down with a pair of handcuffs, the artist's tribute to the Mahatma as the nation's most famous nonviolent 'law breaker,' a man who was willing, and cheerfully, to be thrown into prison for standing up for his principles. In contrast, *Naavu* assembles a throng of the rudimentary footwear, close to 700 of them, many artfully embellished, bringing back to memory the multitude in the constitution of the Mahatma. In New Delhi-based Arpana Caur's terracotta relief, a single pair of khadau presences the absent Mahatma, a barbed wire stretched across them invoking the bloody Radcliffe Line that divided up British India in 1947 even as it provides a melancholic rejoinder to Gandhi's statement that Partition would only happen over his dead body (Figure 3.40).[103] Although the photographic evidence confirms that most often Gandhi wore handmade

Figure 3.36 (facing page) - Tallur L.N., *Eraser Pro*, 2012. Bronze, 200 x 95 x 65 cm. With permission of the artist.

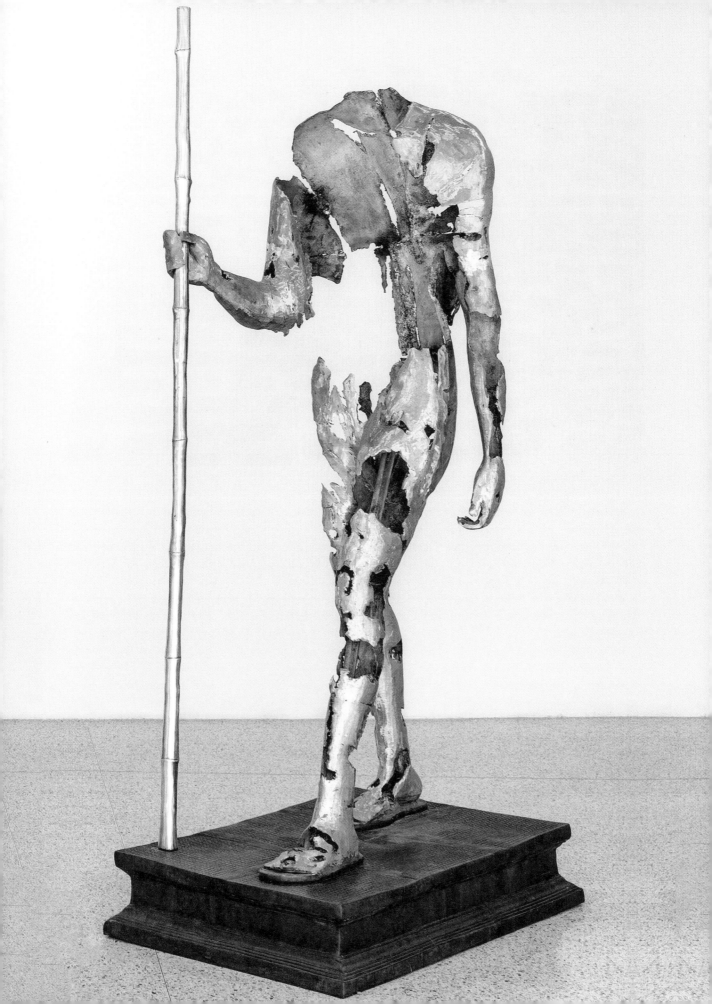

sandals in public, his saintly status, especially in the aftermath of his assassination, has likely ensured the khadau's association with the Mahatma's feet in artworks underwritten by the aesthetic of the ambulatory, in turn providing material and visual sustenance to Nehru's much-quoted words, 'Where he sat was a temple, where he walked was hallowed ground.'[104]

In his own lifetime, Gandhi's handmade sandals were enshrined in the Khadi Pratisthan Museum at Sodepur in Bengal, and since his death, they are amongst the most precious of relic objects on view in various Gandhi memorials scattered across the nation. There is the paradoxical fact of the hyper-vegetarian Gandhi working with his bare hands on dead animal hide and his almost obsessive desire to become an expert tanner; tannery itself was critical to Gandhi's Constructive Work agenda that he carried out across India's villages, and, at his ashrams in Sabarmati and Sevagram, he opened tannery units. On the other hand, such work being habitually confined to the lowest of the low, this gave the Mahatma one more opportunity to disobey some norms of the caste system in his project of getting his fellow caste Hindus to overcome 'the sin' of untouchability. No wonder, then, that the humble sandal has attracted the eye of the artist, and become the object of contemplation and musemization, in accordance with the logic of the aesthetic of the ambulatory (Figure 3.39; see also Figure 3.42).[105]

Figure 3.37 - G.R. Iranna, *Naavu*, 2019. Mixed media installation, 14 x 60 feet. With permission of the artist.

Figure 3.38 (above) - G.R. Iranna, *Cuffed Object*, 2009. Wood, stainless steel, and brass, 10.16 x 15.24 x 30.48 cm. With permission of the artist/ Aicon Gallery, New York.

Figure 3.39 (below) - Ravikumar Kashi, *Artist Book: Everything He Touched* [detail], 2011. Conte, ink and photography transfer on Japanese raka stained, handmade paper, 36.8 x 30.4 cm. With permission of the artist.

Figure 3.40 - Arpana Caur, *1947*, 2013.
Terracotta relief, 45.7 x 45.7 cm.
With permission of the artist.

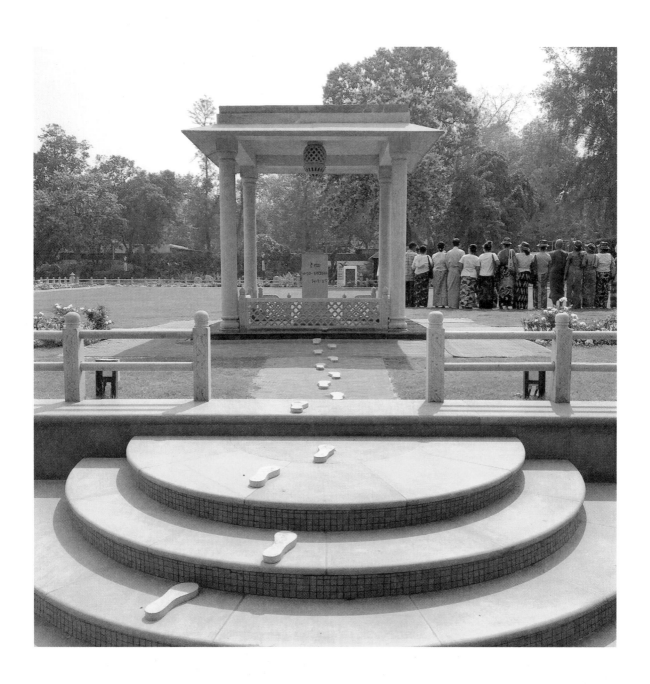

Figure 3.41 - Gandhi Smriti, New Delhi.
Author's photograph.

Figure 3.42 - Yunus Khimani, Untitled, 1995. Linocut,
14.6 x 8.9 cm. With permission of Sahmat, New Delhi.

THE LAST WALK

After many pedestrian events, several mundane, some spectacular, Gandhi embarked on his last walk at the dawn of dusk on 30 January 1948, a few minutes past 5 p.m., his arms draped around Abha and Manu (Figure 3.43). He was running late, and was fussing over this, as well as joking over his meagre evening meal. A few minutes later, three shots rang out and felled him. No camera was there to capture these last moments of the most photographed Indian of his time. In the absence of any photograph or film, in works of art, the moment of his passing is recalled in various ways, including by summoning up his absent presence with a focus on his footwear that is exemplary of what I have called the aesthetic of the ambulatory (For example, Figure 3.42). Decades later, in the museum that has been created on the site of his martyrdom in New Delhi in what might be also called a national garden of loss, Gandhi's last walk has been materialized in some 175 cement footprints that chart the last walk that he took to meet his assassin and his Maker, and indeed what some have characterized as his most glorious moment, his violent death (Figure 3.41; see also Figure 4.24). To the fine art that has emerged around that deadly event across the media and over time, I next turn.

Figure 3.43 - Atul Dodiya, *Evening Walk*, 1998. Watercolour and acrylic with marble dust on paper, 114.3 x 177.8 cm. With permission of the artist.

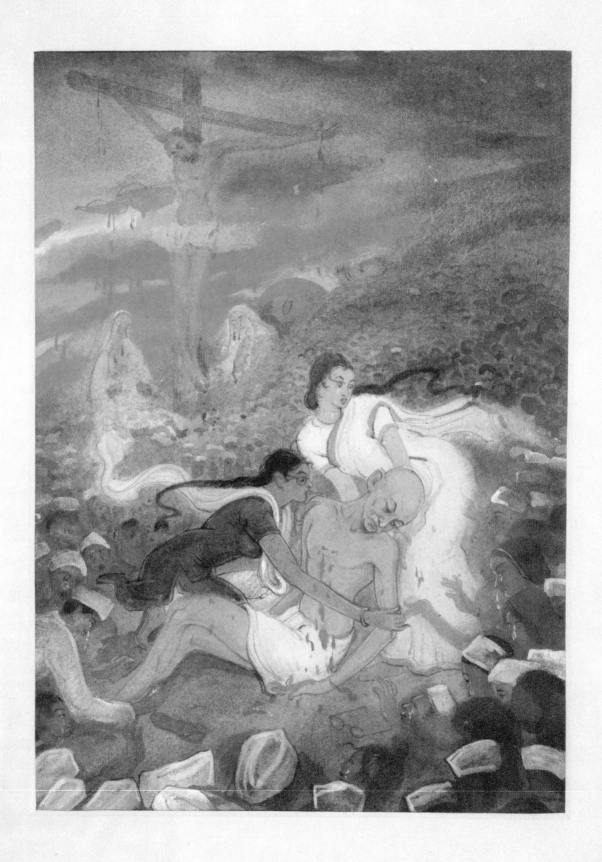

4

THE
FINE ART OF
DYING

'The art of dying follows as a corollary from
the art of living. Death must come to all.'[1]
- *Mohandas Karamchand Gandhi*

A CAMERA-FREE DEATH

It is an undeniable empirical fact of Indian history that the father of the nation was murdered within a few months of the birth of his nation on 15 August 1947.[2] Reflecting on this near-coincidence, one among the Mahatma's numerous biographers, Robert Payne, insisted that Gandhi's violent death was 'a new kind of murder,' 'a permissive assassination' caused 'by negligence, by indifference, by deliberate desire on the part of many faceless people.' The father of the nation was 'an old man who had outlived his usefulness: he had become expendable.'[3] It is of course one of the founding arguments of this book that for India's artists, Gandhi has not (yet) become 'expendable,' possibly no more so than at the moment of his death to which they have returned – in the aftermath – over and again in myriad ways, reliving on paper, canvas, and in other media the violent passing (Figures 3.41–3.43).

In verbal discourse, that murderous moment has been variously recalled, including by the assassin. In one authoritative retelling:

> Gandhi left his room at 5.10 p.m. to wend his way to the prayer meeting on the adjoining lawn [in Birla House]. His grand-daughters [sic], Ma nu and Abha, were by his side. He leaned on them, as he walked. As he passed through the cordoned path through the prayer congregation, he took his hands off the shoulders of the two girls to answer the *namaskars* [greetings] of the people. All of a sudden, someone from the crowd, a Hindu named Nathuram Vinayak Godse, roughly elbowed his way into the cordon from the left. Manu, thinking that he was coming forward to touch Gandhi's feet, remonstrated and tried to stop the intruder by holding his hand. He violently jerked Manu off, causing the spittoon and the *mala* [the rosary], which she was carrying, to fall. As Manu bent down to pick up the scattered articles, he planted himself in front of Gandhi at point-blank range and fired three shots in quick succession from a seven-chambered pistol. All the bullets hit Gandhi on and below the chest on the right side. Two bullets passed right through; the third bullet remained embedded in the lung. At the first shot, the foot that was in motion faltered. The hands which had been raised in *namaskar* slowly came down. He still stood on his legs; then the second shot rang out and he collapsed. He uttered "He Rama," ["Oh God."] The face turned ashen grey. A crimson spot appeared on the white clothes. The body was carried inside and laid on the mattress, where he used to sit and work. Death was instantaneous.[4]

This account of the last few minutes of the Mahatma's life was assembled a few years after his passing by biographer D.G. Tendulkar from eyewitness accounts, including that of Manubehn who was by his side that fateful evening (Figure 3.43). In her *Last Glimpses of Bapu*, Manu recollected the moment of the murder of her granduncle in words that intertwine the optics and acoustics, 'The whole incident hardly took 3 or 4 minutes. The smoke was very thick. The sound of bullets had deafened my ears... What happened to us, the two girls, is beyond description. Streams of blood strained our white clothes all over. It was 17 minutes past 5 by Bapu's watch. With folded hands, Bapu was

Figure 4.1 (pg 126) - Upendra Maharathi, *The Fate of Three Great Men: Gandhi, Buddha and Christ*, n.d. Watercolour on paper, 40.6 x 30.4 cm. With permission of NGMA, New Delhi.

lying in eternal sleep on the green turf on the lap of Mother Earth, as if he wanted to pardon us for our audacity instead of frowning at it.'[5]

Totally absent in that 'decisive moment'[6] were cameras to record that micro-instance of the killing although several photographers immediately rushed to the scene as news spread of the Mahatma's murder.[7] As I have noted, Gandhi was undoubtedly the most photographed Indian of his time, with photographers trailing him everywhere for the previous thirty and more years. Yet they failed to witness his last living moments, leading one of them, Homai Vyarawalla (1913–2012), India's first known female photojournalist, to lament in a later interview, 'There was one big chance of taking the biggest picture ever and I had missed it. Usually I used to photograph the Mahatma at that very spot when he came out of Birla House... If destiny had willed it, I could have had that picture, that record of that tragic day when we lost our leader and Father of the Nation. My hand would as always have been on the camera and I would have automatically taken that picture. Of course, it was the saddest thing imaginable, but I would have had the picture.'[8] Sabeena Gadihoke, who has chronicled Vyarawalla's career, writes that on that fateful evening, the photographer had been planning to cover Gandhi's prayer meeting at Birla House. She was about to set out, armed with a colour movie camera, when she was called back to her office, missing 'the greatest news picture' of her professional life.[9]

Two other photographers had near misses. His 'torturer,' Margaret Bourke-White, recalled that she had secured Gandhi's autograph just the previous day on photographs she had previously taken (Figure 2.16).[10] She met him again on the afternoon of 30 January, her last day in India, for one final interview which she observed ended with her saying to him, 'Goodbye – and good luck.'[11] Also that very afternoon, Henri Cartier-Bresson (1908–2004) interviewed Gandhi for half an hour, and gifted him an album of his photographs, which included one of the French poet Paul Claudel gazing at a hearse passing on the street. The Mahatma apparently paused when he saw the photograph, and 'very distinctly' muttered, 'Death – Death – Death!' The photographer later recalled, 'I said goodbye to him at 4.45 that afternoon, and fifteen minutes later, I heard the cry in the streets, "Gandhi's dead. Gandhi has been killed."'[12]

The result of these near misses has meant – empirically – that Gandhi died what one might call a camera-free death. Theorists of photography have reflected on the macabre intimacy between photography and death. 'It is precisely in death that the power of the photograph is revealed, and revealed to the very extent that it continues to evoke what can no longer be there.'[13] Since 'the invention' of the camera in 1839, 'photography has kept company with death.'[14] The photograph itself has been defined as 'the ghost of a moment that has passed.'[15] In fact, 'the photograph is a farewell. It belongs to the afterlife of the photographed. It is permanently inflamed by the instantaneous flash of death.'[16] Consequentially, each photographic moment is also a profound moment of bereavement. Every photograph signifies 'the return of the departed.'[17] As I already noted, Gandhi himself was not unaware of this macabre intimacy, reportedly remarking when he was shown a photograph taken in 1946 while he slept through an accident, 'I see now how splendid I shall look when I am dead. I have already known how I shall look before my death. Such is this lucky age!'[18]

THE CAMERA AND THE CORPSE

Since the later nineteenth century, the camera has been so indispensable as a truth-telling device that 'there has been no significant event that has not been captured with the artificial eye.'[19] Yet Gandhi's camera-free death troubles this contention, even as the surfeit of photographs from the immediate aftermath of the killing just as strongly proves it. As the news broke of the assassination, Bourke-White, Cartier-Bresson, Vyarawalla, and other photographers rushed to Birla House to join the growing throng of people attempting to get a last glimpse of the Mahatma's dead body. The result is a detailed photo-documentation of the crime scene, the announcement of the death by Prime Minister Nehru at the gates of Birla House, and of the bullet-pierced corpse as it was prepared for cremation. Photographs also abound of the grand spectacle of the hybrid funeral (part military, part Hindu, and part secular-patriotic) less than twenty-four hours later at Raj Ghat, of the collection of the remains on 2 February, and of the immersion of the ashes on 12 February in Allahabad where three of Hinduism's holiest rivers meet.[20] These photographs were subsequently published in the national and international media. Among the most globally circulated accounts were offered in *Life* to accompany photographs by Bourke-White and Cartier-Bresson. Thus, in a commentary titled 'Gandhi Joins the Hindu Immortals,' the US magazine took care to note that the fire that consumed Gandhi's (bare and spare) body at dusk on 31 January, 'was fed by 1200 pounds of sandalwood, 320 pounds of ghee (melted butter), 160 pounds of incense, and 30 pounds of camphor.'[21] Here as well, the optics of the moment alone was not sufficient, for as the Mahatma's body, which he had once declared was his 'last possession,'[22] began to catch fire, a loud roar swept across the immense crowd which the police sought to control. The pyre reportedly burned for fourteen hours. An essay published a month later and titled 'Sacred Rivers Receive Gandhi's Ashes,' accompanied by Cartier-Bresson's luminous photographs, focused on the immersion ritual (*visarjan*), riddled with contradictions, of the last remains of 'a man of peace and simplicity. The immersion of the ashes was signalled by the booming guns that Gandhi hated. Airplanes, which he would not ride in, swooped low over the floating hearse, itself a relic of the war Gandhi had opposed... Hindu ascetics and "holy men," whom Gandhi despised, walked through fire or flung themselves on beds of nails.'[23]

Historian Yasmin Khan insightfully argues that Gandhi's extended funeral was independent India's first state spectacle and assertion of power, efficacy, and sovereignty.[24] Gandhi's funeral was also independent India's first mass photo-performance, conducted around a much-mourned body,[25] but also releasing into the future, 'that rather terrible thing which is there in every photograph: the return of the dead.'[26] In many artworks, these photographs have been melancholically retrieved and repurposed to bear witness and circulate as visual elegies, well after the state-sponsored mourning formally ended, demonstrating in turn the power of the camera as the paradigmatic image-maker of the industrial age.

Three of Atul Dodiya's canvases help me advance this argument. *Voracious Eaters* (1994), among the earliest works on Gandhi produced by this prolific artist, repurposes an unattributed photograph of the moment 'immediately after the shooting [when] Gandhiji was brought into Birla House. Here the doctors are examining him, while with bated breath shocked spectators await the doctor's verdict.'[27] Despite encountering it as a grainy reproduction, which in turn indexes the conditions of its production on that deadly evening, the artist nevertheless meticulously repaints the photograph onto the open page of a

book (or album), along whose margins are drawn a potted plant (possibly signifying the garden where the Mahatma met his end) and discarded sandals, likely including those of Gandhi at the moment of his fall (Figure 4.2). The enigmatic title likely harks back to the 'permissive assassination' argument with which I began this chapter. From the very moment of his death, conflicting reports circulated regarding the exact moment of the Mahatma's passing, some arguing that he breathed his last on the spot in the garden where he was shot, while others insisted that he passed away in the room featured in the photograph (thus offering yet another rationale for the appropriation of Birla House for the nation on account of it being deemed hallowed ground).[28] In either scenario, the absence of a doctor who could immediately tend to Gandhi makes the tragedy unfolding in the room in the grainy photograph also a farce that the later-day artist is likely drawn to by titling his work as he does.

In *Nehru Announcing Gandhi's Death, Birla House, Delhi, January 30, 1948*, Dodiya repurposes a photograph taken by Cartier-Bresson of the moment when the Prime Minister climbed on to the wall of the mansion to officially confirm that Gandhi had indeed died (Figure 4.3). The work cites the terrible beauty of that moment as captured by the French photographer, with the light from a single lamp casting a glow on Nehru delivering the sombre message and on the building behind him where the Mahatma's corpse lay, the whole scene otherwise bathed in black.[29] The photograph visually anticipated the famous words uttered by Nehru in his formal radio broadcast to the nation a little later that night, 'The light has gone out from our lives and there is darkness everywhere.'[30] Pictorially resonating with these much-invoked words more than six decades later, Dodiya's painting is saturated with what we might call visual melancholia, which gives way to outright grief in a work titled *The Funeral Pyre* (Figure 4.4).[31] This canvas too repurposes a Cartier-Bresson photograph that the Frenchman captioned, 'The first flame of Gandhi's funeral pyre. His secretary looks into the flames; his

doctor holds up his hands hoping to quiet the crowd; but as the pyre burned brighter, the people seemed to be on fire too – and they surged forward in a great crushing movement, throwing themselves toward the pyre.'[32] In both canvases, the Indian artist has supplemented the French photographer's images with digital reproductions of works by the Dutch painter Piet Mondrian, known for their abstract universalism. On the one hand, by doing so, Dodiya might well be suggesting the universal meaning of Gandhi's passing. On the other hand, such works – and others that I discuss in this chapter – have undergirded a remarkable exaltation of violent martyrdom, even necrolatry: the visual adoration of the dead body.

In this chapter, I explore this disobedient yearning

Figure 4.2 - Atul Dodiya, *Voracious Eaters*, 1994. Oil, acrylic, and marble dust on canvas, 182.88 x 121.92 cm. With permission of the artist.

Figure 4.3 - Atul Dodiya, *Nehru Announcing Gandhi's Death, Birla House, Delhi, January 30, 1948*, 2014. Left panel: oil on canvas, 55.88 x 76.2 cm; right panel: archival digital print on hahnemuehle bamboo paper, 50.8 x 38.1 cm. With permission of the artist.

to bring back the dead father – what historian Chris Moffat has characterized in another context as 'the desire for the revenant, for the dead man who returns' – and especially the visual and artistic preoccupation with this particular dying moment.[33] I characterize this yearning as 'disobedient,' because it defies Gandhi's own rejection of such exaltation as early as the 1920s when he insisted, 'Let us all be brave enough to die the death of a martyr, but let no one lust for martyrdom.'[34]

Indeed, several artists rushed to take up their brush and turn to their canvas on hearing the news of Gandhi's murder. This was the case with M. F. Husain, some of whose many works on the Mahatma I have explored in this book already, as it was with the Dalit artist Chhaganlal Jadav – a protégé of Gandhi's – who reportedly shut himself up in his room in Ahmedabad for several days and painted a series of grief-filled images whose current provenance is unclear.[35] What has survived is a beautiful work by the relatively little-known Priyaprasad Gupta of the Mahatma seated in thoughtful contemplation, the watch from his waistband registering the time of death (Figure 4.5). Dating his work precisely to 30 January 1948, the artist

also places a halo around Gandhi's head, signifying the hallowed status he achieved in the moment of his violent killing.

Because the camera arrived too late to bear witness to the Mahatma's murder, and no photograph with its indexical capacity for truth-telling exists, that dying moment has thus become productively available to the creative imagination, for art taking over for and from the photograph *not* taken.[36] In other words, in the absence of 'the deadly eye of the camera'[37] that would have arrested and frozen the moment for ever with sensuous fidelity but also unpredictably and with exorbitant indifference, the artist can get to work with interest and care. And work they do to this day, producing a range of images that wrap multiple meanings around Gandhi's singular dying body, meanings that extend beyond its time to ours, across different media with their varying reach and effects.

This is a dying body that died the most violent of deaths, but it is also a dying body that may have died the most perfect, even pleasurable, of deaths. It is as well a dying body that undertook a redemptive death, attempting to save the nation at the near-moment of

Figure 4.4 - Atul Dodiya, *The Funeral Pyre, 1948*, 2014. Left panel: oil on canvas, 55.88 x 76.2 cm; right panel: archival digital print on hahnemuehle bamboo paper, 50.8 x 34.29 cm. With permission of the artist.

Figure 4.5 (facing page) - Priyaprasad Gupta, Gandhi, 1948. Line drawing on paper, 34.5 x 24.8 cm. Victoria Memorial Hall, Kolkata.

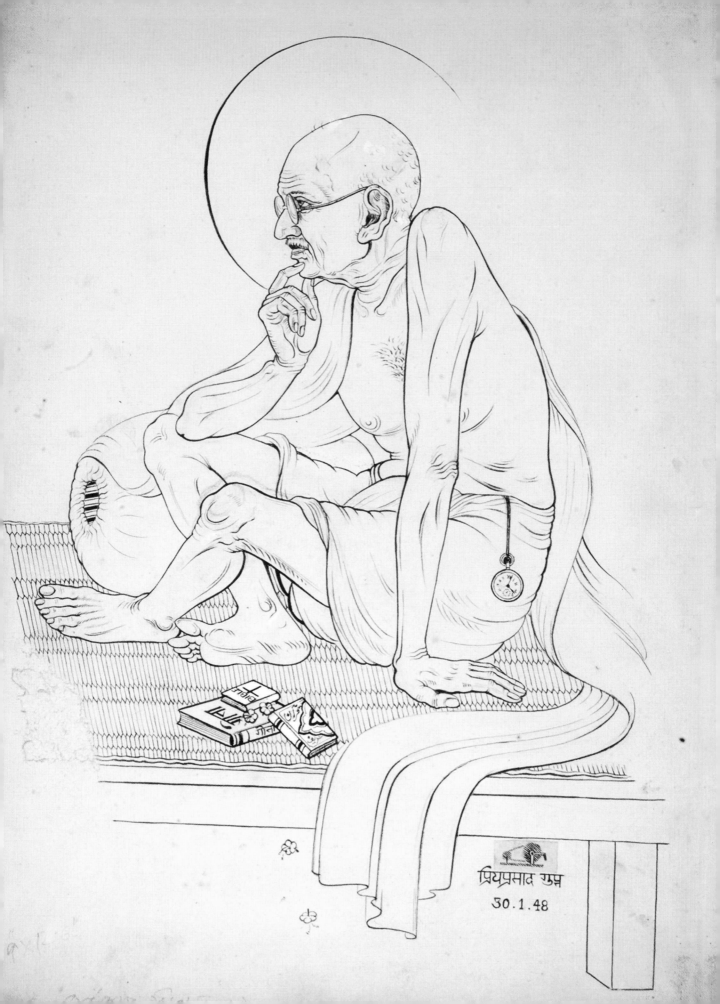

its birth from the catastrophic fallout of Partition. Not least, it is a dying body that reportedly experienced the most pious of deaths, the name of a beloved god its very last utterance before being stilled forever. As in other parts of the world, in India as well, dying moments, if not death itself and the corpse, have attracted the artist's attention over the centuries and across numerous artistic genres.[38] Yet the heterogeneous manner in which Gandhi's dead body has received the care of the artistic imagination stands out even by the standards of the subcontinent's blood-saturated patriotic visual culture.[39] Along the way, we are also reminded that this most non-modern of men died a very modern death, silenced for ever by an assassin's bullets released by a mechanized weapon. For all of Gandhi's preoccupation with living 'naturally,' it was the most unnatural death possible, longed for rather unnaturally, as we will see, by the man himself.

In other words, as I explore what it has meant
for India's artists to abide with, indeed reckon
with, Gandhi's death, materially, imaginatively, and
aesthetically, I am mindful that in our supposedly
disenchanted scientific age, the dead body still matters
(although variously and differently) for individuals,
communities, and nations.[40] Indeed, for some
philosophers, the corpse is the starting point of all
speculation.[41] Gandhi's corpse, in particular, *demands*

an artistic response, not least because when it had
been inhabited by a living, thinking being, it had
insisted that there is an art to dying, as I note in the
epigraph to this chapter. Can the artist then ignore this
challenge? The overwhelming evidence of this chapter
suggests not.

So, what does the art of Gandhi's dying look like
when it is materialized as artwork?

Figure 4.6 - Maqbool Fida Husain, *New Delhi 30 January
1948, c.* 1980s? Acrylic on canvas, 239.64 x 372.10 cm.
Image Courtesy Vadehra Art Gallery, New Delhi.

BULLET HOLES AND BLEEDING WOUNDS:
THE ART OF A VIOLENT DEATH

To answer this question, I begin with a large work titled with chronotopic precision *New Delhi, 30 January 1948*, the caption only leaving out the precise time of death, its compositional elements a reminder that blood and gore are not necessary to visually recall the horror of the violent end to which Gandhi's body was subjected (Figure 4.6). The painting is the work of M.F. Husain, who repeatedly returned to the theme of Gandhi's death, an event that immensely affected him, as I have noted, and might have also sparked

his general fascination with the subject of political assassinations.[42]

On this particular canvas, the bare and spare body of the slain Mahatma is supine, the dhoti all but undone, the shawl adorning his upper body in disarray, ominous dark gashes and wedges seared across his torso (not unlike the wounds of Christ). The force of the absent bullets, Husain seems to visually suggest, was such that the Mahatma's head was separated from his body. His walking stick, a faithful companion on his many ambulatory adventures, lies mute by his side,

Figure 4.7 (facing page) - Maqbool Fida Husain, *Assassination of Gandhi*, n.d. Acrylic on canvas, 163 x 95 cm. Collection of Srinivas Aravamudan and Ranjana Khanna.

Figure 4.8 - Gigi Scaria, *Touch My Wound*, 2007/08. Digital print, variable dimensions. With permission of the artist.

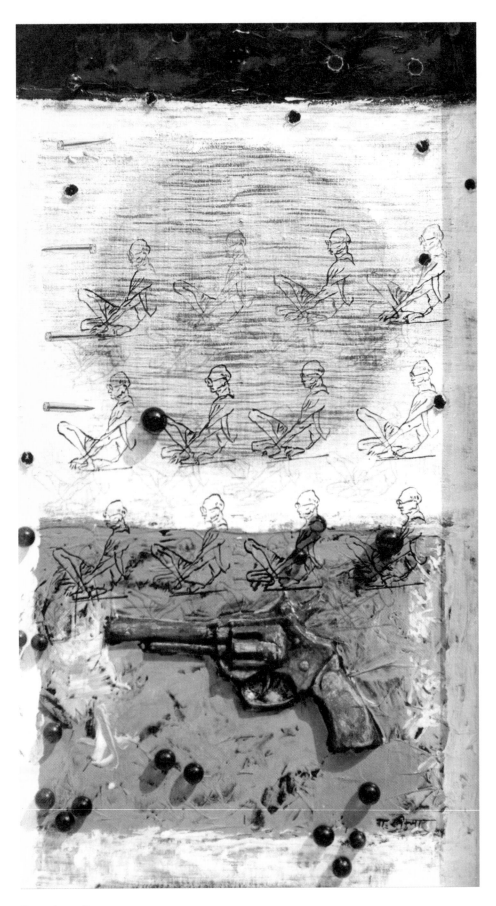

tracing the length of the fallen body. A plump blue goat is carefully painted between Gandhi's splayed legs, facing the Mahatma's corpse, bearing silent witness. Its bulging belly and full udders suggest that it is a mother about to give birth but surely it too stands orphaned – like the rest of the nation – with Gandhi's passing.

In another work titled *The Assassination of Gandhi* (Figure 4.7), Husain imagines the act as it is happening, an ominously cloaked figure in black pointing a gun at the Mahatma, who looms large over his killer, diminishing him even in his very act of falling. Gandhi's skeletal look is on full display here, as if at the moment of his death, he is nothing else but bones and joints. The bleak body painted a gloomy grey seared with black streaks in its moment of yielding up life – and vivid red blood – is placed against a dark background. His walking stick is split apart and loosely hangs from one shoulder joint, while the other arm, bony and bare, hangs helplessly by his side. This is what the Mahatma's art of dying looks like in Husain's eyes, as the slain body is thrown out into

the void, its work done, its purpose exhausted by the assassin's bullet.

As in this canvas, in others as well by other artists, Gandhi's violent ending is recalled with the help of the gun, and murderous bullets.[43] Ravikumar Kashi, whom we encountered in earlier chapters, has produced several multimedia works in which the revolver and the fatal bullets are the principal object of interest, even ironically displacing the famous victim (resurrected via one of K.M. Adimoolam's sketches) who recedes to the background (Figure 4.9). In Mumbai-based Nalini Malani's untitled linocut from January 1995, for a show organized by Sahmat in Baroda titled 'Manas Bana' ('Weave of Humanity'), Gandhi's skeletal hand makes contact with the murder weapon, although the very ambiguity of the image makes us wonder whether he was warding it off, or welcoming it, even giving it his blessing (Figure 4.10). Recall in this regard his grandson Ramachandra's insistence that on that fateful evening, his grandfather stopped 'three bullets on their path of hate.'[44] In a linocut by Shibu Natesan, also on view in the Manas Bana exhibit, the barrel

Figure 4.9 (facing page) - Ravi Kumar Kashi, *Encounter No. 2*, 1998. Khadi cloth, glass marbles, papier-mâché, acrylic colour, ink drawing on glass, printed image on wooden panel, 91.44 x 50.8 x 5.08 cm. With permission of the artist.

Figure 4.10 - Nalini Malani, Untitled, 1994. Linocut, 8.89 x 14.6 cm. With permission of Sahmat, New Delhi.

Figure 4.11 - Upendra Maharathi, *Bloody Sunset*, n.d.
Tempera on paper, 33 x 23 cm. With permission of NGMA, New Delhi.

Figure 4.12 - A. Ramachandran, *Monumental Gandhi: Hey Ram, 2nd Version* (Rear view, detail), 2016. Bronze, 213.36 cm. With permission of the artist.

Figure 4.13 - Feliks Topolski, *Mahatma Gandhi*,
1946. Oil on canvas, 152.4 x 121.92 cm.
The Estate of Feliks Topolski.

of the revolver is aimed at a pair of spectacles, these material objects playing proxy for the assassin and his famous victim (Figure 4.30).

In other works, the blood and gore of the moment is more explicitly – and mimetically – recalled. With a realism keeping pace with photographic realism, the Orissa-born and Calcutta-trained Upendra Maharathi (1908–81) painted *The Fate of Three Men*, in which the artist contemplates the scene in a manner that visually echoes Tendulkar's verbal account with which I began the chapter, but adds to the mix the figures of the Buddha and Christ who are deemed as sharing a similar 'fate' (Figure 4.1). In the same artist's *Bloody Sunset*, the Mahatma's supine dead body is quite occluded by the streaks of red paint that fill up the canvas in large swirls (Figure 4.11). Goan artist Antonio Piedade da Cruz 'Cruzo' (1895–1982) brought the force of

Christian realism to the moment in his *Assassination: Ram, Ram!* In this oil on canvas (exhibited as *January 30, 1948* at the Sarvodaya Divas exhibition held on the first anniversary of Gandhi's death in 1949 in New Delhi), Gandhi lies dying flanked by Abha and Manu, his spectacles and sandals abandoned, blood from his bullet wounds quietly dripping to the ground.[45] The artist describes the work thus: 'The silence of Death. The Mahatma falls stricken to the ground. The noise of battle, the tumult and the shouting die. India's greatest son passes into the Beyond "where never wind blows loudly".'[46] On display in the National Gandhi Museum in New Delhi, which melancholically assembled memorabilia from the murderous moment, including the blood-stained dhoti, are two portraits of the Mahatma by Badal in 1977 and by Vijay Goyal (circa 1995) made from human blood.[47] In Gigi Scaria's

Figure 4.14 - Feliks Topolski, *The East, 1948*, 1948. Oil on canvas, 313.94 x 390.14 cm. With permission of Rashtrapati Bhavan Culture Centre, New Delhi.

digital print, the bullet wounds are the centre of visual attention as the artist creates a collage based on the much-circulated photograph (credited to American photographer Max Desfor) of Gandhi's corpse prepared for its last journey to the cremation pyre, the print itself bathed in a crimson red hue (Figure 4.8). A drop of bright crimson also stands out on the back of A. Ramachandran's 7-foot bronze sculpture (Figure 4.12). It is worth noting that after the Mahatma's corpse had been washed and prepared for the funeral pyre, his youngest son Devdas reportedly folded back the shawl to expose the chest, stating, 'The bullet wounds on Bapu's chest are medals of gallantry awarded to a non-violent warrior, the world must see them.'[48] The force of visual and material culture has ensured the (grieving) son's wish, even as Devdas' words should compel us to reflect upon the celebration thus of the violent end of a 'non-violent warrior.'

The realistic and non-mimetic are fantastically combined in a work by the Polish war artist Feliks Topolski (1907–89) who in 1944 visited India, spent a day in Gandhi's company in Bombay, and produced several evocative albeit raw drawings and sketches.[49] In 1954, a finished painting by Topolski dated to 1946 (Figure 4.13) was printed as the frontispiece to a published edition of these sketches with a foreword by Devdas Gandhi:

> Critics have described it as the artist's premonition of the assassination that was to come, two years later, on January 30, 1948. The artist himself has neither denied nor confirmed the theory of premonition, but the picture is there for everyone to judge. It represents a profoundly calm but limp figure of Gandhiji just prevented from falling by the support of his companions. Observe his right hand, half raised in doubt and pain. Beneath it is another hand, belonging to someone in the crowd, outstretched in readiness to help.[50]

There is no mention in this description of a disembodied hand with the barrel of a gun pointing towards the viewer in the bottom right of the canvas.

Subsequently, Topolski incorporated the painting into his mammoth project in London, *Memoir of the Century* (1975–1984).[51] He also updated the painting sometime in 1948 and inserted it in a large dramatic canvas, which is now part of the President of India's art collection after Prime Minister Nehru acquired it when he visited London in 1949 (Figure 4.14).[52] In this work painted in the aftermath of the assassination, Topolski paints the Mahatma's dying body with rivulets of blood running down the chest from his bullet wounds, the head sagging in complete submission to the deadly moment. He also adds an enigmatic dark figure behind the gun painted in the bottom right of the canvas. Could this have been the artist's attempt to visualize the assassin?

The most enigmatic of such works which shows the horror of the violent ending by resorting to the sanguinary is by Kolkata-based Debanjan Roy (b. 1975) (Figure 4.15). The artist has produced numerous other works on the Mahatma, laced through with edgy playfulness (for example, Figures 5.6 and 5.7), but none that place him in the company of his killer to the point that their faces fuse and partly merge, vivid red streaking across the paper, partly outlining Nathuram Godse's head, a devil's horn distinguishing the assassin from his bespectacled victim.[53] On the one hand, the work may point to Gandhi's desire, reportedly repeatedly voiced in the waning days of his life, for a violent ending. Godse may in fact have enabled what the Gandhian Vithalbhai Jhaveri insisted was the 'supreme moment of [Gandhi's] life,' his violent death in the cause of non-violence.[54] On the other hand, the image may also confirm the theory of 'permissive assassination' with which I began this chapter. In historian Faisal Devji's astute characterization, 'the father of a democracy must die to become one.'[55]

Figure 4.15 (facing page) - Debanjan Roy, Untitled 8, 2009. Watercolour and acrylic on paper, 35.56 x 27.9 cm. With permission of the artist/Aicon Gallery, New York.

PICTURING A PERFECT DEATH

Many years ago, social theorist and psychologist Ashis Nandy insisted, 'Every political assassination is a joint communiqué. It is a statement which the assassin and his victim jointly work on and co-author.'[56] One of the Mahatma's grandsons, Rajmohan, appears to confirm such an unholy pact when he describes his grandfather's dying moments in the following manner: 'A haste to pray. A hush on entering holy ground. A sense of the Eternal. Lines of fellow-worshippers. A gesture of goodwill. Rude elbows. A smell of attack. The ring of three bullets. "God! God!" Possibly a silent "God! Forgive them." Loving hands underneath. Earth, moisture, grass. The open sky. Rays from the dipping sun. *A perfect death.*'[57]

Rajmohan was not alone in expressing such a sentiment. So, the very same Nehru who poignantly claimed on that fateful night that 'the light has gone out of our lives,' also insisted three years later on 30 June 1951 in his foreword to the first volume of Tendulkar's eight-volume biography of the Mahatma that the manner of Gandhi's death 'was the culmination and perfect climax to an astonishing career.'[58] Gandhi's devoted secretary Pyarelal too described his violent passing 'as one perfect act.'[59] Tendulkar himself referred to the bloody end as the fitting 'finale to a majestic symphony.'[60] More earthily, the inimitable Sarojini Naidu reportedly exclaimed to the women gathered in tears over Gandhi's corpse that fateful evening, 'What is all this snivelling about? Would you rather he died of old age or indigestion? This was the only death great enough for him.'[61]

Figure 4.16 - Kripal Singh Shekhawat, *Life of Gandhi* [detail], 1955-58. Fresco in Birla House/Gandhi Smriti, New Delhi. Image courtesy DAG, New Delhi.

Figure 4.17 (facing page) - L.K. Sharma, *Bapuji ki Amar Kahani, c.* 1948. Oil on canvas, 111.76 x 78.74 cm. Collection of Anil Relia, Ahmedabad.

असहकार खबरी १९२०

दांडी मार्च १९३०

केंदसाते म विधायक कार्य १९३२

दक्षिण अफ्रीका से भारत आगे पर १९१५

दक्षिण अफ्रिका से पहले सत्याग्राही १९१४

भारत छोड़ो १९४२

बेरिस्टर १८९१

संपूर्ण स्वराज्य १५ अगस्त १९४७

विद्यार्थी १८८७

FATHER OF NATION

बापू ने जो दीपा जलाया उसकी ज्योती बढ़ायें हम

जन्म २-१०-१८६९

देहांत ३०-१-१९४८

बापू जी की अमर कहानी

अमर भारतात्मा

Turning from the corpse to the corpus, the Mahatma himself wrote to Pyarelal on 15 November 1947, about ten weeks before his brutal killing, that 'Death at a stroke is better than death by inches.'[62] At a prayer meeting on 21 January 1948 – the evening after a failed attempt to kill him – he told his audience (in Hindi), 'If a bomb explodes in front of me and if I am not scared and succumb, then you will be able to say that I died with a smile on my face. Today I do not yet deserve to be praised.'[63] Arguably, Gandhi was at his most disobedient – in this case, to his own principles – in death, the apostle of non-violence longing for a violent end.

So, how might a bloody unnatural ending be visually conjured up as perfect and peaceful, as *ichchha mrityu* (desired death)? One possible example is the finale to a beautiful narrative fresco completed sometime in the 1950s, likely commissioned by G.D. Birla, on the walls of the prayer hall in Birla House, a few feet away from where the Mahatma was murdered (Figure 4.16).[64] In this work by the Santiniketan-trained Kripal Singh Shekhawat (1922–2008), a protégé of Birla's, Gandhi is painted walking with his arms around Abha and Manu, and is then shown as a prone body around which white flowers are scattered; there are no bullet holes or gushing blood, let alone a terrifying assassin, to mark a violent passing, the flower blossoms signalling on the contrary that this might well have been a blessed moment for the Mahatma. In Cruzo's *Death is Our Own*, the bare-bodied Gandhi is painted contemplating a human skull that he holds firmly in his hands. Because he sits with his back to us, it is impossible to tell whether he views the skull with terrified horror or with eager expectation, although it is clear from the artist's description that it is Gandhi's intense desire for death that he intended to convey with and in this work. 'Nothing else is truly ours. Earthly possessions, pride of pomp and peace, we shed them all in the end. To us, death is the starkest reality. It is the only thing that is part and parcel of our being. We are creatures that crumble into dust and ashes.'[65]

Figure 4.18 (above) - K.R. Ketkar, *Amar Bharat Atma* [Immortal soul of India], *c.* 1948. Chromolithograph published by Ketkar Art Inst., 28.5 x 21 cm. Collection of Erwin Neumayer and Christine Schelberger, Vienna.

Figure 4.19 (below) - P.L. Malhotra, *Bapu ke Antim Darshan* [Bapu's Last Sighting], *c.* 1948. Chromolithograph published by Hem Chander Bhargava, Delhi. Image courtesy Christopher Pinney.

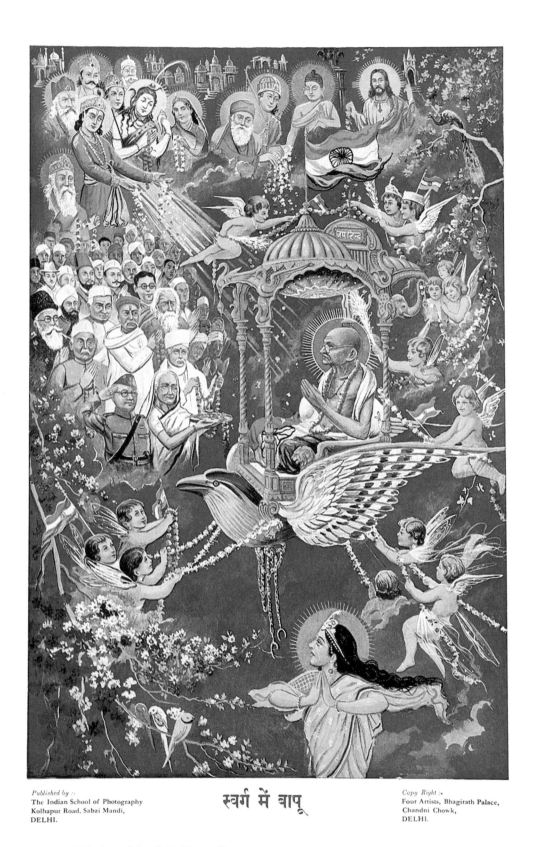

स्वर्ग में बापू

Figure 4.20 - *Svarg Mein Bapu* [Gandhi in Heaven], *c.* 1948.
Chromolithograph published by Indian School of Photography, New
Delhi, 48.9 x 34.7 cm. Image Courtesy Osianama Research Centre,
Archive & Library Collection.

In the colourful world of bazaar prints which largely circulated in arenas quite removed from art works displayed in museums and galleries, there is little of the visual melancholia that permeates paintings produced at the other end of the art spectrum. Instead, desire mingles with pleasure, even joy and 'the strength of coolness'[66] in the very moment of death when Gandhi truly became sovereign and free, his body liberated from its 'mortal frame.'[67] Such prints revel in the violence of the unnatural passing. Instead of pain, the Mahatma's bullet-ridden body is in the thrall of a vital effervescence, visually translating his verbal assertion that 'the art of dying for a satyagrahi consists in facing death cheerfully in the performance of one's duty.'[68] So, in a painting by L.K. Sharma, subsequently transformed into a mass-circulating print in which the Mahatma's life is recalled in visual vignettes from the time of his birth through the various highlights of his career until the time of his death, based mostly on much-circulated photographs, Gandhi stands tall and smiling in the centre of the image, as the life-blood from the three bullet wounds drips on to the map of the nation for which he had sacrificed his life (Figure 4.17).[69] Of course, there is no photographic referent for the martyred figure, given also the absence of the camera at the scene of the murder. In K.R. Ketkar's imagination, the fumes rising from Gandhi's funeral pyre, which also reworks photographs from 31 January 1948, materialize into the smiling face of the 'immortal' Mahatma beaming down upon the cremation of his mortal remains, the vapours also reproducing a cruciform map of India, so inseparable are Gandhi's slain body and the geo-body of the nation (Figure 4.18). In P.L. Malhotra's *Bapu ke Antim Darshan* (Bapu's Last Sighting), Gandhi's corpse lies in state on the eve of its cremation surrounded by some famous mourners – a citation, again, from contemporary photographs (Figure 4.19). The artist, however, adds a non-mimetic element in a smiling Gandhi, a large halo around his head, offering his blessings from up above with an outsized hand in the abhaya mudra, the gesture of fearlessness. Is Malhotra giving us a last glimpse of Gandhi's corpse, or of his post-mortem afterlife when his cremated body is reassembled and restored to its former state (such a state based on his much-photographed mortal look)?

Indeed, many artists who painted such colourful images for mass circulation and consumption are emboldened to imagine a life after death, even what heaven might have looked like for Gandhi. Vasudeo Pandya's *Swargarohan* (Ascent to Heaven) has a garlanded (and rather youthful) Gandhi ascending in an ornate bejeweled pavilion to the realm above, waiting to be greeted by Hindu gods and goddesses, even as he beams down upon earth and blesses the geo-body of the nation, bathed in the glow of a rising sun (Figure 4.21). Similarly, in a print by the veteran artist Narottam Narayan Sharma, many of the chief mourners are modelled on their appearance in the contemporary photographic record. Gandhi's corpse, after its cremation on the pyre, is miraculously restored to wholeness and fleshly plenitude as the bullet-free body ascends to heaven, smiling, bowing, and offering its blessing over the deadly drama below.[70] When the Mahatma reaches heaven, as we learn from prints such as *Svarg Mein Bapu* (Figure 4.20), he is greeted by a medley of characters who confirm that as in his life, in his afterlife as well, he favoured a plurality of faiths: this is a heaven populated by devoted patriots (even potential rivals like Bal Gangadhar Tilak and Subhas Chandra Bose), Hindu deities, Sikh gurus, and a fez-headed man standing in for the generic Muslim. Heaven is also the place where Gandhi meets the Buddha and Christ, and indeed there are numerous prints which establish a pictorial equivalence between the three (although such equivalence is sometimes attempted as well by gallery artists like Upendra Maharathi, Cruzo, Masoji, and some others).[71] Such prints also appear to visually translate a statement made by Sarojini Naidu on 1 February 1948 in a speech that critic Makarand Paranjape argues inaugurates Gandhi's haunting of India. 'Like Christ of old on the third day he has risen again in answer to the cry of his people...'[72]

In their imagination of a Gandhian afterlife, such mass-produced pictures are also indebted to images of paradise to which other earlier nationalist martyrs,

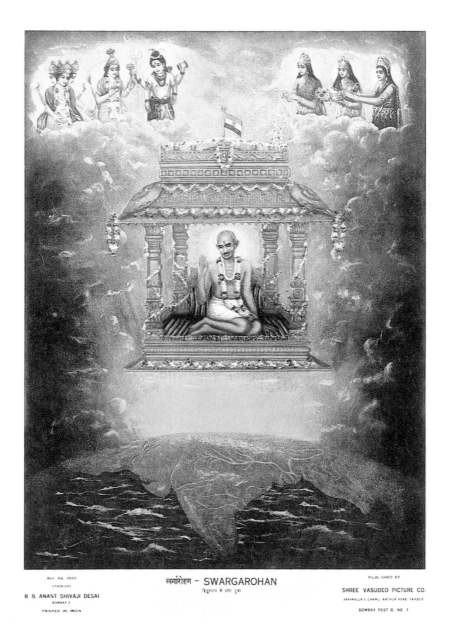

स्वर्गारोहण – SWARGAROHAN
हिंदुस्तान में उमा हुआ

such as Bhagat Singh, ascended (although given their socialist proclivities, there are no gods waiting to receive these other patriots, as they do Gandhi), as in fact to a rich iconography of the heavenly abode in Indic traditions.[73] Thus, the artists of the patriotic bazaar are able to imagine a fulfilling afterlife for Gandhi and establish an equivalence between him and the immortal gods, in contrast to much of modernist art in which, as philosopher Gregg Horowitz argues, the end of life is not absorbed by the beginning of an afterlife elsewhere. 'Death,' Horowitz writes, appears in modernist art 'without a narrative of transcendence to reflect additional layers of meaning back on it from another scene of life... In modernist art, death does not appear as the prehistory of the significance that will be unveiled in its wake; it simply persists... Modern aesthetics and modernist art alike are born of a perception of the finitude of sensuous life.'[74]

Figure 4.21 - Vasudeo Pandya, *Swargarohan* [Ascent to heaven], 1948. Chromolithograph published Shree Vasudev Picture Co. Bombay, 47.3 x 34.1 cm. Image Courtesy Osianama Research Centre, Archive & Library Collection.

'He Ram': The Graphics of a Pious Death

True, modernist artists in India – in contrast to their bazaar brethren – are rarely able to imagine the Mahatma beyond the finitude of his earthly sensuous life, or grant him immortality in heaven, keeping cheerful company with his chosen deities, or locate him in an enchanted Elsewhere in the aftermath of his violent killing. For them, *his death simply is*. Yet it would be a mistake to think that their works, which circulated in more rarified circles than bazaar prints, can in any simple way be deemed secular, for they too are not entirely immune from the driving imperative to show Gandhi dying a pious death.

Taking their cue from his insistence that as one must learn to kill in the training for violence one must also learn to die in the training for non-violence,[75] several commentators have noted that the art of dying for the Mahatma necessarily involved taking with his last breath God's name, specifically the name of Lord Rama, even when faced with the horror of violence. The earliest occasion when this resolve was put to test reportedly was 10 February 1908 in Johannesburg when Gandhi was assaulted by Mir Alam Khan in the course of the protests against the so-called Black Act. 'I at once fainted with the words *He Rama* (Oh God!) on my lips, and lay prostrate on the ground and had no notion what followed,' he was to recall several years later.[76] Fast forward to forty years later to the night before his assassination, Gandhi reportedly declared to Manu (while she was massaging his tired feet), '[if] somebody shot at me and I received his bullet on my bare chest, without a sigh and with Rama's name on lips, only then you should say that I was a true mahatma.'[77] In the aftermath of his murder the next evening, a counternarrative that questioned the veracity of Gandhi's last words surfaced, with his detractors insisting that the Mahatma died uttering 'the faintest Ah!'[78]

In the necro-aesthetic regime that emerged around Gandhi's death in the immediate aftermath, there is no doubt regarding the last utterance. The words 'He Ram' were written out in rose petals next to the corpse readied for cremation. Visual and material culture has subsequently ensured the performative fecundity of these two words, underscoring that the godly cannot be ignored in picturing Gandhi's passing.[79] The words were etched in the official Nagari script on the memorial stone planted by April 1948 on the spot where Gandhi was gunned down, with the date and time carefully inscribed, as seen in a photograph attributed to his grandnephew Kanu (Figure 4.22).[80] The memorial stone covered a large hole created when grieving followers and souvenir seekers scooped up the earth from the spot where the Mahatma fell, as captured by the Associated Press photojournalist Max Desfor on 1 February 1948 (Figure 4.23).[81] Gandhi's dying words were also recreated in the Nagari script with flowers at Raj Ghat in January 1949 on the occasion of the Sarvodaya Divas exhibition, as well as later inscribed on the black granite slab installed on the spot where his body was cremated, as they are on the martyrs' column erected in the 1970s in Birla House/Gandhi Smriti, again in the Nagari script (Figure 4.24).

In the world of fine art, the Goan artist Laxman Pai (b. 1926), among the first to serially visualize the life of Gandhi, showed the dying body, hands held together in his last gesture of namaskar to Godse, the words Shri Ram – a variant on 'He Ram' – tattooed on his chest, once again in the Nagari script.[82] In a linocut that is part of the 1995 Postcards for Gandhi series, Baroda-trained Yunus Khimani absents the dying body but summons back Gandhi through his paltry material possessions: his handmade sandals, his glasses, his staff (now broken), and the words 'He Ram' painted in

Figure 4.22 - Kanu Gandhi, Memorial slab with inscription, 'Hey Ram, 30-1-48, 5.17, Evening', Birla House, New Delhi, 1948. Courtesy National Gandhi Museum, New Delhi.

the Nagari script at the top of the image (Figure 3.42). The words also appear on one of Atul Dodiya's latest canvases in his ongoing melancholic engagement with the Mahatma, a triptych titled *Koodal* (an homage as well to another master artist, Tyeb Mehta) in which three black dots reference the bullet wounds on Gandhi's chest (Figure 4.25). In a work by the Mithila artist (trained in Baroda) Santosh Kumar Das, a visual critique of Gujarat Chief Minister Narendra Modi who in the land of Gandhi had not followed the latter's

ideals, the words 'He Ram' graphically summon back the Mahatma, shown as a supine body at the bottom of the painting.[83]

Switching media and genres, the two words are also inscribed in A. Ramachandran's recent 7-feet bronze sculpture, itself a revised version of a similar work from 2012, with the Nagari letters now added below the crimson-hued single bullet hole drilled into the smooth bronze surface of the Mahatma's back (Figure 4.12). The words had already stood in for

Figure 4.23 - Max Desfor, *Hindu women mourn within a bamboo enclosure at the rear grounds of Birla House, New Delhi, marking the spot where Mohandas K. Gandhi fell when he was shot on Jan. 30, seen Feb. 1, 1948.* © AP Images.

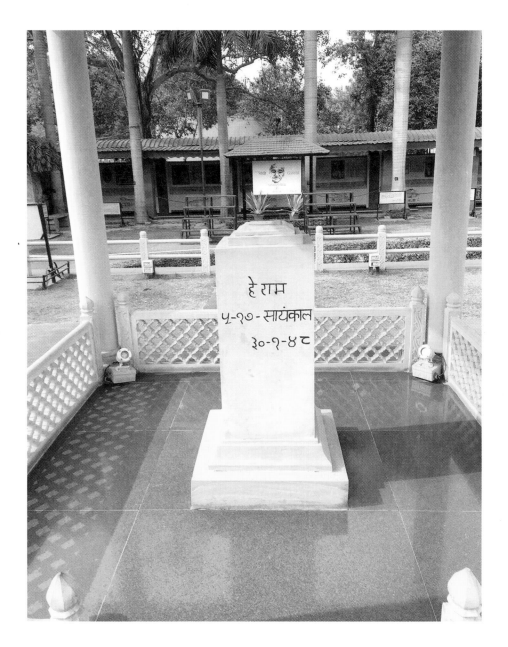

Gandhi's death two decades earlier in a postcard-sized painting by the artist in which the slain Mahatma is visually recalled as a single hand firmly clutching his staff (Figure 4.26).[84] In his own time, Gandhi was a proponent of the Hindustani language, with the utopian hope that all Indians would learn to write the language in both the Nagari and Persian scripts. Yet in the aftermath of his earthly life – and in the wake of the partition of British India which unleashed enduring linguistic consequences – this utopian hope is shattered. Even in the hands of artists of Muslim upbringing like the Paris-returned Sayed Haider Raza (1922–2016), it is the Nagari rendering of the words that is produced luminously on the surface of a 2013 canvas (Figure 4.27). A viewer familiar with the necro-aesthetics of this murderous moment does not need more to conclude that Raza's painting is about Gandhi and his death; the two words 'He Ram' suffice.

It is noteworthy that Raza commenced his series of seven works on Gandhi with this painting, among the

Figure 4.24 - Martyr's Column with Inscription, 'He Ram, 5-17, Evening, 30-1-48', Gandhi Smriti, New Delhi. Author's Photograph.

Figure 4.25 - Atul Dodiya, *Koodal* (Triptych)
2016. Oil, crackle paste and marble dust on canvas,
each panel, 198.12 x 137.6 cm. Overall installed size:
198.12 x 411.48 cm. With permission of the artist.

last he produced on the eve of his own death in 2016. Here is how the poet and literary critic Ashok Vajpeyi recalls the moment: 'One late afternoon in 2013, barely two years after his residence in India, I found him doing a canvas in very subdued hues. I was intrigued since his usual geometrical shapes were not there. When we met in the evening, he told me that he had decided to do a set of Gandhi paintings. The painting in question was the first one which had the last words of the Mahatma as he fell down dead to the bullets of his assassin saying 'Hey Ram.' It is appropriately sombre, subtly refuses to be an end-of-it-all-work: it has a significant use of white – indicating both purity and hope but also engulfing the canvas with the mist or cloud of sadness. The solid column seems to suggest a certain defiance and stubbornness: the body killed but the spirit surviving.'[85] Vajpeyi also notes that Raza recalled, 'My greatest disappointments, akin to unhappiness, were

Figure 4.26 - A. Ramachandran, Untitled, 1995.
Ink and gold paint on paper, 14.6 x 8.9 cm.
With permission of artist and Sahmat, New Delhi.

में राम

in 1948 when Mahatma Gandhi was assassinated... [he] had mobilized the country as one magnificent source of power. The British with all their might had to leave India and it was independent. And then the father of the nation was killed. No other incident had this acute pain and distress in my life.'[86]

Indeed, so indelibly has the phrase 'He Ram' come to be associated with the moment of Gandhi's passing

that another of his grandsons, Gopalkrishna, reflecting recently on Topolski's paintings of the murder (Figures 4.13 and 4.14), reads it into his grandfather's dying gesture as painted by the artist, *even in its absence*. 'The dying man is doing something as life ebbs out of him. He is speaking and his raised hand is also part of the message that is being conveyed. Is "Rama" on his mind in the painting? I am certain he is.'[87]

Figure 4.27 - Sayed Haidar Raza, *He Ram*, 2013. Acrylic on canvas, 59.69 x 59.69 cm. With permission of Raza Foundation.

नाथूराम गोडसे मदनलाल आप्टे

Figure 4.28 - *Nathuram Godse Madanlal Apte,*
c. 1949. Print, 25 x 18.5 cm. Collection of Erwin
Neumayer and Christine Schelberger, Vienna.

How to Paint an Assassin, or Not

Gandhi, of course, remains a hyper-visible presence in the Indian national landscape, although his hallowing has also meant his inevitable hollowing. But what of his assassin, the man named as Nathuram Vinayak Godse?[88] What place has he been, or should be, accorded in the same landscape? Does the slaying of one of the most recognizable men of his time also confer instant recognizability on his killer? In fact, sketching, painting, or otherwise visualizing the murderous moment produces a profound representational dilemma for artists who are drawn to picture this most foundational of national moments: To paint or not to paint the figure of Godse, and how to do so? Does picturing him and placing him in the same frame as Gandhi run the risk of conferring upon the assassin some of the aura that only modern art can arguably bestow in our secular time(s)? As Nehru put it in his emotional broadcast to the nation on the night of the assassination, 'A madman has put an end to his life, for I can only call him mad who did it.'[89] Why even bother to make visible on a painter's canvas a 'madman,' a man whose very name the Prime Minister could not utter that fateful night? Does not the refusal, however, run the risk of making the assassin invisible, and also shore up the argument voiced in the immediate aftermath of the killing, not least by the Prime Minister himself, that the nation itself was responsible for the Mahatma's murder. In other words, does leaving him out of the picture let Godse off the patricidal hook – also problematic because the assassin himself proudly took responsibility for the act?

Adding to these representational burdens confronting the artist is the fact that there is no photograph of the moment when the Mahatma faced his murderer, or indeed, of any other instances of the two of them together. In the absence of a photograph – with its famed indexical capacity to capture and certify presence – what can the artist source to image the murderer, and the moment he came face to face with the Mahatma? A few photographs of Godse do exist in the public domain to which the artist can turn. Several are drawn from the historic trial that began a few months later in May 1948 in New Delhi, leading to his execution the following year.[90] Godse's impassive face in these photos gives little purchase for the artist's imagination to grasp, although some do try, as the anonymous artist of the bazaar who imagined the moment of his hanging (Figure 4.28). Two differently clad but identical-looking men (named 'Nathuram Godse' and 'Madanlal [sic] Apte') face the viewer; their hands and legs are shackled and nooses hang over their heads. Godse's calm look is at odds with a key eyewitness report of the moment when the two men walked to the gallows. 'Godse walked in front. His step occasionally faltered. His demeanour and general appearance evidence a state of nervousness and fear. He tried to fight against it and keep up a bold exterior by shouting every few seconds the slogan "Akhand Bharat" (undivided India). But his voice had a slight croak in it, and the vigour with which he had argued his case at the trial and in the High Court seemed to have been all but expended.'[91]

Not least, how can – and should – the artist, and indeed, we the viewer of the resulting artwork, respond to the fact that the so-called apostle of non-violence rather unnaturally – and going against the grain of his long-held beliefs – desired a violent ending?[92] If the Mahatma might well indeed have forgiven his murderer as he secured his death wish, his iccha mrtyu, on that fateful evening, how do we – and India's artists – visually contend with the man who made Gandhi's death wish come true? Might he have been a good 'son' after all, obediently performing the greatest service for and on behalf of his father?[93]

Confronted with such representational burdens and political-ethical questions, how do artists respond? Some duck the issue altogether. Atul Dodiya,

arguably the contemporary artist who has invested the most in bringing the Mahatma (back) to life on his canvases, insists that he would never ever paint Godse in his company.[94] Similarly, Kripal Singh Shekhawat's moving fresco in Birla House/Gandhi Smriti has no place for an assassin in its complex visual narrative (Figure 4.16). On the contrary, Gandhi appears to have died the most ordinary of deaths, even the most peaceable. More recently, a graphic novel intended for children narrates moment by moment the last few minutes of the Mahatma's life, visually taking us to the brink of his last breath. Switching at this point to a verbal register that eliminates the need to picture the assassin, the author names Nathuram Godse as a 'Hindu fanatic' who 'fired three shots – one into the stomach and two in the chest... Blood stained his white clothes. He inhaled gun smoke. His frail body sank to the earth.' The young reader is then told, 'Mohandas Karamchand Gandhi was no more... a Mahatma was born instead, to live on for centuries to come.'[95] Even in works that do not shy away from showing the violence of the passing, such as Upendra Maharathi's *The Fate of Three Men* (Figure 4.1), A. Ramachandran's *Monumental Gandhi, Version 2* (Figure 4. 12), or Gigi Scaria's *Touch My Wound* (Figure 4. 8), the man responsible for the bullet wounds and the gushing blood is missing.

Some artists who are loathe to engage directly with the figure of Godse turn instead, as I have already noted, to his revolver, to be precise, the M1934 Beretta semi-automatic pistol that was crucial material evidence in the Gandhi murder trial. Among the close to 600 postcard-size paintings produced for the Postcards for Gandhi project in 1995, the assassin's murderous weapon paradoxically rivals even Gandhi's spinning wheel, his simple sandals, and his rustic staff as an object on which the artist lavishes attention. Thus, the revolver appears in two other works by Nalini Malani (in addition to the untitled work in Figure 4.10) in her six-part series titled 'Once Upon a Time There Lived a Man.'[96] In Shibu Natesan's stark linotype, the revolver is pointed at a pair of spectacles, the assassin and his victim summoned to the canvas metonymically through these artifacts (Figure 4.30). In the manner of a crime scene photograph, Sunil Das's work places the revolver next to pools of blood, with an arrow pointing to the spot where Gandhi apparently fell.[97]

It not just Indian artists who appear to be inexorably drawn to the fatal weapon. As we have seen, Felix Topolski's canvases incorporate a gun ominously (but suggestively) next to the falling Mahatma (Figures 4.13 and 4.14). A painting gifted to the National Gandhi Museum by Indonesian artist D. Wira has a smiling Gandhi looking at us, a smoking gun placed in front of him on the blood-red carpet. The murder weapon puts in an appearance in cinema posters, in book covers and illustrations, and also in chromolithographs printed in the aftermath of the assassination. It is pointedly placed near Gandhi's feet in Lakshminarayan Sharma's *Bapuji Ki Amar Kahani*, little puffs of smoke suggesting that the artist had captured the act as it was happening (Figure 4.17). In Dina Nath Walli's *Evolution of Gandhi*, the Mahatma stands tall and smiling on a globe, as blood from his three carefully placed chest wounds drips down to a map of India, the assassin's gun resting by his feet and next to the bloody puddle.[98] An important variant is A. Ramachandran's untitled work produced in 1995 for the Postcards for Gandhi project in which the assassin's 'foul hand' is admitted into the frame, the lethal revolver turning into a long-barrelled gun, which visually parallels the Mahatma's staff (and hand) (Figure 4.26). A disembodied hand pulling the trigger features in a single panel of the *Amar Chitra Katha* comic book on G.D. Birla in whose New Delhi mansion the murder occurred, Gandhi responding with the words 'Hey Ram' [sic]. [99]

Then, there are works in which artists do not shy away from drawing or painting the assassin, but they

Figure 4.29 (pgs 164-65) - Sachin Karne, *Ambush*. Oil on canvas, 182.8 x 121.92 cm. With permission of the artist.

do so in a generic fashion, as in Figure 4.28, rather than as an identifiable figure who bears any sort of fidelity to the flesh-and-blood Godse. Thus, in the immediate aftermath of the assassination, Prabhu Dayal (some of whose prints we encountered in Chapter 2), created two different scenarios of the fateful encounter between the Mahatma and his assassin, in the absence of the camera fixing the moment. In one scenario, the artist sketches the micro-second when Godse fires the fatal shot, the trail of the bullet fired from his revolver occupying the very centre of the print, Gandhi still upright even as the blood from his torso begins spewing to the ground.[100] In another, Dayal paints the moment after Godse fires his shots; the people gathered for prayer surge into action, some cornering the assassin – a revolver prominent in his hand – while Abha and Manu reach for the Mahatma's body, now in free fall under the force of the bullets that had hit his body; others mill about in a state of shock and obvious distress.[101] In an intriguing chromolithograph also printed in the aftermath of the assassination, the assassin is assimilated into the mythical figure of Jara who, it was prophesized, would kill Lord Krishna. As is typical of the representation of the 'perfect death' moment in mass-produced art, Gandhi stands smiling and even happy, as blood streams out of his wounded body.[102]

Switching genres, another *Amar Chitra Katha* comic book titled *Mahatma Gandhi: Father of the Nation* shows the assassin's head in profile pointing his gun at the falling Mahatma, a sunburst visually highlighting the work of the murder weapon.[103] The assassin is neither named, nor the focus of the image. In 1970, in the popular magazine *Illustrated Weekly of India* (read mostly by an English-speaking middle class), one of its principal illustrators, Shabbir Diwan, painted the cover for a special issue published on Republic Day which revisited the murder of the Mahatma. Gandhi is shown in the process of falling, clutching at his chest as blood seeps through his

white shawl, the watch suspended from his waistband registering the time of death as his killer faces him, his back towards us. The centre of the picture is focused on the hand that pulls the trigger. As in most such images, the assassin is shown in a generic fashion as an Everyman, dressed in khaki, brandishing a gun. No attempt is made to show him realistically, neither is he necessarily the focus of the work.[104] This is also true of works from the other end of the artistic spectrum, like Ratan Parimoo's 1957 canvas where the assassin is painted an ominous black figure moving towards a bare-bodied Gandhi, his arms draped about his two grandnieces,[105] as he is in the canvas by M.F. Husain that I discussed earlier (Figure 4.7). In a recent canvas simply titled *Ambush*, Vadodara-based Sachin Karne, some of whose other works we have already encountered in an earlier chapter (Figures 3.32 and 3.34), paints a generic-looking man in uniform, advancing upon an invisible victim, a revolver poised to fire in his hand (Figure 4.29). Beautiful but deadly-looking vines signify that the scene for the murder-to-happen is a garden. Neither victim nor perpetrator are named, the power of the work heightened by the unstated – and understated – visual claims of the violence about to be unleashed.

In striking contrast, Debanjan Roy's untitled acrylic painting places both the victim and the perpetrator within the same frame, even fusing their faces (Figure 4.15). The image recalls a provocative observation made by Godse towards the tail end of his lengthy written statement from which he read at his trial on 8 November 1948, 'Really speaking, my life also came to an end simultaneously with the shot fired by me at Gandhiji.'[106] Indeed, Roy's image reminds us that Gandhi and Godse have come to be irreparably connected on account of the murderous act and moment. As opposed to the other artworks considered in this chapter where Godse is a generic figure, Roy's resembles the assassin's likeness made (somewhat) familiar by his trial photos. In fusing their faces in this

manner, is Roy drawing our attention to the *reverential intimacy* that Gandhi's assassin established with Gandhi? 'I am prepared to concede that Gandhiji did undergo sufferings for the sake of the nation. He did bring about an awakening in the minds of the people. He also did nothing for personal gain... I shall bow in respect to the service done by Gandhiji to the country, and to Gandhiji himself for the said service, and before I fired the shots, I actually wished him and bowed to him in reverence.'[107]

Indeed, there are striking resonances between Gandhi's own utterances about Hinduism and Godse's in the latter's chilling testimony, including their stated adherence to the *Bhagavad Gita*. As historian Vinay Lal notes in a fine analysis of the murderous moment, reminding us that Godse folded his hands in the familiar greeting of namaskar before firing his bullets into the Mahatma's chest, 'Misguided though he thought Gandhi may have been, his assassin nonetheless recognized him as a devoted servant of the nation who strangely deserved both respect and a sentence of death.'[108]

If nations are indeed founded in assassinations,[109] and if Gandhi got not what he deserved but apparently desired, where indeed does this leave the artist who wishes to picture the Mahatma's murderer? Gandhi might well have demonstrated in word and deed that there is a fine art to dying, but the artists who have painted the murderous moment in the aftermath of his killing are left between a rock and a hard place, between the peril of invisibilizing the assassin, and the risk of making him visible, a risk that is all too palpable in contemporary India where Godse's hard-right followers have sought to commemorate him by erecting statues and building temples, even restaging the moment in macabre performances.[110]

As I bring this chapter to a close, I underscore that any analysis of the art that has emerged around Gandhi's death not only has to contend with the representational dilemma posed by the figure of the assassin, but also has to recognize that artists who turn to visualize the murderous moment can – and do – draw upon other examples as distant as Christ's crucifixion (and subsequent resurrection and ascension), and as proximate as Bhagat Singh's execution in 1931, the pictorial representations of which have cast a long shadow over how the Mahatma's dying body is artistically recalled. Even with such precedents, I would argue that Gandhi's death is singular because of who he was, when he died, the (unnatural) manner in which he died, and also because of his insistence in word and deed that there is a fine art to dying. Singular though the biological fact of his death was, a plurality of meanings has proliferated about and around the instance of his passing, a plurality also assured by the fact that he died as I noted a camera-free death which liberated that decisive moment from the clutches of profane realism, even as the excess of photography that followed in the immediate wake ensures the return of the dead. Mimetic and non-mimetic ways of recall collide within this necro-aesthetic regime, as do the contrary pulls of grieving melancholia and joyful effervescence. Not least, with the pressing imperative, especially in the face of the rising tide of Hindu nationalism, to grant Gandhi his dying wish that he should leave this world with Rama's name on his lips, divinity has been smuggled back into the work of even those artists who otherwise are not drawn to the Mahatma's fervent religiosity (which, incidentally, is rarely a subject that commands their attention). Such indeed is the force of (his) death, an ending like none other in our secular times.

Figure 4.30 (facing page) - Shibu Natesan, Untitled, 1995. Linocut, 14.6 x 8.9 cm. With permission of Sahmat, New Delhi.

5
THE CANVAS OF DISOBEDIENCE

'But only he who has mastered the art of obedience to law knows the art of disobedience to law. Only he who thoroughly knows how to construct may destroy.'[1]
– *Mohandas Karamchand Gandhi*

A decade before his murder, Gandhi issued 'a warning' to his followers on the occasion of his seventy-first birthday in October 1939. 'Some would like to erect my statues in public places, some others would have portraits, yet others would proclaim my birthday as a public holiday... These are days of dissensions and discord. I should feel deeply humiliated if my name became in any way an occasion for accentuating them. Avoidance of such opportunity is a real service to the country and me. Statues, photographs and the like have no place today. The only praise I would like and treasure is promotion of the activities to which my life is dedicated.'[2]

Repeatedly though and across the visual spectrum, artists of India ranging from the popular to the elite have rejected the Mahatma's appeal to 'avoid the opportunity' of memorializing him in art and image. Instead, in what might be characterized as wilful disobedience, they have lavished upon him a kind of aesthetic attention that no other political leader of his time (or since) has received. If in 1927, on the occasion of Frieda Hauswirth's visit to Cuttack to sketch him, his followers lamented that 'the country is flooded with bad pictures of him' and that no good artwork on him existed, we hear a similar plaint in 1945 from art critic G. Venkatachalam. 'His seemingly unattractive face has a dignity and charm which no camera has so far succeeded in recording and which only a few artists have been able to sense and recreate in their pictures. Most of them, however, have succeeded in making him look uglier than he is. His real portrait still remains to be done; or will it ever be done at all?'[3]

In this book, I have not been at all interested in asking whether India's artists – past and present – have succeeded in producing a 'real portrait' of the Mahatma, let alone in judging whether they have turned an ugly man into a beautiful being (or vice versa). Instead, my interest lies in exploring why and how they have persisted in making him the focus of such intense and intensive aesthetic contemplation and visual attention. As we have seen, this is a process that began soon after Gandhi's permanent return to

Figure 5.2 - Jagannath Panda, *The Icon*, 2008.
Acrylic and fabric on canvas, 259.1 x 142.2 cm.
With permission of the artist.

Figure 5.1 (pg 170) - Ashim Purkayastha, *Gandhi: Man Without Specs IX*, 2006. Acrylic on postage stamps, 22.8 x 25.4 cm. Set of 100 postage stamps. With permission of the artist.

Figure 5.3 - Vivek Vilasini, *Vernacular Chants II*, 2007. Archival print on hahnemule photo paper, 9 works (93.98 x 83.82 cm). With permission of Aicon Gallery, New York.

India from South Africa in January 1915. It accelerated over the next decades as he became the moral face and force of the Indian national movement, criticisms and alternative candidates notwithstanding. Almost all known major – and many minor – artists were drawn to portray him in some fashion, sometimes multiple times across different media and genres (each with a varying reach and effect). The artworks produced during these decades translated into the realm of the image the Mahatma's words and deeds, making these available for varied forms of visual consumption, and unleashing new itineraries of interpretation and meaning-making.

As importantly, I have noted that a large majority of these works singularize him, abstracting him from the very movement that made him possible (confirmed by numerous photographs of the man, frequently lost from view in the midst of his vast following). The multitude is effaced – repeatedly – to enable the Mahatma to be visually consolidated as a unique icon, unparalleled and incomparable. Indeed, at a national exhibition held in early 1949 in New Delhi to mark the first anniversary of his violent death, the words, 'He walked with the multitudes, and yet alone,' were inscribed below a giant print based on a well-known photograph by one of his grandnephews, Navin (the brother as well of Dhiren, some of whose woodcuts we encountered in Chapters 1 and 2).[4] The artist of disobedience appears to be, ironically, complicit with the operations by which a hyper-icon was created and consolidated, even in his own lifetime and clearly against his expressed wish.[5] The result is a rather 'obedient' art of disobedience, with virtually little visual censure of known failings and foibles. It is worth underscoring this, given that in the discursive realm and the world of words, there has been plenty of criticism of the Mahatma, even in his lifetime.

In the decades immediately following India's independence, Gandhi did not fade in the image realm. On the contrary, his violent passing within a few months of the nation's liberation from colonial rule, assured him a ubiquitous if banal presence in the visual landscape of Nehruvian India, also bolstered by a systematic (if underfunded) project of memorialization carried out through non-governmental institutions

such as the Gandhi Smarak Nidhi (Gandhi Memorial Fund). In such memorialization, his image has been central, materializing him in the face of his loss in flesh, presence, and voice. In museums and memorial spaces set up in these decades, artworks on the Mahatma were collected and commissioned, displayed and enshrined, but also forgotten and carelessly discarded over the years. Photographs were collated, curated, and exhibited, but also misremembered and mislabelled. Commemorative activities routinized him in clichés and platitudes, bringing also to mind a statement by a biographer of another comparable leader from another context, 'We have sought to remember him by forgetting him.'[6] Within days of Gandhi's death, enthusiastic citizens and local and provincial bodies across the nation undertook with great enthusiasm a kind of ad hoc memorializing that led Prime Minister Nehru as early as 25 February 1948 to issue an official admonition against such well-meaning but misplaced devotion:

> All over India there is a tendency to name roads, squares and public buildings after Gandhiji. This is a very cheap form of memorial, and a certain satisfaction is gained without expense or exertion. Almost, it seems to me, that this is exploiting his name, and a showing off that we honour him without any effort on our part. Even more undesirable is to change famous and historical names which have had a distinction of their own. If these tendencies are not checked we shall have thousands of roads and parks and squares named after Gandhiji. That will not contribute either to conveniences or to the glory of the Father of the Nation. Only confusion will result as well as a certain drab uniformity. Most of us will then live in Gandhi Roads, in Gandhinagars, or Gandhigrams.[7]

Despite this public chastising, such 'cheap' memorializing continued apace over the next two decades, peaking in the years leading up to the Gandhi centenary celebrations in 1969, an extravaganza that also marked a new low as far as many Gandhians

Figure 5.4 (facing page) - Gigi Scaria, *Caution! Men at Work*, 2015. Watercolour and automotive paint on paper, 182.88 x 152.4 cm. With permission of the artist.

(and some artists) were concerned, including the proliferation of his image in currency and coins, postage stamps, and calendars. His face and figure were everywhere, his ideas and ideals less so.

In particular, the craze for erecting statues continued unabated despite efforts by Gandhians to remind everyone periodically that the Mahatma wrote vehemently against being transformed into a statue.[8] Over the years, some of India's best sculptors

– artists of the stature of Devi Prasad Roy Chowdhury and Sankho Chaudhuri – were drafted into projects that yielded some landmark art, as we have seen (Figures 3.8 and 3.28). Most Gandhi statues dotting the national landscape are, however, the work of indifferent, even hack artists. As early as February 1948, Nehru lamented, 'The standard in India of such statuary has been low and most people are satisfied with anything that bears a remote resemblance to the person concerned.'[9] Similarly, in November 1965, in the run up to the Gandhi centenary celebrations, a Member of Parliament complained in that august assembly that these installations 'had become so ugly and ridiculous that they have become a laughing stock and create improper feelings among the people for Gandhiji's statues.'[10]

B.C. Sanyal, a veteran artist who had captured Gandhi in a memorable sketch on the eve of the Mahatma's death, put it most acerbically in his memoirs, 'Donors and devotees were busy dotting the Indian landscape with three-legged – one stick and two stick legs – Gandhi statues which, I am sorry to say, were neither Gandhi nor art!'[11] Other artists have turned to image work to cast aspersions on what we might call Gandhi statue mania. Thus, in Jagannath Panda's ironically titled work *The Icon*, the artist offers a visual commentary on the cruel fate visited upon the typical Gandhi statue in our time as it comes to be festooned in faded garlands, or serves as a perch for birds and their droppings (Figure 5.2).[12] Vivek Vilasini's *Vernacular Chants II* confirms that the endless reproduction of Gandhi's visage in street statuary can (and does) lead to distortion to the point of making the familiar face

unrecognizable (Figure 5.3). Gigi Scaria's *Caution! Men at Work* visually underscores the public hollowing out of a haloed figure, the emptying of substance (Figure 5.4). Placed on a pedestal, the half-completed statue of the sandal-wearing dhoti-clad Gandhi, his waist-watch prominently on display, stands poised to go somewhere. However, he has nowhere to go in an India that has abandoned him.

Such images are from a new millennium marked by a shift in the manner in which Gandhi is figured in contemporary artworks, as not so much an end in himself but a means to another end. In contrast to painters and sculptors of the colonial and Nehruvian periods, today's gallery artists largely produce works for an elite global art world (although the internet allows their works to reach beyond circuits for which they might be formally intended). It may seem surprising that they take on the figure of the Mahatma with such interest and intensity, given the risk they run of their work being assimilated into 'the kitschy imagery of Gandhi or interpreted as merely praising the father of the nation.'[13] Yet they persist and persevere, for, as one of them, Riyas Komu, insists, Gandhi is 'beacon, warning, and provocation.'[14] As such, they are drawn to critique the rejection in contemporary India of Gandhian ideas of pluralism and non-violence, the unseemliness of his ubiquitous iconicity and mass branding, and his utter absence even while seeming to be everywhere, as in Debanjan Roy's *Absence of Bapu* in which Gandhi's paltry possessions – his reading glasses, a book, his leather sandals and his wooden khadau, and a statuette of the three monkeys – are carefully arranged on a white fibreglass mattress and guarded over by an armed soldier in fatigues. The Mahatma as figure, however, is nowhere in the picture (Figure 5.5). In such works, the artist as adulator is radically supplemented by the artist as conscience-keeper, albeit still a rather 'obedient' one.

I track this critical shift in artistic sensibility, and indeed, in the complex that I would characterize as the 'obedient' art of disobedience, to a landmark exhibit that I have alluded to several times in these pages: 'Postcards for Gandhi,' conceived in 1995 by the New

Delhi-based Sahmat. Let us compare this show to another symbolically important exhibition mounted in 1949, partly with the blessings of the government. Presided over by Gandhians (who should have known better, given the Mahatma's ambivalence regarding art as well as the camera), the core of the Sarvodaya Divas (or Gandhi Mandap) Exhibition was constituted by over 2,000 photographs and close to 200 art works on Gandhi, many produced over the previous decades, several since his death. The organizers noted that they were considerably challenged in putting together the show, for 'there is a glut of paintings and other portrayals of Gandhiji in the country which cannot pass any test.' Flooded with such works, many quite mediocre, the organizing committee chose the most meritorious, given that 'one of the objects of any exhibition of the type of Gandhi Mandap is to bring to the forefront what is adjudged to be good, fair or passable for the guidance of those concerned.'[15] The venue for displaying these was Raj Ghat, the site where a year earlier, Gandhi's corpse had been cremated at dusk on 31 January 1948. Almost overnight, and not surprisingly, the site turned into a focus of intense mourning, melancholia, and memorialization, and remains to this day the centrepiece of state-sponsored rituals of and for remembering the dead father of the nation.

The Gandhi Mandap exhibition was formally opened on 30 January 1949 on the first anniversary of Gandhi's murder, and indeed, several works reprised that moment, including an arresting woodcut by Vinayak S. Masoji, *Thy Will be Done, 30.1.48* (Figure 5.8), a work that anticipates biographer Robert Payne's words from two decades later, 'In the life and death of Mahatma Gandhi we see re-enacted in our time the supreme drama of humanity: that a prophet should arise and sacrifice himself so that others may live.'[16] Alongside such visual elegies were placed well-known works such as Nandalal Bose's *Dandi March* (Figure 3.20), Jamini Roy's *Bapu*, Upendra Maharathi's *Pilgrim's Progress*, K.C.S. Paniker's *Father of the Nation*, Masoji's *Midnight Arrest* (Figure 3.25), and Abanindranath Tagore's luminous painting of

Figure 5.5 (facing page) - Debanjan Roy, *Absence of Bapu*, 2007-2010. Fiberglass with acrylic paint, 167.64 x 182.88 x 121.92 cm. With permission of the artist and Akar Prakar Gallery.

Gandhi with Tagore and Andrews (Figure 2.12), many of them re-presented to a new generation of viewers in a hugely visited exhibition. Several of these works were subsequently sold, while others were gifted to a proposed institution that would eventually become the National Gandhi Museum, which in the past decades has become a repository of numerous artworks, mostly done in a reverential vein.

In contrast, the Postcards for Gandhi project was conceived and executed by secular artists, some of them amongst the biggest names of the Indian art world of the postcolonial generation, while others, emerging painters and photographers then, have since become the stars of the contemporary art scene. The project was also unusual in showcasing the work of female artists who engaged with the figure of Gandhi in ways that mark in some regards a critical departure from their male counterparts, and a subject that demands a full analysis in its own right. Equally innovative was the fact that the show opened simultaneously in six major cities across India (Ahmedabad, Bangalore, Bombay, Calcutta, Madras, and New Delhi) on the

occasion of the Mahatma's 125th birth anniversary on 2 October, although not a single work focused on his birth as a visual event, and indeed many returned to the moment of his death. The organizers invited 100 artists from across the nation to produce six postcard-size paintings each, and all 600 were then printed and displayed in the course of the exhibition, which in itself was preceded by a year of lectures and performances, a painting workshop titled 'Remembering Gandhi' for schoolchildren, and the release of illustrated books for youngsters by artists Shamshad Husain, Madhvi Parekh and Haku Shah.

It is not possible to offer a detailed analysis here of all of these artworks and their preoccupations, although I have discussed several in the previous chapters, but it is worth underscoring the manner in which the artistic community that Sahmat pulled together chose to 'address' Gandhi, sending a 'postcard,' which visually condensed the woes, anxieties, and the fears, but also the aspirations and desires of the nation to the father of that nation.[17] That the collective effort of these artists should result in the (re)emergence of

Figure 5.6 - Debanjan Roy, *India Shining I (Bapu with Laptop)*, 2007. Aluminum cast, 55.88 x 116.84 x 76.2 cm. With permission of the artist/Aicon Gallery, New York.

the Mahatma as a singular figure worthy of intensive aesthetic attention is worth noting, for across this body of work, Gandhi appears as the nation's conscience, and its saviour. After decades of circulating in the aftermath of his death as an image without substance, he was back as an image *with* substance, and more.

That this should have been enabled by artists, many of who openly and consciously associated themselves with India's intellectual and cultural Left, which historically had been at odds until then with Gandhi and Gandhianism, is not least of the remarkable ironies at work here. Faced with the rising tide of Hindu nationalism in the 1990s as well as economic liberalization, the Left has discovered in Gandhi a new icon of secularism and pluralism to rally around rather than an outdated spiritualist to shun. 'As the members of Sahmat saw Indian politics move away from the modern, secular, and socialist legacy of the national movement, they felt compelled to defend the nation's cultural space against the imposition of a monolithic Hindu-based identity.'[18] With his capacious pluralism, his rejection of consumerist capitalism, and his tolerance for righteous difference, Gandhi became a crutch, and increasingly, a guiding light for these artists. The show itself received fulsome coverage in the news media, also a topic worth analysing more fully than I can do here. The *Economic Times* noted that the postcard-paintings 'are poignant reminders of a lost legacy, of the sturdy idealism, the now fragmented vision of a secular united India,' and two other commentators similarly noted that the exhibit underscored that 'we have lost the essence of the Mahatma. All we have left is a convenient figure to commemorate every now and then.' The *Indian Express* headlined its coverage, 'The Mahatma does not live here anymore.'[19]

Indeed, in the aftermath of Postcards for Gandhi show, other exhibits of recent years with titles such as 'Looking for Bapu,' or 'Re-Imagining Bapu,' are indicative of the acute concern among his postcolonial adherents that Gandhi is missing in action from the hustle and bustle of contemporary India. Once India is emptied of Gandhi's presence, other most un-Gandhian things have rushed in to fill up the landscape: religious intolerance, violence directed towards minorities, runaway consumption, the growing inequalities produced by the advance of global capital, and the fetishizing of technology that makes us all perhaps a little less human, a little less Gandhian. For Gandhi, in contrast to most moderns, 'machines were the epitome of all that is harmful and

Figure 5.7 - Debanjan Roy, *India Shining VI: Walking the Dog*, 2009. Fiberglass with acrylic paint, 116.84 x 38.1 x 35.56 cm (Gandhi); 27.94 x 45.72 x 17.78 cm (dog). With permission of the artist/Aicon Gallery, New York.

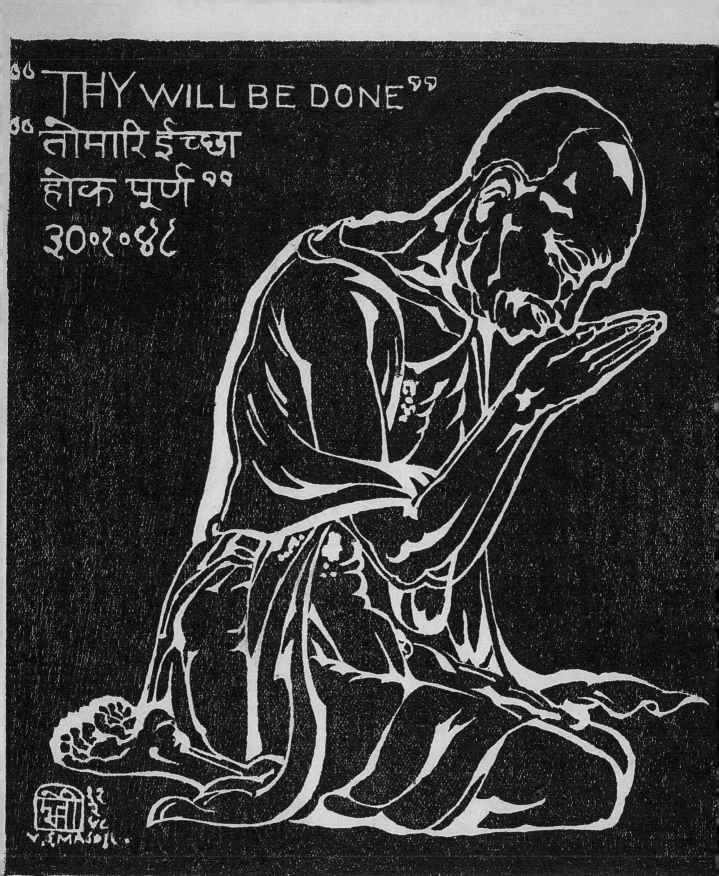

"THY WILL BE DONE"
"तोमारि ईच्छा होक पूर्ण"
३०।२।४८

Vinayak S. Masoji. (wood-cut)
Santiniketan.

oppressive in "modern civilization" and the soulless, avaricious modernity that threatened to overwhelm and further impoverish India.' In historian David Arnold's words, 'If the utopia of Gandhi's imagining is a land innocent of modern machines, the dystopia that threatens to engulf it is essentially machine made.'[20] In large and small sculptures fashioned between 2007 and 2010 by Debanjan Roy from fibreglass and aluminum (and painted in a bright automotive red), the Mahatma appears seduced – like the rest of us – by modern gadgetry as he sits poised over a laptop, listens to his Ipod, speaks on his cellphone, or dons a pair of headphones, all along wearing a big smile on his face (Figure 5.6). In *India Shining VI: Walking the Dog*, rather than practising the sartorial and somatic disobedience that was key to his rejection of modern materialism as I noted in Chapters 2 and 3, Roy casts Gandhi as a worldly flaneur, clad in baggy pants and trainers, talking on his cell phone instead of using the occasion of his walk to engage in inner contemplation and reflection, his bamboo staff transformed into a dog leash (Figure 5.7). Has the great experimenter with truth become, like the rest of us, an experimenter with the alluring (but arguably dystopic) technologies of our times? Is this the only way in which he might appeal to the 'selfie' generation?

There is something disorienting about the Gandhi we encounter in such works, but that is precisely the point as they seek to get the viewer to reflect upon what has been done with and to the Mahatma over the decades, and particularly with his image by all manner of banal forces. 'How do we retrieve him from his busts and statuary at roadside corners, city squares, from postage stamps and rupee notes?' asks Gulammohammed Sheikh, some of whose beautiful works we have encountered in these pages (Figures 2.13, 2.22 and 2.23).[21] Faced with the clichéd circulation of his image, the contemporary artist seeks to rescue Gandhi, creating a (new) 'safe' space for him via the hallowed circuit of fine art. In the process, Gandhi becomes the new crutch, an aesthetic prop for conducting disobedient politics by other means, as is readily apparent in numerous projects such as 'Gandhigiri,' 'Freedom to March,' and 'Through the Eyes of the Artist,' to name a handful from one

random year, 2010. This also means it is through the work of art that Gandhi has been re-auratized and made relevant again in a country and in a context where he has become largely peripheral. The artist emerges as Gandhi's new conscience-keeper, as I have suggested, as the nation itself is urged through such works to connect to its (lost) conscience. There is a considerable measure of irony here in that Gandhi was no admirer of art for its own sake, as I have noted, and would perhaps find many of the ways in which he is being appropriated by the contemporary artist bewildering, perhaps even incomprehensible. And yet, I believe he would also be sympathetic to the fact that just as he sought through his creative disobedience to stretch the boundaries of the political, these artists as well are doing so by bringing to visibility that which is politically yet unimaginable, difficult to state in word, and perform in deed.

All the same, rarely is Gandhi subjected to a searing visual critique by most artists for whom he has become a necessary anchor for their own political and social activism. There are exceptions, although these underscore the rule. In a series revealingly titled *Gandhi: Man Without Specs*, Bengali-speaking Assamese artist (based in New Delhi) Ashim Purkayastha (b. 1967) provocatively disfigures and reconfigures the familiar face so ubiquitous on postage and revenue stamps to draw attention on the one hand to what has been done with a man who has been claimed by every cause and ideology, even those apparently contrary to Gandhi's philosophy and beliefs. Even fascists can apparently make him their own (Figure 5.1). On the other hand, the very title of the series, and of individual works such as *You Call Him Father of the Nation, I Call Him Man Without Specs* (2006), suggests that the Mahatma lacked foresight, and indeed might well have turned a blind eye to a lot that was wrong around him, including and especially structural casteism. *Man Without Specs IX* (in which in all but one in a sheet of 100 postage stamps, Gandhi's face morphs into Hitler's) brings to mind the futile attempt by the Mahatma to reach out to the German dictator in his "dear friend" letters of July 1939 and December 1940. Is the artist also flagging the paradoxical dependence on the opponent's violence that is so essential for non-

Figure 5.8 (facing page) - Vinayak S. Masoji, Untitled (inscription 'Thy Will be Done, 30.1.48'), 1948. Woodcut on paper, 17.8 x 16.5 cm. With permission of DAG, New Delhi.

Figure 5.9 - J. Nandkumar, *Gandhi After Pune Karar*,
2010. Acrylic on canvas, 167.64 x 137.16 cm.
With permission of the artist.

violent disobedience to shine? As art historian Kavita Singh writes astutely, 'As Ashim does the undoable, we become able to think the unthinkable.'[22] Such is the complexity of these works which inaugurates multiple readings, contrary and ambiguous.

In the work of artists of Dalit and Bahujan Samaj backgrounds, there is no ambiguity, as apparent in recent paintings by Aurangabad-based artist J. Nandkumar (b. 1963), which unequivocally reject Gandhi's self-anointed role as the saviour of Harijans, transforming him dramatically instead into a slayer (Figures 5.9 and 5.10). In both paintings, Gandhi stands astride a Dalit body that he has nailed to the earth with his *trishul*-shaped staff, a cobra around his neck poised to finish the job. The titles of both paintings hark back to an important landmark in India's political history, the signing of the Poona Pact in 1932, which for electoral purposes denied separate status for Dalits (or Depressed Classes as they were then labelled by the colonial state). 'On reading the Pune Karar [Pact], I felt that Gandhiji was no longer an embodiment of peace, as I had earlier thought him

to be. This led me to express my ideas in the form of a painting. So, when the organizers asked me to withdraw the painting from the show, I gave them two options – cancel my exhibition altogether, or let it continue in its present way. The outcome was inevitable.'[23] The artist here refers to the shockwaves produced by his work when displayed in a Mumbai show in 2010. This kind of censorship has not, however, either stopped Nandkumar or other young artists like Pinak Bani (b. 1987), who too have visually taken Gandhi's complicated but essentially conservative position on caste to task (Figure 5.11).[24] Bani pulls no punches in his artist's note on his *Chamber of Non-Violence at the National Freedom Struggle Museum* (which also reproduces some of Nandalal Bose's colourful Haripura posters):

> The National Freedom Struggle Museum hosts the memoirs of the Mahatma, the self-attested Messiah of the oppressed and archetype of Ahimsa, in the Chamber of Non-Violence. Among the worldly remains of the Mahatma in the central display, showcases one four-fold pyramid, symbolic of his enduring devotion to the divinity of Varnashrama and a sample 5 kg Pure Lead metal bar, which used to be melted and poured through the ears of the Shudras who disobeyed the rules of Varnashrama. The Museum authority continues to voluntarily provide such samples of pure lead bars to premier institutions of national importance to uphold the rule of Varna through Ahimsa.

The 'anytime exit' sign in Bani's digital photomontage points to the way out of such a caste-saturated society sanctified by the Mahatma, although it is not entirely clear whether what lies beyond the glass doors of 'the National Freedom Struggle Museum' is the caste-free utopia longed for by the oppressed.

On the other hand, other recent works such as Riyas Komu's *Dhamma Swaraj* (Figure 5.12) and Gigi Scaria's *Secularism Dismantled* (Figure 5.13) shows us why in the current climate, it is difficult for the contemporary artist of the progressive ilk to make Gandhi too much

Figure 5.10 - J. Nandkumar, *Gandhi After Pune Karar*, 2011. Acrylic on canvas, 121.92 x 91.44 cm. With permission of the artist.

Figure 5.11 - Pinak Bani, *'Chamber of Non-Violence' at the National Freedom Struggle Museum*, 2017. Digital montage, 50.8 x 46.99 cm. With permission of the artist.

of a target of denunciation, both works attempting a reconciliation in the image realm of Gandhi and B.R. Ambedkar, two 'saviour' leaders who have been pitched against each other in the political culture of our times.[25] In Gigi Scaria's words, 'It is very important to evoke the name of Gandhi at this hour when the secularist position and critical thinking are constantly attacked by religious fundamentalism.'[26] In Riyas Komu's estimation, it is important to bring these two leaders together to counter the rise of majoritarian Hinduism which challenges the legacy of both men.[27] In light of such pressures, including the very real and symbolic ways in which Gandhi's image has been appropriated by forces completely antithetical to his message and meaning, the artist-as-conscience-keeper, it is fair to say, has found it difficult to turn into a sustained critic, let alone an outright denouncer.

Art critic Geeta Kapur has insightfully noted that Gandhi is India's 'abiding abstraction.'[28] This short book has documented the manner in which the visual artist in Gandhi's own time, and especially in the aftermath of his violent death, has participated in, and indeed been critical to, the production of this abiding abstraction. Each transformative moment in the life of the nation and each anniversary from the life and career of the father of that nation has resulted in a new outpouring of work, most immediately the occasion of the 150th anniversary of his birth when among other grand events, the Mahatma became the focus of the India Pavilion at the 2019 Venice Biennale, likely the art world's premier marquee event. Gandhi, it seems, has finally 'arrived' on the international global exhibitionary circuit through the mediation of the artist and the artwork.[29] In the words of curator Roobina Karode, 'Gandhi is a man of his own time as much as ours.'[30]

Of course, it has been one of the founding arguments of this book that Gandhi has been made relevant in and to our time because of the consistent, systematic, but varied artistic investment in him. I have not sought to be comprehensive in my account, but my goal certainly has been to demonstrate the range of ways in which the Mahatma's disobedience along three critical axes has become a subject of aesthetic contemplation. Despite the rich variation and complexity, the general thrust of this body of artwork has been to stabilize Gandhi's form and message across diverse media, making him iconographically secure

Figure 5.12 - Riyas Komu, *Dhamma Swaraj: A Triptych*, 2018. Oil on canvas, 137.16 x 182.88 cm. With permission of the artist.

and visually familiar. Curiously and ironically, at the heart of the art of disobedience is a cult of obedience that has so far not been seriously or systematically breached.

Yet it would be a mistake to assume that India's artists are alone responsible for 'obediently' stabilizing his visual persona and disobedient message, for the other key argument of the book has been to show that Gandhi himself, despite his ambivalence about the work of art and the mediating role of the image, was very much a co-creator. That the artist of India today recognizes that the Mahatma indeed is a fellow artist, an inspiring muse, *and* a critical prop to think with, is beautifully captured in the closing image with which I end this book, a photograph by the New Delhi-based Ram Rahman (Figure 5.14). It captures a playful

moment in late 1994 in the lead-up to the Postcards for Gandhi project when Rahman photographed his friend, the Baroda painter Bhupen Khakhar (1934-2003) seated in the lap of a giant Mahatma statue gifted by a Russian sculptor to the Gandhi Darshan complex in 1987.[31] On the one hand, the painter appears to be receiving the blessings of the Mahatma, the putative father of his nation, and the ultimate artist's muse, as I have argued. On the other hand, the clever composition of the photograph – only possible because of the shrewd collaboration between Khakhar and Rahman, and dare I say, Gandhi – underscores the constitutive role of the artist in ensuring the auratic presence of the Mahatma, who has had an afterlife like none other in the life of the nation, and one that is likely impossible without the labour of art.

Figure 5.13 - Gigi Scaria, *Secularism Dismantled*, 2018. Inkjet on archival paper, 60.96 x 91.44 cm. With permission of the artist.

Figure 5.14 (facing page) - Ram Rahman, Bhupen Khakkar posing with a statue of Gandhi, New Delhi, 1994. Photograph. With permission of the photographer.

NOTES

I THE MAHATMA AS MUSE

1 Forster 1949: 388.

2 With some exceptions, the scholarship on Gandhi has been resolutely textual with a privileging of word over image. For some exceptions, see Guha-Thakurta 1995, Bandyopadhyaya 2004, Pinney 2004, Ramaswamy 2009, Brown 2010, Sinha 2013, Lal 2014a, and Bawa 2018.

3 I have been inspired here by Weber 2015, a compendium of first encounters with Gandhi but which does not include a single Indian artist.

4 http://www.chitralekha.org/articles/m-k-gandhi/portraits-mahatma-gandhi, last date of access 6 June 2019. All statements I quote by Dey in these pages are from this source. Although Dey dates this portrait 'Madras, 1918,' Gandhi was not in the city that year. He visited Madras from March 18 to 23, 1919, and then passed through again on March 30 on his way to Vijayawada (Gandhi's inscription using the lunar date of the Vikram Samvat calendar also allows us to date his meeting with Dey to March 1919). For Dey's place in modern Indian art, see especially Mitter 2007, *passim*.

5 For photographs from just around this time of Gandhi by N.V. Virkar, see Tendulkar 1951: 312–313. Gandhi had cut off his *shikha* on the eve of his departure for London in 1888 but restored it soon after his permanent return to India in 1915, saying he had been motivated by 'false shame' when he first discarded it (Gandhi 2018, 603-606).

6 Dey 1948.

7 *CWMG* 36: 176 (For a later brief testimonial in which Gandhi called upon God to bless Dey, see *CWMG* 85: 150). C.F. 'Charlie' Andrews, the Anglican missionary who befriended Gandhi in South Africa in 1914 (and remained a confidant until his death in 1940), had first met Dey in London in his studio in 1922 on which occasion, the artist reportedly gifted his first portrait of the Mahatma to him.

8 On the concept of the bio-icon, see Ghosh 2011.

9 *CWMG* 15: 510.

10 Thakkar and Mehta 2017: 100. He had also become the butt of jokes, as in 'Girding his loins to mop seacivilization,' published in *Hindi Punch* on his birthday in 1921 (Tarlo 1996: 78).

11 Furst 1925: 93. Despite my best efforts, I have been unable to trace this portrait. On Fyzee-Rahamin, see especially Mitter 2007: 207–10.

12 *CWMG* 30: 79; 177.

13 *CWMG* 46: 304.

14 Hauswirth 1930: 171, 175. Urmila Devi was Congress leader C.R. Das's sister. Reportedly she told Frieda, 'Other religious devotees go to Puri, to Benares, to Nasik, or Rameswaram. Somewhere at least once a year, I go to meet Mahatmaji; that is *my* annual pilgrimage!' (ibid, 175, emphasis in original).

15 Hauswirth 1930: 171. See also http://lakechapalaartists.com/?p=5830, last date of access 8 June 2019.

16 Hauswirth 1930: 171–91.

17 The most widely acknowledged foreign female artists to have painted Gandhi (and with his consent) are likely the Hungarian mother and daughter, Elizabeth Sass Brunner (1889–1950) and Elizabeth Brunner (1910–2001). For a recent analysis, see Bani 2019.

18 Earlier, Mirabehn had resisted Frieda's request to sketch Gandhi reportedly insisting, 'He never consents. He is opposed to such things, and moreover you know he is ill and tired. One could not expect him to pose' (ibid, 179–80). Mirabehn herself turned at some point to sketching, and Gandhi went to the trouble of forwarding her work to the great Santiniketan artist Nandalal Bose, on whose words of praise, see *CWMG* 65: 381.

19 For her exchange with Gandhi about her famous cousin, see Sheridan 1949: 273–74. For her busts of Churchill, see Black 2017: 49–55, 112–20. She wrote to Churchill in December 1942 that he 'had not been easy to model but not nearly as difficult as Gandhi, who had insisted upon sitting on the floor with a spinning wheel! She knew this would needle her cousin, who could not abide Gandhi!' (ibid., 117).

20 Kaul 2014: 81–87.

21 Years later, Davidson recalled, 'My first impression was: "What a homely man this is. His ears stuck out and a front tooth was missing, showing a black space when he grinned. This impression only lasted a split second. Suddenly

Gandhi appeared beautiful' (Davidson 1969: 17). Like other artists, Davidson too, complained of difficulties he faced. '...Gandhi acted as I were not in the room, as if in fact, I did not exist. He simply continued to ignore me. It generally takes two to make a portrait – the sitter and the artist. In this particular case, however, I had to do it all by myself, as I received absolutely no help from the sitter' (ibid., 18). For James Mills' photograph of Davidson in the act of sculpting Gandhi's head, see ibid., 17.

22 Davidson 1969: 18–19. Davidson also records an exchange with Gandhi about clay and mud. When the sculptor showed him photographs of his work, Gandhi apparently said, 'I see you make heroes out of mud.' 'And I retorted, "and sometimes vice versa." Gandhi laughed and agreed to sit for me...' (ibid., 17).

23 https://mumbaimirror.indiatimes.com/mumbai/other/a-bronze-bust-of-gandhi-with-a-churchill-connection/articleshow/60067118.cms, last date of access 8 June 2019.

24 Linlithgow's hope was that Sheridan's bust would eventually 'find a permanent home in the national capital.' Gandhi wondered if the Viceroy had stirred up 'a hornet's nest... You are sure to have protests against the acceptance' (*CWMG* 72:147). See also Weber 2015: 153.

25 Black 2017.

26 On Nandalal Bose, see especially Subramanyan 1983–84, Kowshik 1987, Guha-Thakurta 1995, Mitter 2007, Quintanilla 2008, Subramanyan 2008, and Siva Kumar 2013.

27 Bose 1944: 230. See also Bose 1999: 231.

28 Bose 1944: 234.

29 Dinkar Kowshik offers two possible dates, 1920 and more likely, 1936 (Kowshik 1987: 52–55, 85). Partha Mitter dates the first sighting to 1922 (2007: 82), and K.G. Subramanyan to 1925 (Bose 1999: 232n.3). See also Bose 1944: 230. Gandhi visited Santiniketan – the rural retreat of his important interlocuter Rabindranath Tagore – numerous times, beginning in early 1915 soon after his return to India from South Africa. He even appealed to wealthy donors in 1942 for support, noting that the art school deserved more than the Institute of Science in Bangalore. Indeed, they could 'never give too much to Santiniketan' (*CWMG* 76: 117; see also Mitter 2007: 82–83, and Figure 1.1).

30 Bose 1944: 230.

31 Bose 1999: 232. For Gandhi's favourable response to Nandalal's work, see *CWMG* 62: 299–300.

32 Bose 1999: 233. For a slightly different recollection of the same moment, see Bose 1944: 231. For Gandhi's praise of Bose's work at the Khadi and Village Industries Exhibition in Faizpur, see *CWMG* 64: 170–72.

33 For Gandhi's speech at the Khadi and Village Industries Exhibition in Haripura and praise of Nandalal's accomplishment, see *CWMG* 66: 357–59.

34 Kowshik 1985: 87.

35 Bose 1999: 236–37.

36 Bose 1944. Gandhi in turn responded to this characterization by insisting, 'I have already told you who is a true artist. Nanda Babu comes very close to my ideal, though perhaps he is not the perfect ideal. However, he is so big a man that it would be highly improper for me to say anything in criticism of him' (*CWMG* 79: 194).

37 Dodiya 1999.

38 Shah 2014, epigraph.

39 Subramanyan 2007: 231.

40 *CWMG* 64: 171.

41 *CWMG* 25: 250. See also *CWMG* 23: 193.

42 *CWMG* 10: 407n3; 43: 420; and 66: 326. See also his diagrams of 'the grand figure' of the constellations of the sky in *CWMG* 49: 299 and 314. 'The drawings which we ourselves make will be much better for our purpose than those we find in books' (ibid., 312). For a rough sketch from 1915 of "warp and woof," see *CWMG* 96: 225.

43 *CWMG* 39: 18. See also Ibid., 25: 243-44, 324. At the same time, writing also was 'a fine art' (*CWMG* 65: 234).

44 *CWMG* 79: 193–94.

45 *CWMG* 43: 356.

46 *CWMG* 59: 317.

47 *CWMG* 43: 215.

48 *CWMG* 58: 6.

49 *CWMG* 66: 357.

50 CWMG 21: 218, 395; ibid., 87: 197.

51 *CWMG* 25: 249.

52 *CWMG* 23: 193. See also ibid., 26: 41.

53 *CWMG* 25: 249. See also ibid., 23: 193.

54 *CWMG* 53: 220. See also ibid., 32: 229.

55 *CWMG* 63: 416.

56 *CWMG* 25: 248.

57 *CWMG* 59: 328. See also ibid., 88: 304.

58 *CWMG* 36: 305.

59 Quoted in Thakkar and Mehta 2011: 189. For Gandhi's praise of a 'White-clad India,' including his statement that 'many of us don't like colours, as they are of foreign make,' see *CWMG* 20: 451. For influential – and upper-class – Gandhian women's resistance to Gandhi's penchant for undyed white, see Tarlo 1996: 110–11.

60 *CWMG* 83: 265.

61 The noted author and art critic Mulk Raj Anand recalled a wide-ranging talk with Gandhi in the 1930s when the latter confessed that although he was a great admirer of John Ruskin's *Unto the Last* – indeed, reading that book in 1904 profoundly transformed him, as we know – he had not read the famous Victorian's books on art, since 'his own service of the people from day to day had prevented him from reading extensively

about Art' (Anand 1969: 2). This little-cited interview complicates claims made by scholars regarding the importance Gandhi gave to the arts (Anand 2003; Parel 2016).

62 Chettiar 2007: 7. For similar complaints by contemporary foreign photographers, see Kaul 2014: 71–122.

63 Pinney 2008: 18. The earliest studio photographs of Gandhi date from his boyhood, and there is also a body of photographs – some grainy, others in which he is part of larger groups – from his London days as well as his twenty or so years in South Africa.

64 Gandhi 1948: 93.

65 *CWMG* 3: 212. See also ibid., 5: 407; 6: 444; 7: 199, 10: 180, etc.

66 CWMG 10: 370. See also ibid., 6: 305, 342–43, 348.

67 *CWMG* 7: 212.

68 *CWMG* 44: 192.

69 *CWMG* 9: 556.

70 Tarlo 1996: 67. Until about 1921, as Tarlo demonstrates, Gandhi experimented with various forms of headwear as a sartorial marker of difference and distinction.

71 CWMG 5: 419–23. See also Gandhi 1928: 161–73.

72 For another artwork that repurposes this photograph in an altogether different manner, see Atul Dodiya's *Barrister in Johannesburg, 1908* (2013).

73 *CWMG* 3: 342–43.

74 *CWMG* 7: 156.

75 *CWMG* 3: 343–43, 366, 405; *CWMG* 4: 273, etc.

76 *CWMG* 6: 346.

77 Quoted in Hürlimann 2007: 134.

78 Mittler and Ramaswamy 2019.

79 *CWMG* 30: 177. See also *CWMG* 32: 409.

80 *CWMG* 35: 231.

81 CWMG 47: 357.

82 *CWMG* 79: 364.

83 *CWMG* 81: 185.

84 *CWMG* 61: 88n1. See also ibid., 90: 521n1.

85 *CWMG* 92: 243.

86 *CWMG* 40: 330.

87 *CWMG* 97: 228; see also ibid., 238.

88 *CWMG* 70: 221

89 *CWMG* 26: 309.

90 Gandhi 2007: xix-xx.

91 Barthes 1981: 6.

92 Edwards 2011: 47.

93 Nagy 1997: 73.

94 Foster 2004.

95 *CWMG* 97: 135.

96 CWMG 26: 309. See also ibid., 7: 212; 82: 12, and 83: 260–61.

97 *CWMG* 84: 393.

98 Venkatachalam 1945, n.p. The Mahatma himself was more charitable than the art critic, his own scepticism in this regard notwithstanding, and frequently appended his name and signature to various works, as we saw with Mukul Dey's portrait.

2 THE ART OF BARING

1 Twain 1927: 6.
2 Quoted in Payne 1969: 404. These historic meetings are the subject of numerous works, including Tendulkar 1952: 67–81 and Herman 2010: 347–63. For a fairly widespread perception in the West at this time that Gandhi was not the most handsome of men, one journalist even pronouncing him 'the ugliest man I have ever seen,' see Sclamer 2011: 13.
3 Quoted in Herman 2010: 359, emphasis added.
4 *CWMG* 77: 391–92, emphasis added. See also Herman 2010: 360, 538–39. For a contemporary artist's retort to Churchill, see Riyas Komu's paintings *Black and White* (2014), *Gandhi from Kochi* (2015) and *Oru Jathimadam* (2019). The artist notes that he drew inspiration from a 1931 photograph of Gandhi that 'shows a fakir standing defiantly against a violent world' (https://www.theweek.in/theweek/cover/2019/06/21/gandhi-projects-my-experiments-with-time-artist-riyas-komu.html, last date of access, 25 November 2019).
5 Scalmer 2011: 16.
6 Gandhi's secretary Pyarelal notes that when his close associate C. Rajagopalachari worried over his 'naughty' letter to Churchill, the Mahatma insisted that 'he meant it seriously' and that 'it was his ambition to become completely naked – literally as well as metaphorically – the latter being of course the more difficult' (Pyarelal 1956: 33, 578). See also *CWMG* 77: 478.
7 Tarlo 1996: 33–42. See also Levine 2008. As a younger man, Gandhi shared similar views as, for instance, when he was reported to have expressed concern at a public meeting in Bombay in 1896 about the colonial state's attempts to 'degrade' Indians living in South Africa, reducing them to the level of 'the raw kaffir' (African) who passed 'his life in indolence and nakedness' (*CWMG* 2: 53. See also ibid., 9: 58, 231; 10: 49).
8 *CWMG* 20: 251.
9 Tarlo 1996: 62–93.
10 *CWMG* 12: 38–39.
11 *CWMG* 16: 287.
12 Tarlo 1996: 81. I chart a different course from Emma Tarlo, who writes that for Gandhi, 'the loin cloth was the dress of necessity not desire' (Tarlo 1996: 74). See also Lal 2000.
13 Masquelier 2005: 8.
14 Levine 2008: 190.
15 For Gandhi's criticisms of 'the modern girl,' especially for her sense of dress and deportment, see Guha 2018, 531–533. Although Gandhi's experiments in the pursuit of celibacy have not (yet) provoked the Indian artist's visual censure, it is important to recall his insistence that a perfect brahmachari (celibate) would be 'capable of lying naked with naked women... without being in any manner whatsoever sexually excited' (quoted in Pyarelal 1956: 591).
16 Reproduced in Neumayer and Schelberger 2008, Figure 127.
17 Reportedly on the occasion, the two men 'joked freely and shared in merriment over Churchill's lurid accounts of the "half-naked fakir"... Gandhi had apparently forgotten his shawl. At once Lord Irwin picked it up, remarking with a gentle smile, "Gandhi, you haven't so much on, you know, that you can afford to leave this behind"' (Tendulkar 1952: 71).
18 Scalmer 2011: 17.
19 Quoted in Kaul 2014: 71, emphasis added.
20 Tendulkar 1952: 138–74, Hunt 1993: 175–208, Herman 2010: 364–75, and Guha 2018: 379–96.
21 Quoted in Herman 2010: 368. To recall, Claire Sheridan and Jo Davidson, who we met in the earlier chapter, were among these 'famous artists and sculptors.' For the proliferation of Gandhi in the visual culture of the period in Britain in photographs, sketches, and cartoons, see Tendulkar 1952.
22 Quoted in Herman 2010: 369.
23 Quoted in ibid., 370.
24 Hoare's recollection as reported in Hermann 2010: 374. See also Hunt 1993: 195–96, Kaul 2014: 99–102, and Guha 2018: 393–94.
25 Quoted in Tarlo 1996: 81. A contemporary report quotes him as observing, 'It would be a discourtesy to the King of England if he (Gandhi) should go to dinner in Buckingham Palace in any attire other than his accustomed dhoti [loincloth]' (*The New York Times*, 1 May 1931: 34).
26 Scalmer 2011: 17. See also a cartoon attributed to Reynolds and published in the *Morning Post* captioned 'Reciprocal Courtesies,' which clothes Churchill in a dhoti (and a scowl) and Gandhi in a Churchillian outfit, complete with a cigar (reproduced in Tendulkar 1952, n.p.). See also Kaul 2014: 102.
27 Krishnadas 1928: 203. See also Gandhi's important statements, 'My Loin-Cloth,' in *CWMG* 21: 225–27 and ibid., 24: 456–58. See also Tarlo 1996: 71–74.
28 *CWMG* 48: 26.
29 *CWMG* 48: 79.
30 Scalmer 2011: 16. Note also that one of the common understandings of the English word 'loin' (or 'loins') is 'the region of the sexual organs, esp. when regarded as the source of erotic or procreative power.' The Gujarati word that Gandhi used for the garment was *kacch*.
31 Tarlo 1996: 82. See also a similar photograph titled 'Gandhi entering the sea for a bath at Cape

Comorin, January 1934' (Tendulkar 1952: facing 328). In a volume published in 1944, this same photograph is poorly reproduced with the caption 'Harijan Tour, 1934' (Tendulkar et al. 1944: n.p.). It is likely that such photographs were frowned upon, and perhaps taken unbeknownst to Gandhi (Chettiar 2007: 52).

32 See also Dodiya's recent oil-on-canvas titled *Sea Bath, Dandi, April 6, 1930*, completed in 2017.

33 Tarlo 1996: 78.

34 Nehru 1958: 110.

35 Years later, although he was recovering from a punishing fast and indeed, on the very eve of his death, Nehru's sister Krishna Hutheesing commented after a visit with the Mahatma on how 'his bare brown body was absolutely glowing' (Kapoor 2015: 305. See also Khosla 1963: 206). Another witness interviewed just a few years ago by artist Gigi Scaria for his film *Raise Your Hands Those Who Have Touched Him* (2007) recalled that the Mahatma's skin shone 'like copper.'

36 For a contemporary artist's appropriation of the same image, see Debanjan Roy's *India Shining 7 (Gandhi Sharing Ipod)*, 2009 (http://www.aicongallery.com/artists/debanjan-roy?view=slider#14, last accessed on 14 October 2019).

37 Pinney n.d.

38 For more on Husain's fascination with Gandhi, see Ramaswamy 2016: 115–24.

39 Brown 2010.

40 Siva Kumar 2008: 208. An earlier biography by Govind Chandra Rai noted that the artist might have witnessed the entire scene through a keyhole (Rai 1951: 43). For a likely photograph of the meeting, see Tuli 2002: 165. The National Gallery of Modern Art in New Delhi holds a study for this painting, focused exclusively on Gandhi's head and torso. In December 1945 after seeing some of Abanindranath's works on display in Santiniketan, Gandhi wrote in admiration to him: 'You must live to give India and the world more of such things' (*CWMG* 82: 249). See also Siva Kumar 1996: 64.

41 Sambrani 2019: 146. Apropos of the artistic investment in the Mahatma by artists of Muslim upbringing such as Husain, Komu, and Sheikh, it is worth noting that Gandhi was particularly anxious about how his Muslim 'friends' would respond to his sartorial transformation. Three years after he stepped into his loincloth, in response to chastisement by a Muslim 'brother,' Gandhi observed, "I am always ready to do the utmost for my Muslim friends. My need of them is very great. I had even discussed the matter with a Muslim friend before effecting the change in my dress. He approved of my idea, and that gave me more courage' (*CWMG* 24: 456).

42 Ramaswamy 2016: 44–51.

43 Bean 1989: 358.

44 Dar and Chatterjee 2010. In her insightful study of colour and empire, art historian Natasha Eaton emphasizes Gandhi's counter-appropriations of white and whiteness for his dhoti and the outfits of his followers, but attends less to the important role played by the juxtaposition of brown with white, although see her suggestive discussion of 'mummy brown' (Eaton 2013: 30–34, 259–63). In recent times, historians have drawn discursive attention to the colour brown in titles of chapters they have written on Gandhi without exploring its provenance or power (Guha 2015: 152–77; and Desai and Vahed 2016: 30–48).

45 *Time*, 5 January 1931: 14.

46 He also added, 'When sisters come to bless me, I never feel embarrassed in their presence because of my loin-cloth (*kacch*). I only pray for their goodwill' (*CWMG* 24: 458). See also his statement from more than a decade later, 'I have never felt any embarrassment in being seen naked by a woman' (ibid. 67: 117).

47 Bourke-White 1963: 273. Contemporary reports as well as private musings suggest a more complicated response to Gandhi (Margaret Bourke-White Papers, SCRC, Syracuse University).

48 Bourke-White 1963: 275. There is considerable confusion across Bourke-White's several publications about the location (or even exact date) of this meeting, which was not registered by Gandhi himself in his voluminous correspondence (Brown 2010: 128n1). Archival evidence points to Poona, most likely on Monday, 18 March 1946 (Margaret Bourke-White Papers, SCRC, Syracuse University).

49 Bourke-White 1949: 231.

50 Bourke-White 1968: 89.

51 https://www.gettyimages.com/search/photographer?photographer=Margaret%20Bourke-White&assettype=image&collections=tlpe,lpc,tli&family=editorial&phrase=Mohandas%20Gandhi&sort=best#license, last date of access, 26 October 2019.

52 Goldberg 1986: 302. It is clear that it took the Mahatma's violent death for this photograph to assume its iconic status (http://time.com/3639043/gandhi-and-his-spinning-wheel-the-story-behind-an-iconic-photo/, last date of access, 10 February 2019). See also Brown 2010: 106–08.

53 Gandhi 2018: 770. The Gujarati word that Gandhi uses for zero is *shunyavat*, based on the Sanskrit *shunyata* ('emptiness'), a complex concept in Indian mathematical, grammatical, and philosophical writings that means purity and plenitude, even bliss, among others. I thank Axel Michaels for urging me to explore the concept, and Rich Freeman for a rich exploration of the term.

54 *CWMG* 33: 452. See also ibid., 48: 302, 406.

55 *CWMG* 85: 151.

56 *CWMG* 86: 314. Gandhi also used the word 'zero' in the everyday sense to mean the absence of anything of significance as, for example, when he noted in 1931 on his way to attend the Round Table Conference in London that his expectations were 'zero' (*CWMG* 47: 397).

57 *CWMG* 82: 176.

58 *CWMG* 48: 52.

59 For my larger argument on this, see Ramaswamy 2016: 104–09. For a charming popular print (based on a well-known photograph, taken in October 1931 in London) which shows the Mahatma posing with a white goat, see Neumayer and Schelberger 2008: Figure 128. For contemporary art works that have Gandhi posing with a goat, see Surendran Nair's *Tathaagata* (2008), and Debanjan Roy's *Bapu with Goats* (2009).

60 Tendulkar 1952: 142.

61 Sahmat 1995. See also Moss and Rahman 2013: 134–41.

62 For a revealing critique of this relic culture, see Mehta 1976, 22–32.

63 https://www.nytimes.com/2009/03/06/nyregion/06gandhi.html?ref=nyregion, accessed on 24 February 2019. See also Khanduri 2012.

64 https://sites.duke.edu/iconicinterruptions/counterbrand-india-2-0/

65 *CWMG* 10: 25.

66 Ramaswamy 2016: 115–24.

67 Eaton 2013: 261–62. Bose had an early proclivity for drawing androgynous ascetic bodies as a symbol of masculine strength (Dinkar 2010).

68 Venkatachalam 1945: n.p.

69 Gandhi 1944, n.p. Dhiren, who had grown up in Gandhi's ashram in Ahmedabad, was a disciple of Nandalal Bose and was trained in Santiniketan with the Mahatma's blessings (*CWMG* 54: 243–44; 447). For a recent account of this fast, see Guha 2018: 670–78.

70 *CWMG* 77: 70.

71 *CWMG* 77: 451.

72 Other paintings explicitly dedicated to this single event are *B for Bapu* (2001); *Before Commencing the Fast, Rajkot, March 1939* (2013); *Vijaylaxmi Gandhi and Raliatbehn Massaging Bapu, Rajkot, March 1939* (2013); and *Before Starting the Fast, Rajkot* (2013). Four of Kanu Gandhi's photographs from this moment have been published in Panjiar 2015. For an analysis of the circumstances under which Gandhi undertook the Rajkot fast, see Suhrud 2016.

73 *CWMG* 69: 9, emphasis added.

74 Roy 2010: 95–104.

75 Ibid, 76.

76 For a rare photograph showing Gandhi being weighed after a gruelling twenty-one-day fast (that he undertook in September 1924, when he lost 7 pounds in the first week), see Kapoor 2015: 152.

77 For a 2013 canvas by Atul Dodiya that also makes use of the same photograph but to different effect, see his *On a Weighing Scale, Bombay 1945* (2013). Despite aspiring to zero status, the Mahatma's biomass was certainly more than that, although clearly far less than was acceptable for a man of his build and age.

78 Gandhi 2018: 179.

79 Weber 2004: 33–36, and Guha 2015, passim.

80 For a play in Gujarati from 2016 titled *Yug Purush: The Mahatma's Mahatma*, see http://www.yugpurush.org/, date of access, 2 March 2019. I thank Usha Thakkar for her discussion of the play and its significance.

81 *CWMG* 32: 1–13.

82 Cited in Guha 2015: 140.

83 For Gandhi's criticisms of the Digambar monks in this regard, see *CWMG* 46: 257–58 and *CWMG* 47: 107–09. For a fascinating exchange of views between Gandhi and Satish Chandra Mukerji, a Bengali renunciant who shed his clothes completely, securing for him the title of *nanga baba*, 'the naked saint,' see Guha 2018: 779–80. An influential near-contemporary of Rajchandra, Swami Vivekananda followed the reverse course of transitioning from a bare-chested well-built renunciant to an ochre-robed 'global' monk (Beckerlegge 2008). In popular visual culture, Gandhi's bare and spare look was rivalled in the bare and muscular appearance of the revolutionary martyr, Chandrasekhar Azad (see http://www.tasveergharindia.net/essay/quicksilver-chandra-azad.html, last date of access 1 September 2019.

84 Quoted in Boodakian 2008: 15.

85 Ahuja 2013: 268–316.

86 *CWMG* 90: 503. See also ibid., 25: 255.

87 Tendulkar 1952: 180. See also *CWMG* 48: 434.

88 *CWMG* 49: 37.

89 *CWMG* 63: 416.

90 Quoted in Parel 2006: 159.

91 Parel 1994: 242. See also Lelyveld 2011: 221–22.

92 I thank an anonymous reviewer of an earlier draft for this insightful observation.

93 *CWMG* 62: 323.

94 Chittaprosad 2011: 11.

95 Sunderason 2017: 245. See also Mallik 2009.

96 Dehejia 1997: 17.

97 *CWMG* 15: 43, emphasis added. See also Alter 2000.

3 ARTFUL WALKING

1 Adapted from Martin Luther King, Jr. in Washington 1986: 59.

2 The mural was singled out in contemporary commentary for praise (*Times of India*, 1 October 1969, 1. For the artist's less than complimentary take on how his work – inspired by painted altar pieces in Christian churches and Mexican muralists – was treated by the men who commissioned it, see Ramachandran 2014: 34–35 (also confirmed in interview with the author, July 2018, New Delhi). On the Kerala-born and Santiniketan-trained Ramachandran, including his admiration for Gandhi, see especially Siva Kumar 2003 and 2014.

3 Ramachandran 2014: 34. See also *Study for Gandhi Mural* (reproduced in Siva Kumar 2003, 1: 138) which confirms the centrality of Gandhi's muscled leg for the artist's vision.

4 *CWMG* 43: 6.

5 Sevea 2016. Contemporaries as early as his South African days noted that Gandhi's walking style was rather rapid and ungainly, he himself recommending 'a speed of four miles an hour' (*CWMG* 13: 270). William Shirer, who spent some time with him in Delhi in 1931, recalled that although he 'seemed terribly frail, all skin and bones,' Gandhi 'walked four or five miles each morning at a pace so brisk... that I, at twenty-seven and in fair shape from skiing and hiking in the Alps below Vienna, could scarcely keep up' (Shirer 1979: 28–29). Artists Mukul Dey and Claire Sheridan also specifically noted Gandhi's fast walking pace.

6 Lelyveld 2011: 95.

7 *CWMG* 10: 28. Later in the same work, he insisted, 'Honest physicians will tell you that where means of artificial locomotion have increased, the health of the people has suffered' (Ibid., 59).

8 *CWMG* 43: 148 and 169.

9 Brilliant 1986: 5.

10 Harak 2000: viii–ix.

11 Atul Dodiya's *During Untouchables' Tour* (2017) paints a moment from this event.

12 *CWMG* 57: 488. On the walking tour, see especially Tendulkar 1952: 327–37.

13 *CWMG* 57: 466.

14 Ibid., 495, emphasis mine.

15 *CWMG* 58: 212–13. As I have noted, despite Gandhi's general admonition for humanity to slow down and counter industrial capitalism's empire of speed, he was himself a fast walker.

16 *CWMG* 57: 466.

17 Ibid., 472.

18 Gandhi 1928: 456. For recent scholarship on the Great March, see especially Desai and Vahed 2016: 194–211, and Guha 2015: 464–83.

19 Gandhi 1928: 453. See also *CWMG* 43: 61.

20 Quoted in Desai and Vahed 2016: 201.

21 For primary sources on this moment, aside from Gandhi's own writings collated and translated in *CWMG* 86 and 87, see Pyarelal 1956: 353–618, Gandhi 1964, and Bose 1974. Not everyone was equally impressed with Gandhi's peace walks. For cartoons poking fun at his efforts and published in Muslim League newspapers such as *Dawn*, see Roy 2018: 226–29.

22 For photographs of Gandhi walking in Noakhali, see especially Sinha 1948 and Panjiar 2015. Notwithstanding the minimalism for which he was famed and the injunctions to his followers to travel lightly, his 'kit' included a 'pen, pencil and paper... needle and sewing thread for mending clothes; a few cooking pots, an earthen bowl and a wooden spoon, a galvanized iron bucket for bath, a commode, a hand-basin, and soap; and last but not least his spinning wheel and its accessories' (Pyarelal 1956: 494). Additional items included a portable typewriter, papers, and several books. It is not entirely clear who carried all these items from village to village, the Mahatma himself being too frail by this time to do so.

23 *CWMG* 86: 440.

24 Talbot 2007: 204.

25 I thank Bishnupriya Ghosh for this insight.

26 The scholarship on this event is immense, but see especially Tendulkar 1952 and Weber 1997. Jitish Kallat's magnificent *Public Notice No. 2* (2007) reconstructs – with 4,500 bone-shaped fibreglass alphabets – Gandhi's historic speech of 11 March 1930 when he summarized his disobedient vision for his Salt Satyagraha (*CWMG* 43: 46-48). The Mahatma's forgotten words – 'discarded relics' salvaged from a neglected archive – are updated to meet the challenges of the present (see also (https://www.saatchigallery.com/artists/artpages/jitish_kallat_public2.htm, last date of access 26 November 2019).

27 For the names of Gandhi's followers, along with their occupation and their place of origin in the subcontinent, based on a list compiled by Mahadev Desai, see Weber 1997: 490–95. In addition to the seventy-nine official marchers, there were two others who were allowed to join two days later. On the distance covered, historian Thomas Weber has revised the figure to 220 miles (Weber 1997: 485–89).

28 These bags – which rarely appear in works of art – carried all his worldly possessions, including his spinning wheel.

29 For Gandhi's Gujarati utterance roughly translated into English, see *CWMG* 43: 149.

30 This painting was not on display in the Sabarmati

Ashram when Jacobson visited in 2016 (Personal communication, New York, April 2018).

31 Tendulkar 1952: 31. Contemporary accounts repeatedly noted the pace of Gandhi's walking – also captured on film – and he frequently left even younger followers behind, in his determined stride towards his goal.

32 *CWMG* 43: 180; Ibid., 184–85.

33 Kaul 2014: 71–122, and Dharker 2005: 91–92. For the daily reporting on the march by government monitors, see Weber 1997.

34 Kaul 2014: 76.

35 Bellentani and Gottardi 2007. See also Mittler and Ramaswamy 2019.

36 https://www.moma.org/collection/works/78938, accessed on 11 March 2019.

37 Sinha 2019: 38. Here it is also worth recalling Gandhi's own considerable impatience with the people who thronged to *see* him – but not to hear or heed him (Krishnadas 1928: 198).

38 Kadri 2018. Numbers vary between two and five 'Harijans' among the hand-picked marchers. Recent Dalit scholarship has countered the valorization of Gandhi's Dandi March with the historic significance of the Mahad March of 1927 (focused on access to drinking water for the oppressed) led by the pioneering Dalit leader B.R. Ambedkar (Tharakam 2018).

39 See also *CWMG* 35: 251.

40 http://www.delappe.net/game-art/mgandhis-march-to-dandi-in-second-life/, last date of access 18 June 2019. See also some of the digital exhibits in the Eternal Gandhi Museum in New Delhi (Makkuni 2007).

41 Quoted in Pyarelal 1958: 745.

42 Fischer 1950: 268. A year later, in the wake of signing the Gandhi–Irwin Pact with which I began Chapter 2, the Mahatma celebrated the anniversary of his march with a visit to Dandi by train and car (12–15 March 1931). This visit lacked the aesthetic charge and dramatic force of the earlier event (Tendulkar 1952: 83–85).

43 On Chittaprosad, a 'political' artist who was closely associated with India's burgeoning communist movement in the 1940s, but yet was inspired to draw Gandhi, see Mallik 2011.

44 A plaque accompanying the sculpture explicitly notes, 'Gandhiji leading the March with 12 associates including Abbas Tyabji and Sarojini Naidu in the rear.' The artist (originally from Orissa and trained in Mumbai and Santiniketan), wanted to cast Gandhi as a strong boatman who used his 'oars' to draw his followers behind him. 'Even the stone should run after him' (Interview with the artist, New Delhi, 21 December 2018).

45 http://www.dandimemorial.in/index.html#home See also https://www.theweek.in/theweek/cover/2019/06/21/sadashiv-sathe-making-gandhi-statues-since-1952.html, last accessed, 25 November 2019), and the very interesting Wikipedia entry on the Memorial.

46 I thank R. Siva Kumar and Arkaprava Bose for helping me to track down several versions of this painting. For a preparatory drawing, see Christie's 2013: 45. I am using the title for the work as printed in Anon. 1956.

47 Bose 1999: 231.

48 In the tempera-on-paper version that the artist appears to have first painted and is currently in the collection of the National Gallery of Modern Art in New Delhi, there are eighty background figures, including likely female characters. The painting has two signatures and two sets of dates (12 March 1930 and 2 July 1930). In the tempera-on-wood (Figure 3.20), there are a total of seventy-nine figures, all male.

49 *CWMG* 43: 183. At the same time, Gandhi also noted, 'Our march is in reality child's play' (Ibid., 169).

50 For the numerous iterations of this work, including draft sketches and preparatory drawings, see Christie's 2013: 44–48. This image has had a fantastic afterlife, worthy of a study in and of itself, including mass production and circulation during the course of the Salt Satyagraha in Bengal (Bandopadhyay 1982), and as a postage stamp issued by the Government of India in 1969. In the course of the Gandhi centenary celebrations in 1969, a 12-foot-high printed iteration was placed at the entrance of Gandhi Darshan (Prime Minister's Secretariat: Funds Section/Branch, F. No. 84(104)/69-PMF, NAI).

51 http://www.tasveergharindia.net/essay/national-gallery-constitution-india.html.

52 It is not entirely clear why Bose chose this date to commemorate thus. Records show that Gandhi had a relatively quiet day in Dandi, writing letters and rallying his followers. On the other hand, it also marked the near-culmination of National (or Satyagraha) Week, marked as such since 1919 in memory of the massacre at Jallianwala Bagh.

53 Mitter 2007: 81.

54 *CWMG* 43: 33–35.

55 Quoted in Dharker 2005: 90.

56 Quoted in Dharker 2005: 88. In the aftermath of Gandhi's death, Nehru wrote that of all the pictures in his mind of the Mahatma, 'the dominant and most significant is as I saw him marching, staff in hand, to Dandi on the Salt March in 1930. Here was the pilgrim on his quest of Truth, quiet, peaceful, determined and fearless, who would continue that quest and pilgrimage, regardless of consequences' (Tendulkar 1951: xv).

57 Pinney 2004: 128–33.

58 Gandhi recommended to all marchers (regardless of their faith) to carry a copy of the *Gita* with them. This is one among many Hindu elements

59 that saturated the putatively 'secular' march (*CWMG* 43: 12).

59 Gandhi at his spinning wheel is a favourite topic of many artists, and needs a complete analysis in itself, but for an important beginning, see Brown 2010.

60 I am grateful to Rich Freeman for his elaboration on the range of meanings of this term. Gandhi himself insisted in 1925 that 'there is no sutradhara as skilled as God' (*CWMG* 26: 143).

61 Cited in Dharker 2005: 90.

62 Muzumdar 1932: 34. For a slightly variant account, see Tendulkar 1952: 47–48.

63 Masoji 1944: 220.

64 Ibid.

65 The scholarship on this transformative sculptor is extensive, but see especially Guha-Thakurta 1995 and Bandyopadhyay and Ghosh 2012. For readings on the artist that are at odds with the dominant narrative and foreground his caste subjectivity, see Alone 2017 and Santosh 2012.

66 For a discussion of the many versions of this sculpture, see Radhakrishnan and Siva Kumar 2012: 258–63.

67 This motif has been variously interpreted by scholars as the sculptor's take on Gandhi's 'triumphing over violence and death' (Radhakrishnan and Siva Kumar 2012: 263), as the Mahatma marching 'to calm the mayhem and sectarian violence of Noakhali' (Bawa 2018: 58), and contrarily, as Gandhi becoming the Mahatma 'by crushing people' (Alone 2017: 148). A later iteration of the statue in bronze was installed in 1970 in Gauhati. In 2017, the decision to remove the statue because it apparently distorted the Mahatma's true proportions was forestalled after protests, https://indianexpress.com/article/india/assam-to-dismantle-47-year-old-distorted-gandhiji-statue-made-by-ram-kinkar-baij-4787837/; https://www.telegraphindia.com/states/north-east/furore-over-silvered-gandhi-statue/cid/1670984, last accessed on 15 March 2019.

68 Guha-Thakurta 2018: 18. On the sculptor, see especially Daw 1998 and Mitter 2007: 168–76.

69 'Martyrs' Memorial at Rajghat,' (Prime Minister's Office Papers: Funds Branch (F. no. 84(146)/71-73-PMF), NAI. The government held out against demands to locate this memorial near Rajghat, and it was eventually installed at the crossing of Sardar Patel Marg and Willingdon Crescent Road.

70 Daw 1998: 10.

71 Reprinted in Sahmat 1995: 114.

72 See also Barry Chann's untitled work for the Postcards for Gandhi project (Sahmat 1995: 54), and Subimal Das, *March to Freedom* (2016).

73 Adapted from Gandhi 1984: 208. Nehru was to recall, 'Salt suddenly became a mysterious word, a word of power' (Nehru 1958: 157).

74 That pinch of 'illegal' salt was auctioned off to the highest bidder for Rs 1,600 (Fischer 1950: 269).

75 Kapur 2000: 390–91.

76 Sinha 2013: 126.

77 https://www.telegraphindia.com/culture/arts/paresh-maity-painter-of-longest-work-pays-tribute-to-tallest-leader-gandhi/cid/1672816, last accessed on 15 July 2019.

78 Dar and Chatterjee 2010: 28. The artist notes that the title was inspired by Lord Irwin's statement (as he heard it in Richard Attenborough's blockbuster film from 1982), 'Mr Gandhi will find that it takes a great deal more than a pinch of salt to bring down the British Empire.'

79 Reprinted in Sahmat 1995: 60.

80 http://shellyjyoti.com/salt-the-great-march-2013/art-installations/. See also http://www.thehindu.com/features/friday-review/art/khadi-is-her-canvas/article6548157.ece

81 Tendulkar's authoritative biography captions the photograph credited to Krishna Studio thus, 'Breaking the salt law by picking up a lump of natural salt at 8.30 a.m., April 6, 1930' (Tendulkar 1952, n.p.). Thomas Weber has argued on the basis of little known but accurate Gujarati sources that the photograph was actually taken a few days later on 9 April at Bhimrad (Weber 1997: 349). See also the frontispiece to *CWMG* 43, where it is captioned, 'Gandhiji picking up salt at Bhimrad (April 9, 1930).' It remains a puzzle why this most disobedient of moments from 6 April has not left a more robust photographic record (Weber 1997: 348–49).

82 https://www.istampgallery.com/dandi-march/. See also Siva Kumar 2003, I: 138. Other works which repurpose this iconic photograph/moment include Jatin Das, *Mahatma Breaks the Salt Law* (1999), Aditya Pande, *So Far So Good* (2011), and Arpita Singh, *Killing a Memory* (2011).

83 See also Atul Dodiya's untitled work for the same project (reprinted in Sahmat 1995: 72).

84 Gandhi 1984: 207–08.

85 Guha-Thakurta 2018: 18–19; see also Guha-Thakurta 1995: 136.

86 Ahuja 2013: 59–63.

87 Quoted in Gandhi 1995: 445.

88 Gandhi 2018: 48.

89 A photograph by M. Fine of Gandhi from his Durban days of disobedience in late 1913/early 1914 shows him clad in a white lungi and holding a staff. The photograph is repurposed by Atul Dodiya in *The Mocking* (1998), by Sudhir Patwardhan for the Postcards for Gandhi series (1995), and in 2019 by Nawal Kishore in *Gandhi (An Untold Story)* (see frontispiece).

90 *CWMG* 44: 420.

91 Weber 1997: 137. See also Anon. 1956: x.

92 Kashi 2009: Figure 13. For a literary satirization

of the fetishizing of Gandhi's staff, see Upamanyu Chatterjee's novel *English, August* (1994).

93 I am indebted to Johann Matthew for this suggestion. See also a revealing exchange with young men of the Rashtriya Yuvak Sangh in May 1942 (*CWMG* 76: 156).

94 Bawa 2018: 60-61. See also https://www.ndtv.com/patna-news/bihar-village-celebrates-gifting-lathi-to-mahatma-gandhi-505379

95 One of the earliest references I have been able to find is from July 1930, some months after his Dandi march in a letter in Hindi, in which he uses the word *lathi* (*CWMG* 44: 19). In September 1935, Gandhi declared his intention of 'renouncing' this practice, but photographic evidence suggests otherwise as do subsequent comments (*CWMG* 61: 436–437; see also Ibid., 67: 115–117).

96 See, for example, *CWMG* 37: 258–59; 41: 231–32; 62: 372; 67: 132–133 and 147–49; and 88: 19.

97 Later revelations of his sexual experiments (with Manu, especially in 1947) ought to surely compel us to look again at this habit. See, for instance, Manu's seemingly innocent but disturbing recollection, 'If we ever grumbled and did not want to serve as a stick..., Bapu would catch hold of us and forcibly use us as his stick' (Gandhi 1962: 308).

98 Captioned 'The Aging Mahatma... Here, in the early dawn, after prayers, walking with his granddaughter Sita and his grandniece Abha,' the photograph is reproduced in Bourke-White 1949, facing page 38. The artist offers a different take on this work which he painted on a mirror so as to enable ordinary citizens to see themselves reflected in the empty spaces and so serve the Mahatma with their body (email from Sachin Karne, 4 September 2019).

99 Sinha 2013: 126. For Kanu Gandhi's photograph, see Panjiar 2015. See also a photograph captioned, 'A foot-bath after a fatiguing journey,' in Gandhi 1948: 32.

100 Gandhi 1964: 13, 19, 20, 22, 28, 58, 77, 83, 95, et. al. That such care could also lead to (intimate) cruelty is apparent from Gandhi's severe rebuke directed at her when Manu misplaced a pumice stone she used to take care of his feet (Ibid., 102–03).

101 Pyarelal 1956: 494.

102 *CWMG* 10: 407. Although written in Gujarati, Gandhi uses the English word 'sandal.'

103 For a photograph of 'wooden slippers which the Mahatma acquired for his tour of riot-torn Noakhali not wanting to tread on the remains of the dead, wearing leather chappals,' see Dixit 1970.

104 See, for example, Gandhi 1948, cover; Pyarelal 1958, frontispiece. For Gandhi's worry that his wooden footwear could become objects of idolatry, see *CWMG* 44: 192.

105 Among other artworks that feature Gandhi's sandals as the principal object of attention, see especially Arun Kumar, *His Shoes* (2010) and Pramod Ganpatye, *Foot Steps* (2010). Numerous works in the Postcards for Gandhi project also feature Gandhi's sandals (Sahmat 1995: 41, 160, 165, 167, 169).

1. M.K. Gandhi, 14 March 1946 (*CWMG* 83: 258).

2. Gandhi himself observed on 22 September 1947 in an article published in *Harijan*, 'A new age for India began on 15th August last. There is no place for me in that age' (*CWMG* 89: 216).

3. Payne 1969: 647. For other similar views, see Nandy 1980: 70–98 and Markovits 2002: 370–71. For insightful treatments of Gandhi's death, see especially Lal 2014b and Paranjape 2014.

4. Tendulkar 1954: 347–48. See also Pyarelal 1958: 773. For an argument regarding the production of this eight-volume 'official biography' as part of 'the political instrumentalization' of Gandhi's death and the reframing of his image by the Congress Party and Prime Minister Nehru, see Markovits 2002: 374.

5. Gandhi 1962: 309.

6. Cartier-Bresson 1952.

7. The role of photography in the coverage of Gandhi's death has yet to be systematically studied, but for preliminary analyses, see Cookman 1998 and Srivatsan 2000: 107–21.

8. Gadihoke 2010: 83.

9. Ibid.

10. In exchange for the autograph which Gandhi affixed to her two photographs 'in his spidery hand,' adding the date, 'January 29, 1948,' the photographer handed over ten rupees (Bourke-White 1949: 225). See also *CWMG* 90: 521–22, and Gandhi 1962: 284–85.

11. Bourke-White 1949: 233. See also Pyarelal 1958: 771.

12. Hofstadter 1992: 56. See also ibid., 60–65 and Pyarelal 1958: 770–71. Cartier-Bresson's recall is contradicted by the official record, which shows that Gandhi's last visitor for the day was Home Minister Vallabhbhai Patel who met him a little after 4.00 p.m. (*CWMG* 90: 535).

13. Cadava 1997: 13.

14. Sontag 2003: 24.

15. Salkeld 2014: 11.

16. Cadava 1997: 13.

17. Ibid., 11.

18. *CWMG* 84: 393.

19. Ernst Jünger, quoted in Cadava 1997: xxiii.

20. For official photographs taken by the Press Information Bureau, as well as by photographers associated with the *Hindustan Times*, see Gandhi 1948 and Pyarelal 1958. For contemporary film footage (produced by Pathé News) of the funeral, see https://www.youtube.com/watch?v=oI41BpDpBc8. For footage of the collection of cremains and followers offering their homage to the still-smouldering pyre, see https://www.youtube.com/watch?v=3XaSdN6gb4w. For the immersion of ashes in different parts of India,

see the film titled *Bapu's Demise*, https://www.youtube.com/watch?v=qwwh2WPRSAU.

21. Anon. 1948a, 26–27.

22. *CWMG* 59: 317. See also ibid., 50: 213.

23. Anon. 1948b: 76.

24. Khan 2011.

25. Kapur 2010: 140.

26. Barthes 1981: 9.

27. Captioned as such in Gandhi 1949: 61. The first edition of this valuable work published the previous year did not include this rare photograph. For an eyewitness account of this moment, see Pyarelal 1958: 774.

28. *Times of India*, 19 December 1968: 13. See also Maitland 2017.

29. The published caption to the photograph reads, 'The dark was filled with the sounds of sobbing people. (This picture was taken at ¼ second at 1.5, and by holding my breath)' (Cartier-Bresson 1952: No. 84).

30. Reprinted in Gopal 1987: 5, 35.

31. Critic Jonathan Flatley invites us to consider melancholia as a positive affective force. 'Melancholizing is something one *does*: longing for lost loves, brooding over absent objects and changed environments, reflecting on unmet desires, and lingering on events from the past. It is a practice that might, in fact, produce its own kind of knowledge' (Flatley 2008; 2).

32. Cartier-Bresson 1952: No. 83. For a slightly different caption, see Anon. 1948a: 25. The man in tears in the left panel of the painting is Brij Krishna who had earlier prepared Gandhi's corpse for cremation (Guha 2018: 847–48).

33. Moffat 2019: 1.

34. *CWMG* 32: 459.

35. Ramaswamy 2016: 122; personal communication, Amit Ambalal. The South African artist Willem De Sanderes Hendrikz (1910–1959) similarly produced his beautiful wooden sculpture *Martyr of the Twentieth Century* in March 1948 'after spending a sleepless night the followed the hearing of the news' (Hendrikz 1953).

36. Azoulay 2012: 227–31.

37. Cadava 1997: 118.

38. Ahuja 2018.

39. Ramaswamy 2010: 217–36. See also Copeman 2013.

40. Laqueur 2015. See also Moffat 2019: 1–20.

41. I am indebted here to Ranjana Khanna for this idea.

42. Ramaswamy 2016: 20–22.

43. These were exhibited at the trial that began a few months later on 27 May 1948 (File No. 66, List No. 112, List of Mahatma Gandhi Trial Papers, NAI, New Delhi).

44 Quoted in Suhrud 2013: 3.

45 Anon. 1949b: 59.

46 https://cruzostudio.wordpress.com/work/paintings/assassination/

47 Badal's painting is titled *Khoon Ke Khataron Se Bana Chitra* ('Portrait Painted with Blood Drops') and was subsequently also printed by the museum in a calendar for October 2003–September 2004, which included eleven of his other paintings on Gandhi. In an interview, the artist confirmed that he made the work 'as a form of homage' (Interview with the author, 17 April 2019).

48 Gandhi 2007: 8.

49 For his brief discussion of Gandhi in his flamboyant autobiography, see Topolski 1988.

50 Gandhi 1954: n.p.

51 http://www.topolskicentury.org.uk/memoir/post-independence-india/, last date of access, 15 June 2019. See also Hiley 2007. I am grateful to the artist's daughter Teresa for discussing her father's work with me.

52 The work was brought to Nehru's attention by V.K. Krishna Menon, high commissioner to the United Kingdom, and a friend of Topolski's. In an undated letter to Nehru, Menon wrote '... Topolski's "mural" of Gandhi's crucifixion called the Rise of the East or something like that... is regarded as an outstanding piece of work. He had thought in terms of £3000 or so but has said to me that he so much meant it to go to India that he would like a much lower figure, which I gather, to be £1000. Whether we can make a lower offer, I don't know. I will offer him £750 or ten thousand rupees, which is a very low price. Whether our public opinion cares for paintings or will accept a foreigner's painting, I do not know' (File No. 21, J.N. Papers (S.G.), Nehru Memorial Museum and Library). Topolski apparently carried the painting with him to India in late 1949 when he was invited by Nehru to participate in the celebrations around the inauguration of the Republic in January 1950 (http://www.topolskicentury.org.uk/memoir/post-independence-india/). In 1969, on the occasion of the Gandhi birth centenary celebrations, the detail featuring Gandhi's murder from this large painting was printed under the title *Descent from the Cross* (Government of India, 1969).

53 The artist produced this work after a reading of Malgaonkar 2009 (Interview with Debanjoy Roy, Calcutta, December 2016).

54 In a memorandum dated 29 January 1969, about his film on the life of Gandhi ending with a segment titled 'Martyrdom,' Jhaveri wrote, 'The epic life of Mohandas Karamchand Gandhi came to an end. He met death facing the forces of darkness and hatred with compassion and love. The day will be known as the blackest day in India's history, but for the Mahatma it was the supreme moment of his life. He had said, "If I am to die by the bullet of a dead man, I must do so smiling. There must be no anger within me. God must be in my heart and on my lips." He bowed to his assassin and died with the name of God on his lips. He was the victorious one in death as in life' (Prime Minister's Secretariat: Funds Section, File No. 84 (108)/69-77-PMF- 'I', NAI, New Delhi).

55 Devji 2014: 18.

56 Nandy 1980: 70.

57 Gandhi 1995: 438 (emphasis added). Rajmohan's uncles Manilal and Ramdas even asked the government to commute Godse's death sentence, a plea that was ignored by the state (Payne 1969: 643–44).

58 Reprinted in Tendulkar 1951: xi.

59 Pyarelal 1958: 747–85.

60 Tendulkar 1951: xvii.

61 Quoted in Payne 1969: 647. Gandhi had stated just a few months earlier in April 1946 that a true satyagrahi would not wish to die 'as a result of a heart failure or failure of respiration' (*CWMG* 83: 258).

62 *CWMG* 90: 46.

63 Ibid., 472.

64 For a recent assessment of the artist, see Michael 2018. Within a decade of the work being completed, the *Times of India* reported that the painting 'was marred by cobwebs' (*Times of India*, 30 October 1968: 9). A decade later, administrators connected to the newly acquired Birla House (by then converted into a national memorial) continued to complain of the poor state of the painting and the need to restore it (Memo dated 15 September 1978, F. No. 84 (150)/71-79-PMF, Vol. VIII closed (NAI).

65 https://cruzostudio.wordpress.com/work/paintings/death-is-our-own/, last accessed on 17 May 2019). I have been unable to locate this particular quotation attributed to Gandhi in his published writings, although it resonates with similar sentiments about death that Gandhi uttered over the course of his lifetime. The work was completed by November 1964 when it was included in the artist's exhibition in Bombay of his 'Historical Episodes in the Life of Mahatma Gandhi.' (https://cruzostudio.wordpress.com/events/exhibitions/1964-2/, last date of access, 17 May 2019).

66 *CWMG* 87: 197. The Hindi phrase that Gandhi used is *tandi taakat*.

67 'The man who knows in his heart of hearts that this mortal frame is liable to perish any moment will be ever ready to meet death' (*CWMG* 13: 30).

68 *CWMG* 83: 258.

69 In chromolithographs based on this oil painting, a halo has been added around Gandhi's head (Ramaswamy 2010: 217).

70 Pinney 2004: 139–40.

71 For example, Ramaswamy 2010: Figure 25.

72 Paranjape 2014: 57.

73 In his insightful study of images of hell in popular visual culture, Christopher Pinney suggests that the only prints he has seen of representations of heaven are associated with Gandhi (Pinney 2018: 50). Kama Maclean's work, though, would lead us to a different conclusion (see especially Maclean 2015: 119–45).

74 Horowitz 2001: 2–3.

75 *CWMG* 72: 416 (The English gloss on Gandhi's Gujarati words has incorporated the word 'art.')

76 Gandhi 1928: 258. On the importance of the name of Rama ('Ramanama') in Gandhi's life, see Suhrud 2013.

77 Gandhi 1962, 298. For similar statements reportedly uttered in the days leading up to his death, ibid., 222, 234.

78 Lal 2001: 35. Godse's lengthy testimony at his trial in New Delhi in November 1948 is silent on this issue (Anon. 1949a, 2: 12–64).

79 Derrida 1989: 266.

80 Gandhi 1948: 90. See also Gandhi 1970.

81 See also Gandhi 1948: 68. Such a gesture is not unique to India (and Indians): for a comparable account from two decades later in Memphis of some of his colleagues scooping up Martin Luther King Jr.'s blood from the spot where he was shot, see Frady 2002: 205–06.

82 Pai 2000: 173.

83 Reproduced in Sambrani 2005: 82. For the artist's statement, see ibid. 80. The work is part of a series of twenty-two paintings that Das produced in the aftermath of the 2002 riots in Gujarat that also includes a work titled *Ram, Gandhi and Mother Earth All in Distress and Tears at the Terrible Carnage*. Many paintings in the Postcards for Gandhi project also incorporate the talismanic words (see especially contributions by Jairam Thakore, Jyoti Bhatt, Madhvi Parekh, Shakuntala Kulkarni, Siddharth Ghosh, V.M. Shinde, and Vasudha Thozhur).

84 These words also appear in the other paintings that Ramachandran produced for the project. In one, the words are inscribed next to a pair of sandals laid transversely across the top while a pair of boots – metonymically standing in for the assassin – dominates, while in another, Gandhi's clear and transparent spectacles are contrasted with Godse's dark glasses. Yet again, Gandhi's round watch is contrasted with the assassin's bomb, and Gandhi's staff with the assassin's dagger.

85 Vajpeyi 2017: 35.

86 Ibid., 30.

87 https://www.hindustantimes.com/columns/on-gandhi-s-death-anniversary-need-to-do-more-than-lament-the-tragedy/story-dEGMIcFJ70ZLPqlt8hCyrJ.html, last accessed on 17 May 2019.

88 For the extreme responses that Godse incites in the Indian imagination to this day, see, for example, https://theprint.in/opinion/godse-raised-as-a-girl-saw-gandhi-as-an-effeminate-father-who-didnt-protect-mother-india/235838/ and https://theprint.in/opinion/in-1964-calling-godse-patriot-led-to-uproar-in-parliament-now-pragya-thakur-gets-approval/237236/, last date of access, 17 May 2019.

89 Reprinted in Gopal 1987: Vol. 5, 35.

90 See, for example, a much-circulated photograph attributed to Max Desfor of Godse with his fellow accused (http://www.apimages.com/metadata/Index/Watchf-Associated-Press-International-News-Indi-/df9db8a4ff864525988b659270a3f37f/10/0, last date of access 1 September 2019). That trial eventually resulted in the assassin's hanging in Ambala Jail on 15 November 1949, followed by a cremation inside the prison with his ashes apparently immersed in an unmarked undisclosed location nearby, in contrast, of course, to the spectacular visibility accorded to his victim's funeral some months earlier (Sharma 2015).

91 Khosla 1963: 244. Notwithstanding its resemblance to some earlier pictures of the execution of anti-colonial martyrs like Khudiram Bose and Bhagat Singh, the print also offers a realistic visual synopsis of the moment as reported by Justice G.D. Khosla, one of the last men to engage with Godse before his execution: 'A single gallows had been prepared for the execution of both. Two ropes, each with a noose, hung from the high crossbar in parallel lines. Godse and Apte were made to stand side by side, the black cloth bags were drawn over their heads and tied at the necks. After adjusting the nooses, the executioner stepped off the platform and pulled the lever' (ibid., 245). Note that the print has Apte's first name as Madanal rather than Narayan (Figure 4.28).

92 Suhrud 2013. It is also important to recall a volte-face in this regard. Gandhi's most important political and philosophical, not to mention, disobedient, text, *Hind Swaraj* (1909) was written to counter a penchant for politically motivated assassinations amongst his fellow Indians in the first decade of the twentieth century. At one point in that text, he also asks, 'Do you not tremble to think of freeing India by assassination? What we need to do is to sacrifice ourselves. It is a cowardly thought, that of killing others. Whom do you suppose to free by assassination?' (*CWMG*, Vol. 10: 42; see also ibid., 14n2). See also a 1916 speech when he rhetorically asked, 'Is the dagger of an assassin a fit precursor of an honorable death?' (*CWMG* 13: 214).

93 In his trial statement in November 1948, Godse insisted that in supporting the Muslim cause for Pakistan, 'Gandhiji... has failed in his duty which was incumbent upon him to carry out as the Father of the Nation. He has proved to be the Father of Pakistan. It was for this reason alone that I as a dutiful son of Mother India thought it my duty to put an end to the life of the so called Father of the Nation who had played a very prominent part in bringing about vivisection of the country – Our Motherland' (Anon. 1949a: 61).

94 Discussion with the author, 22 February 2018, Mumbai.

95 De 2015: 144.

96 Reprinted in Sahmat 1995, 33.

97 See also the works by Navjot Altaf, Rekha Rodwittiya, Shakuntala Kulkarni, and Vasudha Thozhur (all female artists), and Umesh Verma.

98 Pinney 2004: 142–44.

99 McLain 2007: 73.

100 Reproduced in Neumayer and Schelberger 2008: Figure 142.

101 Priya Paul Collection, New Delhi.

102 Reproduced in Neumayer and Schelberger 2008: Figure 147.

103 Dutt and Patel 2008: 59. For a fine analysis of the representations of Gandhi's murder in comic books from this widely read series, see Mclain 2007.

104 See reproduction in https://vinaylal.wordpress.com/2013/01/30/gandhi-and-the-art-of-dying/, last accessed 19 May 2019). This is the not only time Shabbir Diwan, based then in Bombay, drew or painted Gandhi for the *Weekly*, another striking cover placing the Mahatma in the company of Mao (4 October 1970). Gandhi was one of his idols, and whenever given an opportunity, he would draw or paint him (conversation with author, May 2018).

105 Tuli 2002: 250–51.

106 Anon. 1949a: 62. Godse also stated, 'The day on which I decided to remove Gandhiji from the political stage, it was clear to me that personally I shall be lost to everything that could be mine' (ibid., 56), and 'Briefly speaking, I thought to myself and foresaw that I shall be totally ruined and the only thing that I could expect from the people would be nothing but hatred and that I shall have lost all my honour even more valuable than my life, if I were to kill Gandhiji (ibid., 61).

107 Anon. 1949a: 62.

108 Lal 2014b: 330–31.

109 Barrow 2014.

110 https://www.washingtonpost.com/news/worldviews/wp/2015/01/30/why-some-indians-want-to-build-a-statue-of-mahatma-gandhis-killer/, last access 5 November 2019.

5 THE CANVAS OF DISOBEDIENCE

1 Gandhi, October 26, 1919.

2 *CWMG* 70: 221–22. See also ibid., 88: 34. Such statements should be certainly factored into ongoing attempts and calls to tear down Gandhi statues in different places across the globe.

3 Venkatachalam 1945: n.p.

4 Anon. 1949b: 12.

5 I thank historian Charu Gupta for this insight.

6 Quoted in Frady 2002: 7.

7 Prime Minister's Secretariat: Funds Section/Branch, File No. 2 (76)/48-PMS – PMS, Vol. 1, NAI, New Delhi.

8 Despite his resistance in this regard, Gandhi participated in the inauguration ceremonies of the statues of other national leaders over the course of his long political career (for example, *CWMG* 40: 53. See also ibid., 42: 527).

9 Prime Minister's Secretariat: Funds Section/Branch, File No. 2 (76)/48-PMS – PMS, Vol. 1, NAI, New Delhi.

10 Prime Minister's Secretariat: Funds Section/Branch, F. No. 84(10)/66-71, PMF, Vol. II (NAI, New Delhi).

11 Sanyal 1999: 3.

12 See also Brown 2010: 114–15.

13 Quoting from an anonymous reviewer of an earlier version of this manuscript, to whom I am very grateful for this insight.

14 https://www.theweek.in/theweek/cover/2019/06/21/gandhi-projects-my-experiments-with-time-artist-riyas-komu.html, last date of access, 25 November 2019.

15 Anon. 1949b: 3. See also Devdas Gandhi Papers, File No. 6, 'Papers relating to the organization of [the] Gandhi Mandap Exhibition at Raj Ghat, 1949' (Private Papers Collection, NMML, New Delhi).

16 Payne 1969: 15–16.

17 As one commentator noted, 'For Sahmat, a postcard is a typical symbol of the Gandhian spirit as it typifies simplicity and brevity, and yet can be lucid and communicative' (The *Economic Times*, 10 October 1995). Of course, the postcard – a Victorian innovation – was one of Gandhi's own favourite means of communicating with friends and family, as well as his innumerable followers.

18 Moss and Rahman 2013: 129.

19 Press coverage file, 'Postcards for Gandhi,' Sahmat Archives, New Delhi.

20 Arnold 2013: 18.

21 Sheikh 2019: 5.

22 Singh 2006: 45. For Gandhi's letters to Hitler, *CWMG* 70: 20–21 and 73: 253–56. For another astute evaluation of Purkayastha's Gandhi works, see Sinha 2013: 119–120, 125–26. Jitish Kallat's *Covering Letter* (2012) offers quite a different take on Gandhi's letter to Hitler penned on 23 July 1939.

23 http://www.openthemagazine.com/article/arts/gandhi-the-untouchable, last date of access 14 June 2019; the author's interview with the artist.

24 Alone 2017. I also thank Y.S. Alone for introducing me to these artists.

25 'To have excised Ambedkar from Gandhi's story, which is the story we all grew up on, is a travesty. Equally, to ignore Gandhi while writing about Ambedkar is to do Ambedkar a disservice, because Gandhi loomed over Ambedkar's world in myriad and unwonderful ways' (Roy 2017: 39). In the art world, the two figures have yet to be brought together in a systematic and sustained manner, making the words by Komu and Scaria even more powerful. In this regard, see also a work by Ashim Purkayastha, titled *Harijan* (2006).

26 The artist's interview with the author, June 2017.

27 The author's interview with the artist, December 2018. See also https://www.theweek.in/theweek/cover/2019/06/21/gandhi-projects-my-experiments-with-time-artist-riyas-komu.html, last date of access, 25 November 2019. For a work that offers a very different take on the complex relationship between Ambedkar and Gandhi, see Ashim Purkayastha's *Harijan* (2006).

28 Kapur 2010: 141.

29 Curated by Roobina Korade of the Kiran Nadar Museum of Art in New Delhi (in collaboration with the Government of India's Ministry of Culture), the exhibition evocatively titled 'Our Time for a Future Caring,' featured works by Nandalal Bose, M.F. Husain, Atul Dodiya, Jitish Kallat, Ashim Purkayastha, Shakuntala Kulkarni, Rummana Hussain, and G.R. Iranna (several of whom are artists discussed in this book) (https://www.knma.in/our-time-future-caring)

30 Karode 2019: 43. 'The curatorial process consciously paced away from a literal and figural representation of Gandhi, resisting the resurrection of his memory/image through extensive memorabilia, his accessories and innumerable painted portraits, statues and artistic production' (ibid., 42).

31 The author's conversation with Ram Rahman, August 2018, and with Dipankar Shrigyan, director, Gandhi Darshan and Darshan Smriti, July 2019. Bhupen Khakhar was also a featured artist in the Postcards for Gandhi project (as well as the related 'Phir Gandhiji: Manas Bana' exhibition in Baroda, 1 January 1995). For a 1997 watercolour by him titled *50 Years of Independence and Gandhi Postage Stamps*, see Moss and Rahman 2013: 141.

LIST OF ARTWORKS

FIGURE 2.14
Maqbool Fida Husain, *Gandhiji*,
1972. Oil on canvas,
255.27 x 113.03 cm. ©The
Estate of Maqbool Fida Husain,
Image courtesy of Peabody Essex
Museum.

FIGURE 2.15
Maqbool Fida Husain, *Gandhi:
Man of Peace*, October 1969.
Oil on canvas, 166.8 x 143.8 cm.
©2009 Christie's Images Limited.

FIGURE 2.16
Margaret Bourke-White, Gandhi
Spinning, 1946. Gelatin silver
print, 27.8 x 35.7 cm. Image
courtesy The Museum of Fine
Arts, Houston.

FIGURE 2.17
Gopal Swami Khetanchi, *Spinning
Alive*, 2010. Oil on canvas,
106.68 x 106.68 cm. With
permission of the artist.

FIGURE 2.18
D.B. Mahulikar, *Mahatma
Gandhi in Yeroda Jail*, 1933.
Chromolithograph. Priya Paul
Collection, New Delhi.

FIGURE 2.19
Ravikumar Kashi, *Back and
Forth-1*, 2011. Oil on canvas,
91.44 x 121.92 cm. With
permission of the artist.

FIGURE 2.20
Haku Shah, *Gandhi and His
Things*, 2013. Oil on canvas,
60.96 x 60.96 cm. With
permission of the artist's family.

FIGURE 2.21
Nandalal Bose, Untitled, *c.* 1946.
Pen and ink, reproduced as
frontispiece, 14.5 x 8.4 cm. With
permission of Rakesh Sahni,
Gallery Rasa.

FIGURE 2.22
Gulammohammed Sheikh,
*Ahmedabad: The City Gandhi Left
Behind,* 2015–2016. Casein and
pigment on canvas, 202.2 x 353.6 cm.
With permission of the artist.

FIGURE 2.23
Gulammohammed Sheikh,
Ahmedabad: The City Gandhi

Left Behind [detail], 2015–2016.
Casein and pigment on canvas,
202.2 x 353.6 cm. With
permission of the artist.

FIGURE 2.24
Ravikumar Kashi, *Artist Book:
Everything He Touched* (cover
page), 2011–2012. Conte, ink and
photocopy transfer on Japanese
raka stained Hanji paper,
36.83 x 30.48 cm. With
permission of the artist.

FIGURE 2.25
Gigi Scaria, *Flyover*, 2011. Inkjet
print on Epson enhanced matte
paper, variable dimensions. With
permission of the artist.

FIGURE 2.26
Dhiren Gandhi, *Sacrifice for
Humanity*, 1943. Print from
woodcut, 35.56 x 27.73 cm. Anil
Relia collection, Ahmedabad.

FIGURE 2.27
Dhiren Gandhi, *Love-The
Sustainer* 1943. Print from
woodcut, 35.56 x 27.73 cm. Anil
Relia collection, Ahmedabad.

FIGURE 2.28
Atul Dodiya, *Fasting in Rajkot*
(From *The Artist of Nonviolence*
Series), 1998. Watercolour on
paper, 114.3 x 177.8 cm. With
permission of the artist.

FIGURE 2.29
Surendran Nair, *The Unbearable
Lightness of Being, Corollary
Mythologies*, 1998. Oil on canvas,
180 x 120 cm. With permission of
the artist and Sakshi Gallery.

FIGURE 2.30
*Shrimad Rajchandra Nijabhyas
Mandap*, n.d. Print published by
M. Wadilal & Co., Amdavad.
Reproduced in *Adhyatma
Yugapurush Srimad Rajchandra*
(No publication information
available). Image courtesy Mani
Bhavan Gandhi Sangrahalaya,
Mumbai.

FIGURE 2.31
Chittaprosad, *Halisahar,
Chittagong, 1 August 1944*.
Brush and ink on paper,
24.6 x 35.6 cm. Private collection

(With permission of DAG, New
Delhi).

FIGURE 3.1
A. Ramachandran, *Dandi March
Stamp*, 1980. Original etching,
38.1 x 27.94 cm. With permission
of the artist.

FIGURE 3.2
A. Ramachandran, *Gandhi
and the 20th-Century Cult of
Violence*, 1969. Oil on wooden
panels, 365.76 x 548.64 cm. With
permission of the artist.

FIGURE 3.3
Maqbool Fida Husain, *Gandhi:
The Spirit of Freedom Forges
Ahead*, 2000. Oil on canvas,
149.86 x 91.44 cm. Photo courtesy
William J. Clinton Presidential
Library, National Archives and
Records Administration.

FIGURE 3.4
K.M. Adimoolam, *Walk Towards
Navkali*, 1969. Pen and ink on
paper, 40.64 x 32 cm. With
permission of K.M. Adimoolam
Foundation.

FIGURE 3.5
Arpana Caur, *Gandhi and Health*,
2019. Pencil and Gouche on Pastel
Paper, 31.75 x 41.91 cm. With
permission of the artist.

FIGURE 3.6
Atul Dodiya, *Evening Walk
on Juhu Beach*, 2017. Oil on
canvas, 137.16 x 198.12 cm. With
permission of the artist.

FIGURE 3.7
Fredda Brilliant, *Model of
Gandhiji Walking*, c. 1951/1960s.
Bronze, 10 x 19 x 29 cm. With
permission of NGMA, New Delhi.

FIGURE 3.8
Devi Prasad Roy Chowdhury,
Gandhi on his way to Dandi, 1959.
Bronze, Marina Beach Road,
Chennai. Author's photograph.

FIGURE 3.9
Jatin Das, *Noakhali*, 1999. Study
for the Mural at Parliament
Annexe, *Journey of India:
Mohenjodaro to Mahatma Gandhi*
(2001). Conté on paper,

75.0 x 55.4 cm. With permission of the artist.

FIGURE 3.10
Natu Mistry, *Gandhi-Dandi Satyagraha*, 2005. Oil on canvas, 60.96 x 50.8 cm. Anil Relia collection, Ahmedabad.

FIGURE 3.11
Satyagraha: Dandi March—Pledge for Independence, 12.3.1930. Photograph by Doranne Jacobson of oil painting in Gandhi Ashram at Sabarmati, 2016. With permission of Doranne Jacobson.

FIGURE 3.12
Gandhi leading Salt March, Photograph by Doranne Jacobson of painting in Gandhi Ashram at Sabarmati, 1991. With permission of Doranne Jacobson.

FIG. 3.13
Hindol Brahmbhatt, 'I want world sympathy in this battle of right against might. Dandi M.K. Gandhi, 5.4.30', 2005. Acrylic on canvas, 50.8 x 60.96 cm. Anil Relia Collection, Ahmedabad.

FIGURE 3.14
Atul Dodiya, *Reading a Newspaper at Dandi, 1930* 2019. Left panel: oil on canvas, 91.44 x 91.44 cm. Right panel: archival digital print on hahnemuehle rag paper, 91.44 x 66.4 cm. With permission of the artist.

FIGURE 3.15
Chittaprosad, *Dandi Chalo*, 1939. Watercolour on paper, 52 x 46 cm. Collection of Vijay Kumar Aggarwal.

FIGURE 3.16
Adwaita Gadanayak, *Dandi March-Salt Satyagraha*, 2005. Black Marble, on the grounds of National Gandhi Museum, New Delhi. Author's photograph.

FIGURE 3.17
Atul Dodiya, *The Arrival* [open view], 2011. Enamel paint on metal roller shutters and acrylic and marble dust on canvas,

274.3 x 185.4 x 35.6 cm. With permission of the artist.

FIGURE 3.18
Atul Dodiya, *The Route to Dandi* 1998. Watercolour, marble dust and charcoal on paper, 177.8 x 114.3 cm. With permission of the artist.

FIGURE 3.19
Gigi Scaria, *In Search of Salt* 2010. Acrylic on canvas, 121.92 x 121.92 cm. subsequently reproduced as digital print. With permission of the artist.

FIGURE 3.20
Nandalal Bose, *Dandi March, March 1930*, 1930. Tempera on Wood, 39.37 x 24.76 cm. Ex-collection Raja Praphullanath Tagore, as reproduced in *An Album of Nandalal Bose, with a Biographical Note* (Calcutta: Santiniketan Asramik Sangha), 1956. With permission of Supratik Bose.

FIGURE 3.21
Nandalal Bose, *Bapuji 12-4-1930*, 1930. Linocut on paper, 35 x 22.3 cm. Art Institute of Chicago, gift of Supratik Bose, 2009.743. Photo credit: The Art Institute of Chicago/Art Resource, NY.

FIGURE 3.22
Charanjit Lal, 'I want world sympathy in this battle of Right against Might. Dandi, MK Gandhi, 5.4.30', 1980. First day cover issued by Indian Posts and Telegraphs Department on the 50th anniversary of Salt March.

FIGURE 3.23
Rupkishor Kapur, *Rastre ke Sutradhar: Mahatma Gandhi (Dandi Camp Mein)*, 193?. Chromolithograph published by Babu Lal Bhargava, Kanpur. Priya Paul Collection, New Delhi.

FIGURE 3.24
Karadi Kamp Mein Mahatma Gandhi Ki Giraftari (Mahatma Gandhi's Arrest in Karadi Camp) 193?. Lithograph published by

Shyam Sunder Lal, Kanpur. Priya Paul Collection. New Delhi.

FIGURE 3.25
Vinayak S. Masoji, *The Midnight Arrest*, 1944? Medium and dimensions not available.

FIGURE 3.26
Ramkinkar Baij, *Dandi March-II*, 1948. Plaster of Paris, 49 x 23 x 29 cm. With permission of NGMA, New Delhi.

FIGURE 3.27
Gigi Scaria, *Who Deviated First?* 2010. Acrylic and serigraph on canvas, 76.2 x 152.4 cm. With permission of the artist.

FIGURE 3.28
Devi Prasad Roy Chowdhury, *Martyrs Column*, 1981–82. Bronze, 17.5 feet (height), Sardar Patel Marg, New Delhi. With permission of American Institute of Indian Studies.

FIGURE 3.29
A. Ramachandran, *Dandi March Stamp*, 1980. With permission of the artist.

FIGURE 3.30
Haku Shah, *Meethu* (Salt), 2013. Oil on canvas, 60.96 x 60.96 cm. With permission of the artist's family.

FIGURE 3.31
Vivan Sundaram, Untitled, 1995. Collage with photograph and metal, 14.6 x 8.9 cm. With permission of Sahmat, New Delhi.

FIGURE 3.32
Sachin Karne, *Gandhi My Friend*, 2008. Oil on mirror, 150 x 118 cm. With permission of the artist.

FIGURE 3.33
Atul Dodiya, *Draw as You Walk* (Bako Series), 2011. Oil, acrylic, watercolour, oil bar and marble dust on canvas, 198.12 x 198.12 cm. Overall size with stand: 229.87 x 204.47 x 60.96 cm.

FIGURE 3.34
Sachin Karne, *The Walk: Gandhi the Cartographer*, 2008. Oil

on canvas, 122 x 183 cm. With permission of the artist.

FIGURE 3.35
Amit Ambalal, *The March*, 1995. Watercolour on paper, 14.6 x 8.9 cm. With permission of Sahmat, New Delhi.

FIGURE 3.36
Tallur L.N., *Eraser Pro*, 2012. Bronze, 200 x 95 x 65 cm. With permission of artist.

FIGURE 3.37
G.R. Iranna, *Naavu*, 2019. Mixed media installation, 14 x 60 feet. With permission of the artist.

FIGURE 3.38
G.R. Iranna, *Cuffed Object*, 2009. Wood, stainless steel, and brass, 10.16 x 15.24 x 30.48 cm. With permission of the artist/ Aicon Gallery, New York.

FIGURE 3.39
Ravikumar Kashi, *Artist Book: Everything He Touched* [detail], 2011. Conte, ink and photography transfer on Japanese raka stained handmade paper, 36.8 x 30.4 cm. With permission of the artist.

FIGURE 3.40
Arpana Caur, 1947, 2013. Terracotta relief, 45.7 x 45.7 cm. With permission of the artist.

FIGURE 3.41
Gandhi Smriti, New Delhi. Author's photograph.

FIGURE 3.42
Yunus Khimani, Untitled, 1995. Linocut, 14.6 x 8.9 cm. With permission of Sahmat, New Delhi.

FIGURE 3.43
Atul Dodiya, *Evening Walk*, 1998. Watercolour and acrylic with marble dust on paper, 114.3 x 177.8 cm. With permission of the artist.

FIGURE 4.1
Upendra Maharathi, *The Fate of Three Great Men: Gandhi, Buddha and Christ*, n.d. Watercolour on paper,

40.6 x 30.4 cm. With permission of NGMA, New Delhi.

FIGURE 4.2
Atul Dodiya, *Voracious Eaters*, 1994. Oil, acrylic, and marble dust on canvas, 182.88 x 121.92 cm. With permission of the artist.

FIGURE 4.3
Atul Dodiya, *Nehru Announcing Gandhi's Death, Birla House, Delhi, January 30, 1948*, 2014. Left panel: oil on canvas, 55.88 x 76.2 cm; right panel: archival digital print on hahnemuehle bamboo paper, 50.8 x 38.1 cm. With permission of the artist.

FIGURE 4.4
Atul Dodiya, *The Funeral Pyre, 1948*, 2014. Left panel: oil on canvas, 55.88 x 76.2 cm; right panel: archival digital print on hahnemuehle bamboo paper, 50.8 x 34.29 cm. With permission of the artist.

FIGURE 4.5
Priyaprasad Gupta, Gandhi, 1948. Line drawing on paper, 34.5 x 24.8 cm. Victoria Memorial Hall, Kolkata.

FIGURE 4.6
Maqbool Fida Husain, *New Delhi 30 January 1948, c.* 1980s? Acrylic on canvas, 239.64 x 372.10 cm. Image courtesy Vadehra Art Gallery, New Delhi.

FIGURE 4.7
Maqbool Fida Husain, *Assassination of Gandhi*, n.d. Acrylic on canvas, 163 x 95 cm. Collection of Srinivas Aravamudan and Ranjana Khanna.

FIGURE 4.8
Gigi Scaria, *Touch My Wound*, 2007/08. Digital print, variable dimensions. With permission of the artist.

FIGURE 4.9
Ravi Kumar Kashi, *Encounter No. 2*, 1998. Khadi cloth, glass marbles, papier-mâché, acrylic colour, ink drawing on glass,

printed image on wooden panel, 91.44 x 50.8 x 5.08 cm. With permission of the artist.

FIGURE 4.10
Nalini Malani, Untitled, 1994. Linocut, 8.89 x 14.6 cm. With permission of Sahmat, New Delhi.

FIGURE 4.11
Upendra Maharathi, *Bloody Sunset*, n.d. Tempera on paper, 33 x 23 cm. With permission of NGMA, New Delhi.

FIGURE 4.12
A. Ramachandran, *Monumental Gandhi: Hey Ram, 2nd Version* (Rear view, detail), 2016. Bronze, 213.36 cm, With permission of the artist.

FIGURE 4.13
Feliks Topolski, *Mahatma Gandhi*, 1946. Oil on canvas, 152.4 x 121.92 cm. The Estate of Feliks Topolski.

FIGURE 4.14
Feliks Topolski, *The East, 1948*, 1948. Oil on canvas, 313.94 x 390.14 cm. With permission of Rashtrapati Bhavan Culture Centre, New Delhi.

FIGURE 4.15
Debanjan Roy, Untitled 8, 2009. Watercolour and acrylic on paper, 35.56 x 27.9 cm. With permission of the artist/Aicon Gallery, New York.

FIGURE 4.16
Kripal Singh Shekhawat, *Life of Gandhi* [detail], 1955–58. Fresco in Birla House/Gandhi Smriti, New Delhi. Image courtesy DAG, New Delhi.

FIGURE 4.17
L.K. Sharma, *Bapuji ki Amar Kahani, c.* 1948. Oil on canvas, 111.76 x 78.74 cm. Collection of Anil Relia, Ahmedabad.

FIGURE 4.18
K.R. Ketkar, *Amar Bharat Atma* [Immortal soul of India], *c.* 1948. Chromolithograph published by Ketkar Art Inst., 28.5 x 21 cm. Collection of Erwin Neumayer and Christine Schelberger, Vienna.

FIGURE 4.19
P.L. Malhotra, *Bapu ke Antim Darshan* [Bapu's Last Sighting], *c.* 1948. Chromolithograph published by Hem Chander Bhargava, Delhi. Image courtesy Christopher Pinney.

FIGURE 4.20
Svarg Mein Bapu [Gandhi in Heaven], *c.* 1948. Chromolithograph published by Indian School of Photography, New Delhi, 48.9 x 34.7 cm. Image Courtesy Osianama Research Centre, Archive & Library Collection.

FIGURE 4.21
Vasudeo Pandya, *Swargarohan* [Ascent to heaven], 1948. Chromolithograph published Shree Vasudev Picture Co. Bombay, 47.3 x 34.1 cm. Image Courtesy Osianama Research Centre, Archive & Library Collection.

FIGURE 4.22
Kanu Gandhi, Memorial slab with inscription, 'He Ram, 30-1-48 5.17, Evening', Birla House, New Delhi, 1948. Courtesy National Gandhi Museum, New Delhi.

FIGURE 4.23
Max Desfor, *Hindu women mourn within a bamboo enclosure at the rear grounds of Birla House, New Delhi, marking the spot where Mohandas K. Gandhi fell when he was shot on Jan. 30, seen Feb. 1, 1948.* AP Images.

FIGURE 4.24
Martyr's Column with Inscription 'He Ram, 5-17, Evening, 30-1-48'. Gandhi Smriti, New Delhi. Author's Photograph.

FIGURE 4.25
Atul Dodiya, *Koodal* (Triptych), 2016. Oil, crackle paste and marble dust on canvas, each panel, 198.12 x 137.6 cm. Overall installed size: 198.12 x 411.48 cm. With permission of the artist.

FIGURE 4.26
A. Ramachandran, Untitled, 1995. Ink and gold paint on paper, 14.6 x 8.9 cm.

With permission of artist and Sahmat, New Delhi.

FIGURE 4.27
Sayed Haidar Raza, *He Ram*, 2013. Acrylic on canvas, 59.69 x 59.69 cm. With permission of Raza Foundation.

FIGURE 4.28
Nathuram Godse Madanlal Apte, *c.* 1949. Print, 25 x 18. 5 cm. Collection of Erwin Neumayer and Christine Schelberger, Vienna.

FIGURE 4.29
Sachin Karne, *Ambush*, 2019. Oil on canvas, 121.92 x 182.8 cm. With permission of the artist.

FIGURE 4.30
Shibu Natesan, Untitled, 1995. Linocut, 14.6 x 8.9 cm. With permission of Sahmat, New Delhi.

FIGURE 5.1
Ashim Purkayastha, *Gandhi: Man Without Specs IX*, 2006. Acrylic on postage stamps, 22.8 x 25.4 cm. Set of 100 postage stamps. With permission of the artist.

FIGURE 5.2
Jagannath Panda, *The Icon*, 2008. Acrylic and fabric on canvas, 259.1 x 142.2 cm. With permission of the artist.

FIGURE 5.3
Vivek Vilasini, *Vernacular Chants II*, 2007. Archival print on hahnemule photo paper, 9 works (93.98 x 83.82 cm). With permission of Aicon Gallery, New York.

FIGURE 5.4
Gigi Scaria, *Caution! Men at Work* 2015. Watercolour and automotive paint on paper, 182.88 x 152.4 cm. With permission of the artist.

FIGURE 5.5
Debanjan Roy, *Absence of Bapu*, 2007–2010. Fiberglass with acrylic paint, 167.64 x 182.88 x 121.92 cm. With permission of the artist and Akar Prakar Gallery.

FIGURE 5.6
Debanjan Roy, *India Shining I (Bapu with Laptop)*, 2007. Aluminum cast, 55.88 x 116.84 x 76.2 cm. With permission of the artist/ Aicon Gallery, New York.

FIGURE 5.7
Debanjan Roy, *India Shining VI: Walking the Dog*, 2009. Fiberglass with acrylic paint, 116.84 x 38.1 x 35.56 cm (Gandhi); 27.94 x 45.72 x 17.78 cm (dog). With permission of the artist/Aicon Gallery, New York.

FIGURE 5.8
Vinayak S. Masoji, Untitled (inscription 'Thy Will be Done, 30.1.48'), 1948. Woodcut on paper, 17.8 x 16.5 cm. With permission of DAG, New Delhi.

FIGURE 5.9
J. Nandkumar, *Gandhi After Pune Karar*, 2010. Acrylic on canvas, 167.64 x 137.16 cm. With permission of the artist.

FIGURE 5.10
J. Nandkumar, *Gandhi After Pune Karar*, 2011. Acrylic on canvas, 121.92 x 91.44 cm. With permission of the artist.

FIGURE 5.11
Pinak Bani, '*Chamber of Non-Violence' at the National Freedom Struggle Museum*, 2017. Digital montage, 50.8 x 46.99 cm. With permission of the artist.

FIGURE 5.12
Riyas Komu, *Dhamma Swaraj: A Triptych*, 2018. Oil on canvas, 137.16 x 182.88 cm. With permission of the artist.

FIGURE 5.13
Gigi Scaria, *Secularism Dismantled*, 2018. Inkjet on archival paper, 60.96 x 91.44 cm. With permission of the artist.

FIGURE 5.14
Ram Rahman, Bhupen Khakkar posing with a statue of Gandhi, New Delhi, 1994. Photograph. With permission of the photographer.

REFERENCES

Ahuja, Naman P. 2013. *Rupa-Pratirupa: The Body in Indian Art and Thought*. Brussels: Europalia International.

_____. 2018. 'The Dead, Dying, and Post-Death: Visual Exemplars and Iconographic Devices.' In *Imaginations of Death and the Beyond in India and Europe*, edited by Günter Blamberger and Sudhir Kakar. Singapore: Springer.

Alone, Y.S. 2017. 'Caste Life Narratives, Visual Representation, and Protected Ignorance.' *Biography* 40 (1): 140–169.

Alter, Joseph S. 2000. *Gandhi's Body: Sex, Diet, and the Politics of Nationalism*. Philadelphia: University of Pennsylvania Press.

Anand, Mulk Raj. 1969. 'Gandhi on Art.' *Marg Magazine* 22 (4): 2–10.

Anand, Y.P. 2003. *Mahatma Gandhi and Art*. New Delhi: Indira Gandhi National Centre for the Arts.

Anon. 1948a. 'Gandhi Joins the Hindu Immortals: Photographs for Life by Margaret Bourke-White and Henri Cartier-Bresson.' *Life*, February 16, 21–29.

_____. 1948b. 'Sacred Rivers Receive Gandhi's Ashes.' *Life*, March 15, 76–78.

_____. 1949a. *In the High Court of Judicature for the Province of East Punjab at Simla: Mahatma Gandhi Murder Case, Printed in 6 Volumes*. 8 vols. Simla: Himalia Press.

_____. 1949b. *Gandhi Mandap, Sarvodaya Day, Raj Ghat, Delhi: An Art Exhibition Devoted to the Memory of Mahatma Gandhi*. New Delhi: N.P.

_____. 1956. *An Album of Nandalal Bose, with a Biographical Note*. Calcutta: Santiniketan Asramik Sangha.

Arnold, David. 2013. *Everyday Technology: Machines and the Making of India's Modernity*. Chicago: University of Chicago Press.

Azoulay, Ariella. 2012. *Civil Imagination: A Political Ontology of Photography*. London: Verso.

Bandopadhyay, Prabhatmohan. 1982. 'Karusangha and Jatiya Andalon.' *Desh Binodan (Nandalal Birth Centenary Volume)*: 42–43.

Bandyopadhyay, Bhawati. 2004. 'Mahatma Gandhi and his Contemporary Artists.' *Gandhi Marg* 26 (3): 333–341.

Bandyopadhyaya, Somendranath, and Bhaswati Ghosh. 2012. *My Days with Ramkinkar Baij*. Translated by Bhashwati Ghosh. New Delhi: Niyogi Books.

Bani, Pinak. 2019. 'Containing the Cosmetic Nation: Acquisition of Sass Brunner Paintings.' *Prabuddha: Journal of Social Equality* 3: 50–76.

Barrow, Ian. 2014. 'Finding the Nation in Assassination: The Death of SWRD Bandaranaike and the Assertion of a Sinhalese Sri Lankan Identity.' *The Historian* 76 (4): 784–802.

Barthes, Roland. 1981. *Camera Lucida*. New York: Hill & Wang.

Bawa, Seema. 2018. 'Power and Politics of Portraits, Icon, and Hagiographic Images of Gandhi.' *Economic and Political Weekly* LIII (5): 54–61.

Bean, Susan. 1989. 'Gandhi and Khadi: The Fabric of Indian Independence.' In *Cloth and the Human Experience*, edited by Annettte B. Weiner and Jane Schneider, 355–376. Washington, D.C.: Smithsonian Institution Press.

Beckerlegge, Gwilym. 2008. 'Swami Vivekananda's Iconic Presence and Conventions of Nineteenth-Century Photographic Portraiture.' *International Journal of Hindu Studies* 12 (1): 1–40.

Bellentani, Guiia R.M., and Lorenzo Gottardi, eds. 2007. *India in Gandhi's Time* Milano: Guinti.

Black, Jonathan. 2017. *Winston Churchill in British Art, 1900 to the Present Day*. London: Bloomsbury.

Boodakian, Florence Dee. 2008. *Resisting Nudities: A Study in the Aesthetics of Eroticism*. New York: Peter Lang.

Bose, Nandalal. 1944. 'The True Artist.' In *Gandhiji: His Life and Work*, edited by D.G. Tendulkar et al., 230–35. Bombay: Karnatak Pub. House.

_____. 1999. *Vision and Creation*. Calcutta: Visva-Bharati Publishing Department.

Bose, Nirmal Kumar. 1974. *My Days with Gandhi*. Bombay: Orient Longman.

Bourke-White, Margaret. 1949. *Halfway to Freedom: A Report on the New India in the Words and Photographs of Margaret Bourke-White*. New York: Simon and Schuster.

_____. 1963. *Portrait of Myself*. New York: Simon and Schuster.

Brilliant, Freda. 1986. *Biographies in Bronze*. New York: Steimatzky.

Brown, Rebecca. 2010. *Gandhi's Spinning Wheel and the Making of India*. London: Routledge.

Cadava, Eduardo. 1997. *Words of Light: Theses on the Photography of History*. Princeton, N.J.: Princeton University Press.

Cartier-Bresson, Henri. 1952. *The Decisive Moment:*

Photography by Henri Cartier-Bresson. New York: Simon and Schuster.

Chettiar, A.K. 2007. *In the Tracks of the Mahatma: The Making of a Documentary*. Translated by S. Thillainayagam. Hyderabad: Orient Blackswan.

Chittaprosad. 2011. *Chittaprosad: Art as Rebellion*. New Delhi: Delhi Art Gallery.

Christie's. 2013. *The Art of Nandalal Bose, Abanindranath Tagore, Rabindranath Tagore: The Collection of Supratik Bose, Tuesday 17 September 2013*. New York: Christie's.

Cookman, Claude. 1998. 'Margaret Bourke-White and Henri Cartier-Bresson: Gandhi's Funeral.' *History of Photography* 22 (2): 199–209.

Copeman, Jacob. 2013. 'The Art of Bleeding: Memory, Martyrdom, and Portraits in Blood.' *Journal of the Royal Anthropological Institute (N. S.)*: S149–S171.

Dar, Vishal K., and Siddhartha Chatterjee. 2010. *BrowNation: More Experiments in Becoming*. New Delhi: Gallery Espace.

Davidson, Jo. 1969. 'Between Sittings with Gandhi.' In *Profiles of Gandhi: America Remembers a World Leader*, edited by Norman Cousins, 18–19. Delhi: Indian Book Co.

Daw, Prasanta. 1998. *Art and Aesthetics of Deviprasad*. Calcutta: Indian Society of Oriental Art.

De, Aditi. 2015. *Mohandas Karamchand Gandhi, Great Lives*. Gurgaon: Scholastic India.

Dehejia, Vidya. 1997. 'Issues of Spectatorship and Representation.' In *Representing the Body: Gender Issues in Indian Art*, edited by Vidya Dehejia, 1–21. New Delhi: Kali for Women.

Derrida, Jacques. 1989. 'The Deaths of Roland Barthes.' In *Philosophy and Non-Philosophy since Merleau-Ponty*, edited by Hugh Silverman, 259–96. New York: Routledge.

Desai, Ashwin, and Goolam Vahed. 2016. *The South African Gandhi: Stretcher-Bearer of Empire*. Stanford: Stanford University Press.

Devji, Faisal. 2014. 'Politics Without Paternity.' *Seminar* 662: 18–24.

Dey, Mukul. 1948. *Portraits of Mahatma Gandhi*. Bombay: Orient Longman.

Dharker, Anil. 2005. *The Romance of Salt*. New Delhi: Roli Books.

Dinkar, Niharika. 2010. 'Masculine Regeneration and the Attenuated Body in Swadeshi Art: Reconsidering the Early Work of Nandalal Bose.' *Oxford Art Journal* 33 (2): 167–88.

Dixit, Devendra N. 1970. 'Gandhiji's Personal Effects.' *The Illustrated Weekly of India*, January 25: 8–9.

Dodiya, Atul. 1999. An Artist of Non-Violence: Water Colours. Mumbai: Gallery Chemould.

Dutt, Gayatri Madan, and C.N. Patel. 2008. *Mahatma Gandhi: Father of the Nation*. Mumbai: Amar Chitra Katha.

Eaton, Natasha. 2013. *Color, Art, and Empire*. London: I.B. Tauris.

Edwards, Elizabeth. 2014. 'Photographic Uncertainties: Between Evidence and Reassurance.' *History and Anthropology* 25 (2): 171–88.

Fischer, Louis. 1950. *Life of Mahatma Gandhi*. New York: Harper & Brothers.

Flatley, Jonathan. 2008. *Affective Mapping: Melancholia and the Politics of Modernism*. Cambridge, Mass.: Harvard University Press.

Forster. E.M. 1949. 'Mahatma Gandhi.' In *Mahatma Gandhi: Essays and Reflections on his Life and Work, presented to him on his Seventieth birthday, October 2nd, 1939. Together with a New Memorial Section*, edited by S. Radhakrishnan, 386–88. London: G. Allen and Unwin.

Foster, Hal. 2004. 'An Archival Impulse.' *October* (110): 3–22.

Frady, Marshall. 2002. *Martin Luther King, Jr*. New York: Penguin Group.

Furst, Herbert. 1925. 'Mr. Fyzee-Rahmin's Paintings.' *Apollo: A Journal of the Arts* 2: 91–94.

Gadihoke, Sabeena. 2010. *India in Focus: Camera Chronicles of Homai Vyarwalla*. Ahmedabad: Ananda Publishers.

Gandhi, Dhiren. 1944. *A Glimpse into Gandhiji's Soul: Six Wood-Cuts by Dhiren Gandhi*. Bombay: International Book House Ltd.

Gandhi, Devdas. 1954. 'Introduction.' In *Sketches of Gandhi by Topolski*. New Delhi: Hindustan Times.

Gandhi, Devdas, ed. 1948. *Memories of Bapu*. New Delhi: Hindustan Times, 1st edition.

_____. 1949. *Memories of Bapu*. New Delhi: Hindustan Times, 3rd edition.

Gandhi, Kanu. 1970. Oral History Transcript. Cambridge South Asia Oral History Archive.

Gandhi, Manuben. 1962. *Last Glimpses of Bapu*. Translated by Moti Lal Jain. Delhi: Shiva Lal Agarwala.

_____. 1964. *The Lonely Pilgrim (Gandhiiji's Noakhali Pilgrimage)*. Ahmedabad: Navajivan.

Gandhi, M.K. 1928. *Satyagraha in South Africa*. Translated by Valji Govindji Desai. Madras: S. Ganesan.

_____. 2018. *An Autobiography, or the Story of My Experiments with Truth, translated from the Original in Gujarati by Mahadev Desai, Introduced with Notes by Tridip Suhrud*. Gurgaon: Penguin Random House.

Gandhi, Rajmohan. 1995. *The Good Boatman: A Portrait of Gandhi*. New Delhi: Viking.

Gandhi, Ramchandra. 1984. *I am Thou: Meditations on the Truth of India*. New Delhi: Indian Philosophical Quarterly Publications.

Gandhi, Tushar. 2007. *'Let's Kill Gandhi!': A Chronicle of His Last days, the Conspiracy, Murder, Investigation, and Trial*. New Delhi: Rupa and Co.

Ghosh, Bishnupriya. 2011. *Global Icons: Apertures to the Popular*. Durham: Duke University Press.

Goldberg, Vicki. 1986. *Margaret Bourke-White: A Biography*. New York: Harper and Row.

Gopal, Sarvepalli, ed. 1987. *Selected Works of Jawaharlal Nehru, 2nd series*. New Delhi: Oxford University Press.

Government of India. 1969. *Paintings and Sculptures on Mahatma Gandhi*. Calcutta: Ministry of Information & Broadcasting.

Guha, Ramachandra. 2015. *Gandhi Before India*. New York: Vintage Books.

_____. 2018. *Gandhi 1914-1948: The Years That Changed the World*. New York: Alfred P. Knopf.

Guha-Thakurta, Tapati. 1995. 'Locating Gandhi in Indian Art History: Nandalal and Ramkinkar.' In *Addressing Gandhi*, 135–152. New Delhi: Sahmat.

_____. 2018. 'Why Statues Matter: The Changing Landscape of Calcutta's Colonial and Postcolonial Statuary.' Victoria Memorial Lecture, Kolkata.

Harak, Simon. 2000. *Nonviolence for the Third Millennium: Its Legacy and Future, Macon, Ga.* Mercer University Press.

Hauswirth, Frieda. 1930. *A Marriage to India*. New York: The Vanguard Press.

Hendrikz, Willem De Sanderes. 1953. 'Martyr of the Twentieth Century.' *Harijan* XVII (31): 1.

Herman, Arthur. 2010. *Gandhi and Churchill: The Rivalry that Destroyed an Empire and Forged our Age*. New York: Random House.

Hiley, Nicholas. 2007. 'To Bear Witness: Feliks Topolski's 'Memoir' of the Twentieth Century.' *Times Literary Supplement*, April 6, 14.

Hofstadter, Dan. 1992. *Memoirs of Henri Cartier-Bresson and Other Artists*. New York: Open Road Media.

Horowitz, Gregg M. 2001. *Sustaining Loss: Art and Mournful Life*. Stanford: Stanford University Press.

Hunt, James D. 1993. *Gandhi in London*. Revised ed. New Delhi: Promilla & Co.

Hürlimann, Annemarie. 2007. 'Walter Bosshard: Pioneer in Photojournalism.' In *India in Gandhi's Time*, edited by Guiia R.M. Bellentani and Lorenzo Gottardi, 125–142. Milano: Guinti.

Kadri, Rizwan. 2018. *Unseen Drawings of Dandi March: Drawings of Chhaganlal Jadav*. Ahmedabad: Sri Swaminarayan Sansthan.

Kapoor, Pramod. 2015. *Gandhi: An Illustrated Biography*. Delhi: Roli Books.

Karode, Roobina. 2019. 'Our Time for A Future Caring.' In *India Pavilion: Our Time for A Future Caring (58th International Art Exhibition, La Biennale di Venezia)*, 39–57. New Delhi: Kiran Nadar Museum of Art.

Kapur, Geeta. 2000. *When was Modernism: Essays in Cultural Practice in India*. New Delhi: Tulika.

_____. 2010. 'Mortal Remains.' In *After the Event: New Perspectives on Art History*, edited by Charles Merewether and John Potts, 132–55. Manchester: Manchester University Press.

Kashi, Ravikumar. 2009. 'When Gandhi Gets Down from His Pedestal.' *Maurya*, October: 82–87.

Kaul, Chandrika. 2014. *Communications, Media, and the Imperial Experience: Britain and India in the Twentieth Century*. Houndsmill, Basingstoke, Hampshire: Palgrave Macmillan.

Khan, Yasmin. 2011. 'Performing Peace: Gandhi's Assassination at a Critical Moment in the Consolidation of the Nehruvian State.' *Modern Asian Studies* 45 (01): 57–80.

Khanduri, Ritu. 2012. 'Some Things about Gandhi.' *Contemporary South Asia* 20 (3): 303–325.

Khosla, G.D. 1963. *The Murder of the Mahatma, and Other Cases from a Judge's Notebook*. London: Chatto & Windus.

Kowshik, Dinkar. 1987. *Nandalal Bose: The Doyen of Indian Art*. New Delhi: National Book Trust.

Krishnadas. 1928. *Seven Months with Mahatma Gandhi: Being an Insider View of the Non Cooperation Movement (1921-22)*. Madras: S. Ganesan.

Lal, Vinay. 2000. 'Nakedness, Nonviolence, and Brahmacharya: Gandhi's Experiments in Celibate Sexuality.' *Journal of the History of Sexuality* 9: 105–136.

_____. 2001. '"He Ram": The Politics of Gandhi's Last Words.' *Humanscape* 8 (1): 34–38.

_____. 2014a. 'The Archivist's Gandhi.' *Seminar* 662: 2–8.

_____. 2014b. 'On the Art of Dying: Death and the Specter of Gandhi.' In *Experiments with Truth: Gandhi and Images of Nonviolence*, edited by Josef Helfenstein and Joseph N. Newland, 329–335. Houston, Tx/New Haven, Conn.: The Menil Collection/Yale University Press.

Laqueur, Thomas. 2015. *The Work of the Dead: A Cultural History of Mortal Remains*. Princeton: Princeton University Press.

Lelyveld, Joseph. 2011. *Great Soul: Mahatma Gandhi and His Struggle with India*. New York: Alfred P. Knopf.

Levine, Philippa. 2008. 'States of Undress: Nakedness and the Colonial Imagination.' *Victorian Studies* 50 (2): 189–219.

Maclean, Kama. 2015. *A Revolutionary History of Interwar India: Violence, Image, Voice and Text*. London: Hurst and Company.

Maitland, Padma D. 2017. 'A House for the Nation to Remember.' In *Historicizing Emotions: Practices and Objects in India, China, and Japan*, edited by Barbara Schuler, 33–56. Leiden: Brill.

Makkuni, Ranjit. 2007. *Eternal Gandhi: Design of the Multimedia Museum*. Mumbai: Sacred World Research Laboratory.

Malgaonkar, Manohar. 2009. *The Men Who Killed Gandhi* (Concept, Research & Editing by Pramod Kapoor). Revised ed. New Delhi: Roli Books.

Mallik, Sanjoy. 2009. 'Social Realism in the Visual Arts: "Man-Made" Famine and Political Ferment, Bengal, 1943-46.' In *Art and Visual Culture in India, 1857-1947*, edited by Gayatri Sinha, 150–161. Mumbai: Marg Publications.

Mallik, Sanjoy, ed. 2011. *Chittoprasad, 1915-1978: A Retrospective*. 2 vols. New Delhi: Delhi Art Gallery.

Markovits, Claude. 2002. 'Representing Gandhi in Independent India.' In *Thinking Social Science in India: Essays in Honour of Alice Thorner*, edited by Sujata Patel, Jaosdhara Bagchi and Krishna Raj, 367–379. New Delhi: Sage Publications.

Masoji, Vinayak S. 1944. 'Midnight Arrest.' In *Gandhiji: His Life and Work (Published on his 75th Birthday)*, edited by D.G. Tendulkar, et al., 219–221. Bombay: Keshav Bhikaji Dhawale.

Masquelier, Adeline. 2005. 'Dirt, Undress, and Difference: An Introduction.' In *Dirt, Undress, and Difference: Critical Perspectives on the Body's Surface*, edited by Adeline Masquelier, 1–32. Bloomington: Indiana University Press.

Michael, Kristine. 2018. *The Art of Kripal Singh Shekhawat*. New Delhi: DAG.

Muzumdar, Haridas T. 1932. *Gandhi versus the Empire*. New York: Universal.

McLain, Karline. 2007. 'Who Shot the Mahatma? Representing Gandhian Politics in Indian Comic Books.' *South Asia Research* 27 (1): 57–77.

Mehta, Ved. 1976. *Mahatma Gandhi and his Apostles*. New York: Viking.

Mittler, Barbara and Sumathi Ramaswamy, eds., 2019. *Envisioning Asia: Gandhi and Mao in the Photographs of Walter Bosshard*. Heidelberg: CATS.

Mitter, Partha. 2007. *The Triumph of Modernism: Indian Artists and the Avante Garde, 1922-1947*. London: Reaktion.

Moffat, Chris. 2019. *India's Revolutionary Inheritance: Politics and the Promise of Bhagat Singh*. Cambridge: Cambridge University Press.

Moss, Jessica, and Ram Rahman, eds. 2013. *The Sahmat Collective: Art and Activism in India since 1989*. Chicago: Smart Museum of Art, University of Chicago.

Nagy, Peter. 1997. 'The Sher-Gil Archive.' *Grand Street* 62: 68–73.

Nandy, Ashis. 1980. *At the Edge of Psychology: Essays in Politics and Culture*. New Delhi: Oxford University Press.

Nehru, Jawaharalal. 1959. *Toward Freedom: The Autobiography of Jawaharlal Nehru*. Boston: Beacon Press.

Neumayer, Erwin, and Christine Schelberger. 2008. *Bharat Mata: India's Freedom Movement in Popular Art*. New Delhi: Oxford University Press.

Pai, Laxman. 2000. *My Search, My Evolution*. New Delhi: Laxman Pai.

Panjiar, Prashant, ed. 2015. *Kanu's Gandhi*. New Delhi: Nazar Foundation.

Paranjape, Makarand. 2014. *The Death and Afterlife of Mahatma Gandhi*. Abingdon: Routledge.

Parel, Anthony. 1994. 'Aesthetics and Action in Gandhi's Political Philosophy.' *Indian Horizon* 43 (4): 225–245.

_____. 2006. 'Art and Society.' In *Gandhi's Philosophy and the Quest for Harmony*, edited by Anthony Parel, 157–174. Cambridge: Cambridge University Press.

_____. 2016. 'Arts and Gandhi's Political Philosophy.' In *Pax Gandhiana: The Political Philosophy of Mahatma Gandhi*, 156–179. Oxford: Oxford University Press.

Payne, Robert. 1969. *The Life and Death of Mahatma Gandhi*. London: Bodley Head.

Pinney, Christopher. 2004. *Photos of the Gods: The Printed Image and Political Struggle in India*. New Delhi: Oxford University Press.

_____. 2008. *The Coming of Photography in India*. London: The British Library.

_____. 2018. *Lessons from Hell: Printing and Punishment in India*. Mumbai: Marg.

_____. n.d. 'From Portrait to Avatar: Gandhi in the Popular Imagery.' Unpublished paper.

Pyarelal. 1956. *Mahatma Gandhi: The Last Phase, Volume I*. Ahmedabad: Navajivan.

_____. 1958. *Mahatma Gandhi: The Last Phase, Volume 2*. Ahmedabad: Navajivan.

Quintanilla, Sonya R., ed. 2008. *Rhythms of India: The Art of Nandalal Bose*. San Diego, Calif.: San Diego Museum of Art.

Radhakrishnan, K.S., and R. Siva Kumar, eds. 2012. *Ramkinkar Baij: A Restrospective, 1906-1980*. New Delhi: National Gallery of Modern Art.

Rai, Govind Chandra. 1951. *Abanindranath Tagore*. Calcutta: Thacker, Spinker & Co.

Ramachandran, A. 2014. 'Life Linedrawings.' In *A. Ramachandran: Life and Art in Lines, Drawings, Sketches and Studies, 1958 to 1987*, edited by R. Siva Kumar, 10–64. New Delhi: Vadehra Art Gallery and Lalit Kala Akademi.

Ramaswamy, Sumathi. 2009. 'The Mahatma as Muse: An Image Essay on Gandhi in Popular Indian Visual Imagination.' In *Art and Visual Culture in India, 1857-1947*, edited by Gayatri Sinha, 236–249. Mumbai: Marg Publications.

_____. 2010. *The Goddess and the Nation: Mapping Mother India*. Durham: Duke University Press.

_____. 2016. *Husain's Raj: Visions of Empire and Nation*. Mumbai: Marg.

Roy, Arundhati. 2017. 'The Doctor and the Saint.' In *Annihilation of Caste: The Annotated Critical Edition*, 15–181. Delhi: Navayana.

Roy, Anwesha. 2018. *Making Peace, Making Riots: Communalism and Communal Violence, Bengal 1940-47*. Cambridge: Cambridge University Press.

Roy, Parama. 2010. *Alimentary Tracts: Appetites, Aversions and the Postcolonial*. Durham: Duke University Press.

Sahmat. 1995. *Addressing Gandhi*. New Delhi: Sahmat.

Salkeld, Richard. 2014. *Reading Photographs: An Introduction to the Theory and Meaning of Images*. London :Bloomsbury.

Sambrani, Chaitanya. 2019. 'At Home in the World.' In *At Home in the World: The Art and Life of Gulammohammed Sheikh*, edited by Chaitanya Sambrani, 94–157. New Delhi: Tulika Books in association with Vadehra Art Gallery.

Sambrani, Chaitanya, ed. 2005. *Edge of Desire: Recent Art in India*. London: Philip Wilson.

Santosh, S. 2012. 'What was Modernism (in Indian Art?).' *Social Scientist* 40 (5/6): 59–75.

Sanyal, B.C. 1999. *The Vertical Woman: Reminiscences of B.C. Sanyal: From 1947 to Present*. New Delhi: National Gallery of Modern Art.

Scalmer, Sean. 2011. *Gandhi in the West: The Mahatma and the Rise of Radical Protest*. Cambridge: Cambridge University Press.

Sevea, Iqbal. 2016. 'The Saints Who Walk: Walking, Piety, and Technologies of Circulation in Modern South Asia.' In *Walking Histories, 1800-1914*, edited by Chad Bryant, Arthur Burns and Paul Readman, 243–264. Basingstoke: Palgrave Macmillan.

Shah, Haku. 2014. *Nitya Gandhi: Living Reliving Gandhi*. New Delhi: Center for Media and Alternative Communication.

Sharma, Kanika. 2015. 'Spectacular Justice: Aesthetics and Power in the Gandhi Murder Trial.' In *The Courtroom as a Space of Resistance: Reflections on the Legacy of the Rivonia Trial*, edited by Awol Allo, 323–343. Burlington: Ashgate.

Sheikh, Gulammohammed. 2019. 'Reading Gandhi in Our Time.' *Social Scientist* 47 (3-4): 3–7.

Sheridan, Claire. 1949. 'The Great Little Mahatma.' In *Mahatma Gandhi: Essays and Reflections on his Life and Work, presented to him on his Seventieth birthday, October 2nd, 1939. Together with a New Memorial Section*, edited by S. Radhakrishnan, 272–280. London: G. Allen and Unwin.

Shirer, William L. 1979. *Gandhi: A Memoir*. New York: Simon and Schuster.

Singh, Kavita. 2006. 'In the Name of the Father and the Son.' In *Ashim Purkayastha: Borderline*, 44-47. New Delhi: Anant Art

Sinha, Braja Kishore. 1948. *The Pilgrim of Noakhali: A Souvenir Album of Gandhiji's Peace Mission to Noakhali*. Calcutta: The Photographer.

Sinha, Gayatri. 2013. 'The Afterlives of Images: The Contested Legacies of Gandhi in Art and Popular Culture.' *South Asian Studies* 13 (1): 111–129.

_____. 2019. 'Gandhi Darshan (Returning the Gaze): The Role of Walter Bosshard.' In *Envisioning Asia: Gandhi and Mao in the Photographs of Walter Bosshard*, edited by Barbara Mittler and Sumathi Ramaswamy, 38–41. Heidelberg: CATS.

Siva Kumar, R. 1996. 'Abanindranath: From Cultural Nationalism to Modernism.' *Nandan: An Annual on Art and Aesthetics* XVI: 49–71.

_____. 2008. *Paintings of Abanindranath Tagore*. Kolkata: Pratikshan.

_____. 2013. 'Nandalal Bose and His Place in Indian Art.' In *The Art of Nandalal Bose, Abanindranath Tagore, Rabindranath Tagore: The Collection of Supratik Bose, Tuesday 17 September 2013*, 6–9. New York: Christie's.

Siva Kumar, R. ed. 2003. *Ramachandran: A Retrospective*. 2 vols. New Delhi: National Gallery of Modern Art and Vadehra Art Gallery.

_____. ed. 2014. *A. Ramachandran: Life and Art in Lines, Drawings, Sketches and Studies, 1958 to 1987*. 2 vols. New Delhi: Vadehra Art Gallery and Lalit Kala Akademi.

Sontag, Susan. 2003. *Regarding the Pain of Others*. New York: Farrar, Straus and Giroux.

Srivatsan, R. 2000. *Conditions of Visibility: Writings on Photography in Contemporary India*. Calcutta: Stree.

Subramanyan, K.G. 1983–84. 'Nandalal Bose: A Biographical Sketch.' *The Visva-Bharati Quarterly (Nandalal Centenary Number)* 49 (1-4): 1–23.

_____. 2007. *The Magic of Making: Essays on Art and Culture*. Calcutta: Seagull Books.

_____. 2008. 'The Nandalal-Gandhi-Rabindranath Connection.' In *Rhythms of India: The Art of Nandalal Bose*, edited by Sonya Rhie Quintanilla, Nandalala Basu, John M. Rosenfield and Pramod Chandra, 92–102. San Diego, Calif.: San Diego Museum of Art.

Suhrud, Tridip. 2013. *Emptied of All Love: Gandhiji on 30 January, 1948*. New Delhi: Nehru Memorial Museum and Library.

_____. 2016. 'Exiled at Home: The Burden that is Gandhi: Third Tarun Mitra Memorial Lecture.' *The Dawn: An Organ of National Council of Education, Bengal* VI (18): 1–14.

Sunderason, Sanjukta. 2017. 'Shadow-Lines: Zainul Abedin and the Afterlives of the Bengal Famine of 1943.' *Third Text: Critical Perspectives on Contemporary Art & Culture* 31 (2-3): 239–261.

Talbot, Phillips. 2007. 'With Gandhi in Noakhali, February 16, 1947.' In *An American Witness to India's Partition*, 202–212. Los Angeles: Sage Publications.

Tarlo, Emma. 1996. *Clothing Matters: Dress and Identity in India*. Chicago: University of Chicago Press.

Tendulkar, D.G. 1951. *Mahatma: Life of Mohandas Karamchand Gandhi, Volume 1: 1869-1920*.

Bombay: Vithalbhai K. Jhaveri and D.G. Tendulkar.

_____. 1952. *Mahatma: Life of Mohandas Karamchand Gandhi, Volume 3: 1930-1934*. Bombay: Vithalbhai K. Jhaveri and D.G. Tendulkar.

_____. 1954. *Mahatma: Life of Mohandas Karamchand Gandhi, Volume 8: 1947-1948*. Bombay: Vithalbhai K. Jhaveri and D.G. Tendulkar.

Thakkar, Usha, and Jayshree Mehta. 2011. 'Raihana Tyabji.' In *Understanding Gandhi: Gandhians in Conversation with Fred J. Blum*, 155–242. New Delhi: Sage Publications.

Thakkar, Usha, and Sandhya Mehta. 2017. *Gandhi in Bombay: Towards Swaraj*. New Delhi: Oxford University Press.

Tharakam, Bojja. 2018. *Mahad: The March That's Launched Every Day*: The Shared Mirror.

Topolski, Feliks. 1988. *Fourteen Letters: An Autobiography*. London: Faber & Faber.

Tuli, Neville. 2002. *A Historical Epic: India in the Making, 1757-1950: From Surrender to Revolt, Swaraj to Responsibility*. Mumbai: Osian's.

Twain, Mark. 1927. *More Maxims of Mark*. Edited by Merle Johnson. New York: Privately Printed for Private Distribution.

Vajpeyi, Ashok. 2017. 'Life, Art and Gandhian Light.' In *Gandhi in Raza*, 29–39. New Delhi: Akar Prakar.

Venkatachalam, G. 1945. 'The Moods of a Mahatma: Six Pencil Sketches by Dhiren Gandhi.' In *Prayer and Other Sketches of Mahatma Gandhi by Dhiren Gandhi*, none. Bombay: Nalanda Publications.

Washington, James Melvin, ed. 1986. *A Testament of Hope: The Essential Writings of Martin Luther King, Jr.* San Francisco: Harper & Row.

Weber, Thomas. 1997. *On the Salt March: The Historiography of Gandhi's March to Dandi*. New Delhi: HarperCollins.

_____. 2004. *Gandhi as Disciple and Mentor*. Cambridge: Cambridge University Press.

_____. 2011. *Going Native: Gandhi's Relationship with Western Women*. New Delhi: Roli Books.

_____. 2015. *Gandhi at First Sight*. New Delhi: Roli Books.

INDEX